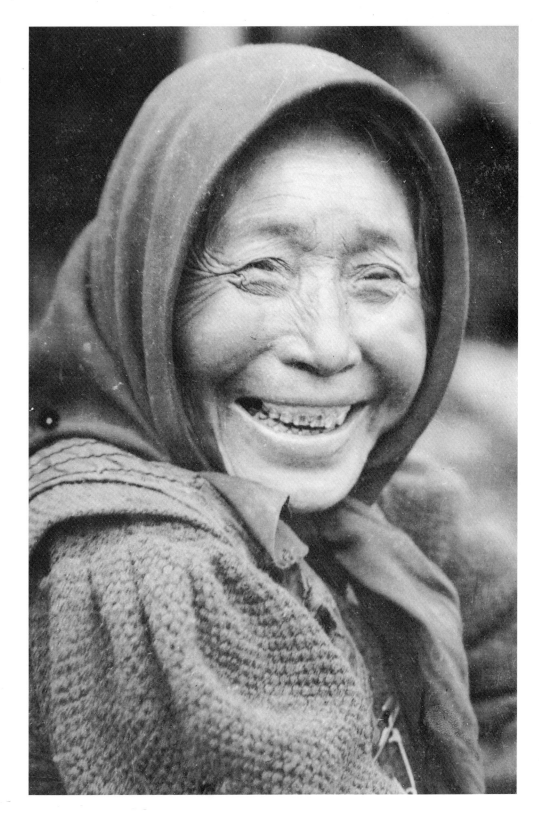

Woman at the old Songhees Reserve,
1904–8; the same woman appears in the
photograph on page 141.
RBCM PN8890.

Songhees Pictorial

A History of the Songhees People as Seen by Outsiders, 1790–1912

Grant Keddie

ROYAL BC MUSEUM

Victoria, Canada

Published by the Royal BC Museum, 675 Belleville Street, Victoria, British Columbia, V8W 9W2, Canada.

Typeset in Bembo 11.5/13 (body)
 and Bembo Semibold (titles and headings).
Edited, formatted and typeset by Gerry Truscott, RBCM.
Digital imaging and final restoration, Liam Regan
Designed by Chris Tyrrell, RBCM.
Printed in Canada by Kromar Printing, Winnipeg.

National Library of Canada Cataloguing in Publication Data
Keddie, Grant R.
 Songhees pictorial : a history of the Songhees people
 as seen by outsiders (1790–1912)

 Includes bibliographical references.
 ISBN 0-7726-4964-2

 1. Lekwungen Indians – Pictorial works. 2. Indians of
North America – British Columbia – Victoria – History. 3.
Victoria (B.C.) – History. I. Title. II. Title: History of the
Songhees people as seen by outsiders (1790–1912)

E99.L35K42 2003 971.128'004979 C2003-960237-0

Contents

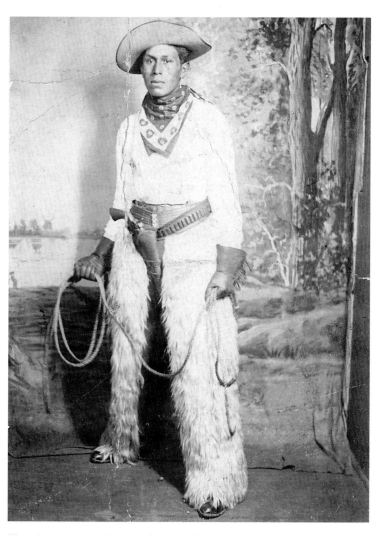

Tom James posing in a cowboy outfit in Joyner's Studio, Nanaimo. He is not the Tom James described on page 154; this man grew up on Discovery Island and, in the late 1940s, provided information to anthropologist Wayne Suttles.
Postcard; RBCM PN 6346.

To the children of the Lekwungen
and to the memory of Chief John Albany (1916–96),
who strongly believed that young people should learn about their past.

A Place of Refuge

The way of the Indian is most often associated with the Indian reserves,
because most Indians are at home on the reserve. The reserve is their life. It's
where they were born, where they spent their childhood.
And even if they do go to work in the city
the reserve is still the place they'll mostly think of as home.

Chief John Albany,
from *The Way of the Indian* (1961).

Introduction

The old Songhees Reserve was a prominent feature in the heart of Victoria in the latter half of the 19th century. The reserve and its people played significant roles in the local history from 1843 to 1911, when the Songhees moved to their present reserve in Esquimalt. Now part of the community of Victoria West, the old reserve land continues to play an important role in the development of the city.

After 1844, many of the Songhees left their traditional villages and congregated on the Inner Harbour reserve. The reserve was not only the home of most local Songhees, but also a seasonal trading resort for thousands of aboriginal peoples in the region and as far north as Alaska. For two decades after the Hudson's Bay Company established Fort Victoria as a trading post, aboriginal people made up the majority of the local population. The 19th-century economy of the region was dependent on aboriginal trade, their purchase of goods and their labour.

Over the years, stories about First Nations have been presented from a limited colonial perspective. The majority of writers have described First Nations cultures as static and strictly traditional until the arrival of Europeans, cultures that quickly and passively fell apart when confronted with the more powerful societies of the colonists.

But the information gathered from oral accounts, archaeology and environmental history tells a very different story. For thousands of years before contact with Europeans, First Nations cultures adapted continually to the environmental changes, including occasional extreme winters of starvation, earthquakes, floods, tsunamis, diseases, warfare and trade. Populations fluctuated, moved and mixed as a result of these events and the changing access to resources, the development of new technologies and changing social patterns that resulted. After Europeans arrived and established settlements, First Peoples took an active role in directing the changes

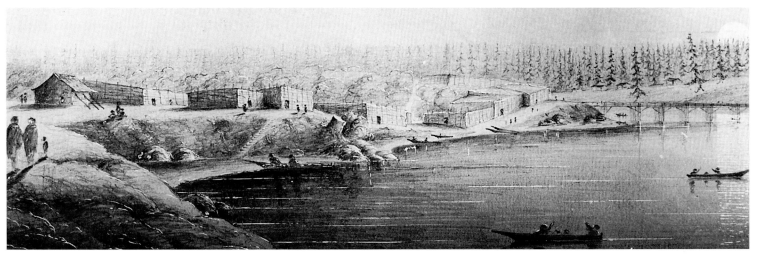

Songhees Reserve, 1857, from Songhees Point (bottom left) to the first Johnson Street Bridge (right). Many extended family groups moved here after the summer of 1844, where they built the traditional plank houses shown here. No village existed here before.
Art by James Madison Alden; RBCM PN6811.

South end of the old Songhees Reserve from across the harbour, about 1900. Laurel Point is on the left with Mud Bay in the distance above it. Songhees Point is at the centre next to the large Marine Hospital. RBCM PN16951

that affected them. These changes spanned generations and varied in complexity from region to region.

The Songhees and Esquimalt nations, who have a shared territory around greater Victoria, have now passed through ten generations since the first European visitors came to their shores. The historical events recounted in this book form part of the larger political, social and economic world of the first six of those generations. The Songhees and Esquimalt world view (see Appendix), once learned mostly from the landscape around them, had to give way to a new outlook dominated by the imperial culture and technology of the new visitors. But the Songhees and Esquimalt peoples adapted, and they continue to adapt, in their own way.

Much of what happened on the old Songhees Reserve has not been recorded. Written accounts are mostly from non-aboriginal people, most of whom lacked an understanding of First Nations societies. And the colonists' attitudes toward First Peoples in 19th-century Victoria ranged from hateful bigotry to patronizing support. But sadly, because the early literature contains few direct accounts from First Peoples, I must present most of this history through the eyes of culturally biased observers.

The images of people, buildings and events in this book are especially important in providing a view of the changes that local and visiting First Nations experienced. Few of the Europeans who produced the images did so as an attempt to record aspects of First Nation's culture; most of them focused on specific activities or general views that would

Condominiums occupy the site of the old reserve today. Songhees Point is at the centre. Norm Charbonneau photograph, RBCM, 2003.

sell. Though museum and archive collections contain numerous photographs, paintings, drawings and maps of the old Songhees Reserve and surrounding lands, few have been correctly identified with their date, location and contents. It was, therefore, important to combine the images with written records to gain a better understanding the history of the Songhees and early Victoria.

Most written accounts of First Peoples in early Victoria ignore the Songhees and Esquimalt nations, because northern visitors attracted more attention, their actions dominating the local news reports. The written history of the Songhees is a scattered view that reflects the European world more than that of the Songhees. But it does present an important aspect of their history, in their interaction with visitors and colonists, and their response to events in the world at large.

This book draws together information from many sources and perspectives: newspaper accounts, personal diaries, government and church records, aboriginal oral accounts, and the archaeological record. Though most of the observations are brief glimpses by outsiders, I hope that the combination of voices will give readers a good perspective of the events and activities on and around the old Songhees Reserve.

For More Information

A supplement to this book can be found on the Royal BC Museum's web site (www.royalbcmuseum.bc.ca) under Research – Articles and Papers by Curators. The article entitled "Supplement to the 2003 book, *Songhees Pictorial*" contains more detailed information on the images used in this book, as well as additional images and information related to the old Songhees Reserve and its people.

About the Photographs

Dan Savard

Despite initial appearances, photographs are not objective. Photographic images were created for specific purposes and for certain audiences. No photograph can be accepted as "representative" of a way of life without additional documentation. — V. Wyatt, 1989

Illustrations and photographs of the old Songhees Reserve exist from almost as far back the establishment of the village. The earliest visuals are sketches made by Captain Henry Warre in 1845; photographs date from the late 1850s. A large corpus of extant photographs exists partly because of the location of the village and the presence of photographers whose businesses were located in the city. The reserve was easily accessible to local and itinerant photographers especially when compared to the remote coastal villages and those of the interior of British Columbia. Many of the earliest photographs appearing in this book (1857–80s) were made using glass-plate negatives. In 1851, Frederick Scott Archer, an English designer/sculptor invented the wet-plate process. Early glass-plate negatives were not pre-sensitized as photographic film is today, but had to be coated and exposed while still wet; otherwise the emulsion (a sticky solution of guncotton and light-sensitive silver halides dissolved in a mixture of alcohol and ether) would lose its sensitivity to light. After the negative had been exposed in the camera, it was rushed to the dark-tent to be developed, fixed and washed, then dried in the sun. Finally, the side of the glass plate carrying the emulsion was coated with varnish to protect it and the finished glass-plate negative was placed in a slotted wooden storage box for transportation to the photographer's gallery.

Photography was limited to a few professionals who had not only mastered the complicated technology but also had the money to purchase a photographic gallery, equipment and supplies. Victoria-based photographers could transport, with relative ease, field cameras, tripods, chemicals, water, a supply of glass-plate negatives and a portable darkroom (dark-tent) to the Songhees Reserve, and make several photographs in a day. (I say *make* rather than *take*, because the wet-plate process was a relatively lengthy process, usually about 20 minutes from sensitizing the negative to the final wash. And, unlike the convenient 35-mm film that we use in our cameras today, glass plates — sometimes measuring as large as 18.5 x 23.5 cm — were fragile, bulky and heavy, which limited the number of photographs that could be made, even on a day trip. A photographer had to very much want to make a photograph, as it was necessary to set up the camera and dark-tent at every new venue.)

Given the difficulty in making a photograph, it is surprising that so many survived from the wet-plate era. Preserved today in archives, libraries, museums and private collections, these early photographs are available for researchers to view, interpret, view again and reinterpret. The photographs printed in this book were not chosen solely to supplement the text, but as primary source material in their own right. Rich in visual information, they make independent statements about the Songhees, their culture and the changing physical landscape of their village.

By the late 1850s, Victoria was large enough to warrant the establishment of a number of photographic galleries. The owners were entrepreneurs as much as photographers, dependent upon producing marketable images that would ensure the economic viability of their galleries. They mounted prints on various types of cardboard stock and sold them primarily to non-aboriginal customers as souvenirs or collectibles.

Carlo (Charles) Gentile, Hannah Maynard, Frederick Dally and George R. Fardon are some of the Victoria photographers who documented the Songhees and other First Nations visitors to Victoria. First Peoples came to the

Dan Savard is Manager of the Audio-Visual Collections in Anthropology at the Royal BC Museum.

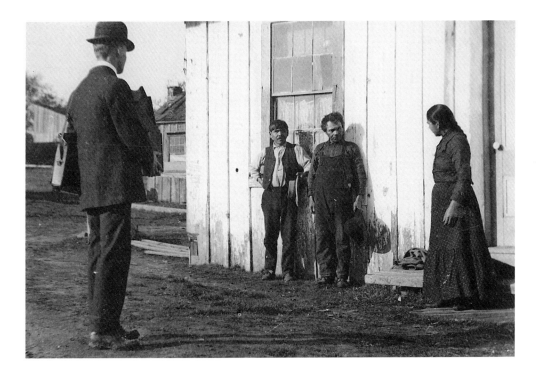

An unknown photographer on the Songhees Reserve about 1904. Facing him are (left to right) Jimmy Fraser (the well-known storyteller and grandson of King Freezy), Daniel Joseph and Elizabeth Joseph (Jimmy's sister).
RBCM PN8816

galleries primarily as models but also as customers. Arthur Wellington Clah, a Tsimshian elder, recalled his visit to a photographer's gallery, likely Richard Maynard's: "Rebekah ask if I go to likeness house. So I go. To give myself likeness. Rebekah stand alongside me." Clah returned a few days later to purchase his likenesses, probably stereographs "at $2.50 per half dozen cards".

It is difficult to determine how much influence First Peoples had in how they were represented in a photograph. Did they decide how they would dress or were they selected because of the way they dressed? Was there a preconceived idea, perhaps a saleable, stereotypical view, of what First Peoples should look like? Being an oral society, First Nations have no written accounts of their perspective on the subject. Some aboriginal people were paid to pose for photographs: in 1864, King Freezy and his wife received "four bits" for their session in Carlo Gentile's studio (see pages 92–93). Others who posed as peddlers of fish, potatoes or firewood may have also received cash or photographs of themselves as payment for their time.

Exercise caution when viewing these early images. Many researchers fall into the trap of interpreting the motives of late 19th- and early 20th-century photographers from a 21st-century perspective. There are few written accounts of interaction between First Peoples and Euro-Canadian photographers. In the absence of clear empirical evidence, it is impossible to say with certainty what motivated the photographer to frame a particular view.

Clearly the technology of wet-plate photography intimidated anyone who sat for a portrait. Because of the long exposure times, both European and First Nations subjects appear stiff and unsmiling. Photographers employed a variety of supports to steady their subjects. If you examine a studio photograph closely, you may see part of the base of an iron stand between the subject's feet – the stand helped support the subject's back.

But Victoria's photographers did not wait passively in their galleries for opportunities to photograph the Songhees and their visitors. Potlatches and panoramas seem to have been the major attractions that drew photographers to the village during the 1860s and 1870s. An important geographical feature of the village was Mission Hill. It afforded an ideal vantage point from which to photograph the expanding city across the Inner Harbour. The many panoramas made during this period, whether by design or default, usually included some part of the village in the foreground.

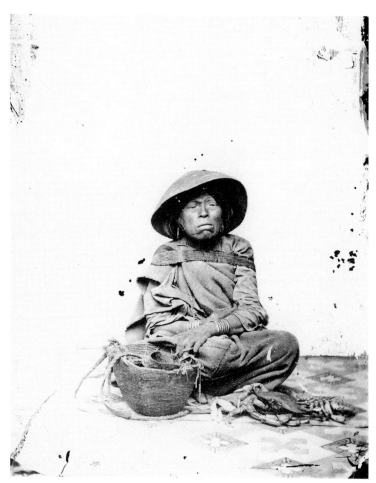

A "peddler" selling crabs: this woman posed
for Hanna Maynard in her studio.
RBCM PN5901.

Toward the turn of the century, photographers began to record the more everyday aspects of life: beached canoes, scenes of family life, temporary tent encampments and evolving house styles.

Changes in the architectural landscape are well documented in photographs, and potlatches remained a constant source of interest from the early 1860s to the first decade of the 1900s. But there are few photographs showing people engaged in technology. This near absence of images of people weaving baskets or mats, carving masks or poles, repairing canoes, preparing food or building houses is characteristic of early ethno-historic photography throughout the Northwest Coast.

All of the extant photographs on the reserve were taken outdoors during daylight hours. The lack of interior photography was due in part to the technical limitations of the art. By the 1880s, flash photography was available using powdered magnesium, but its use was problematic, as it could explode rather than illuminate. Many photographs have no documentation with them. Occasionally the name of the photographer or person who appears in the photograph is recorded, perhaps the date, but little else. We can only speculate on the context in which many of these photographs were made. We know, for example, that the events associated with the legal transfer of the reserve were well documented and that they were taken to illustrate articles published in newspapers or commemorative albums. But why did photographers make so many photographs of houses, tents, canoes and boats lining the shore of the Inner Harbour and Mud Bay in the early 1900s? Clearly, these were not made to be sold as post cards or curios. Perhaps they represent an early attempt to record what many thought was a disappearing way of life.

The body of photographic fieldwork on the Songhees Reserve is documentary in nature. The images are clear and sharply focused – or at least that was the intent of the photographer (some of the people in early Frederick Dally photographs are blurred, appearing as ghost-like images, caused by the long exposure times required for wet-plate negatives). Field photographers focused on recording ethnographic information, rather than the aesthetics. Unlike the studio portraits, most of the field photographs are candid – not posed. Canoe and house types, potlatch goods and ceremonial events, everyday dress, commerce, and social gatherings are reproduced without embellishment in the images that have survived in print, negative or lantern-slide format over the past 140 years.

Very early in the history of photography, photographs were considered as true representations of what existed. But the bias of the photographer must always be considered when viewing any image. Subject matter and composition were usually the prerogatives of someone who was not Songhees. The photographic narrative that unfolds in this book is, therefore, somewhat distant from the people who appear in it. When viewing these images, ask yourself if this is the photographic record that the Songhees would have chosen to leave of themselves and their village.

1
Songhees – the Place and the People

The municipalities of Victoria, Oak Bay, Esquimalt, View Royal, Colwood and Metchosin, as well as parts of southern Saanich, are within the traditional territory of peoples who collectively became known as the Songhees. Today these peoples are represented by the Esquimalt and Songhees nations. The two groups have adjoining reserves, extending inland from the northeastern part of Esquimalt Harbour. These peoples were originally composed of a diverse group of extended families who shared a common dialect of the North Straits Salish language that they called Lekwungen.

In 1850, Lekwungen elders defined their people's territories as extending from Cowichan Head, at the north end of Cordova Bay, to Parry Bay, west of Albert Head. In what is now Washington, U.S.A., Songhees villages and fishing sites extended from Open Bay on Henry Island and along the western shore of San Juan Island to Eagle Cove. Descendants of 19th-century Songhees can be found among First Nations on the east and west coasts of Vancouver

Territory of the families that eventually amalgamated on the old Songhees and Esquimalt reserves. The small squares indicate historic villages and shell middens.

Island, the lower Fraser River, northern Washington, and as far away as Kansas.

The extended family groups, comprising 700 people in 1845, lived in villages on bays around what is now Greater Victoria. Household groups owned important areas for plant collecting, hunting, fishing and specific house locations, and they shared other common areas of their territories.

The T'Sou-ke, Saanich and Lummi, neighbours of the Songhees and Esquimalt nations, also spoke dialects of North Straits Salish, which is one of 23 languages in the Salish language family that are unintelligible to each other. Though the Songhees could communicate with their neighbours, who spoke similar dialects, they could only converse with outsiders through people who could speak two or more languages. When we say that the Songhees are a Coast Salish people, we mean that they are one of many coastal groups whose language shares a common origin. This is equivalent to saying that English is part of the Indo-European language family that includes most languages of Europe and others with a common origin stretching across Turkey and India.

With the building of Fort Victoria, most of the Songhees families (then called "Samose" by James Douglas) amalgamated in a village on the northwest shore of Victoria's Inner Harbour. The village occupied the land from the constriction of the Inner Harbour at Laurel Point to just north of what is now the Johnson Street Bridge. This location became part of a larger reserve from the 1850s until 1911.

The Songhees sometimes called this village Lekwungen. Alexander Anderson of the Hudson's Bay Company said that it was "more properly" referred to as the "Stamish" village, after the most prominent group of people who settled here.

The first written reference to the Songhees by name may be in the Fort Langley journal on December 22, 1829: "One of the Sonese Indians came in with about 10 beaver." A census taken at Fort Langley in 1827, uses a Halkomelem

This map, drawn by Joseph Pemberton in 1852–53, shows the fortified village at Cadboro Bay. The Hudson's Bay Company's Uplands Farm is west of the bay. The main survey lines drawn here later defined much of the boundary of the Municipality of Oak Bay.

Hudson's Bay Company Archives, Provincial Archives of Manitoba, G.1/2581.

language rendition of the name as "Tchanmus". James Teit recorded the Cowichan variation as "Stsamis" and a Puget Sound version as "Etzamish". In 1839, another census refers to 127 "Samus" living in a village at the northeastern corner of Cadboro Bay, headed by a man named Chaythulm. The census lists 12 men, 14 women, 22 boys, 9 girls, 70 followers, 26 canoes and 17 guns.

Charles Ross, who was in charge of Fort Victoria, was the first to write "Songhees" in 1844, when he referred to the aboriginal people "encamped near the fort", and adding, "whose lands we occupy". Before "Songhees" took hold as the common spelling, the name for the people and the main reserve appeared as "Songies" or "Songish".

Songhees families from Cadboro Bay to Ross Bay saw themselves as the main Lekwungen peoples – they considered the groups from the Esquimalt area and Discovery Island somewhat different.

The Sapsum people lived at the village of Kalla, south of Thetis Cove at Esquimalt Harbour. They formed the basis of the Esquimalt Reserve in 1852. Their traditional main

village, Kosampsom, was on the north side of the narrows between the Gorge and Portage Inlet. Colqahoun Grant, an early colonist, noted in the mid 1850s:

Most tribes, besides the main village, which is placed in some sheltered spot, have a fishing village, in a more exposed situation, to which they resort during summer, and the fishing groups of some tribes extend to a distance of several miles from their fixed habitation.... The Tsomass [Songhees], for instance, have fisheries on Belle-Vue [San Juan] Island, some 15 miles [24 km] distant from their winter village.... To these fishing stations they emigrate in the salmon season, with their wives and families and all their goods and chattels, leaving their villages tenanted by merely a few old dogs.... All the tribes are singularly jealous of their fishing privileges, and guard their rights with the strictness of a manorial preserve.

The extent to which this settlement pattern was traditional – practised before the arrival of Europeans – is still a subject for debate. The numerous remains of village sites

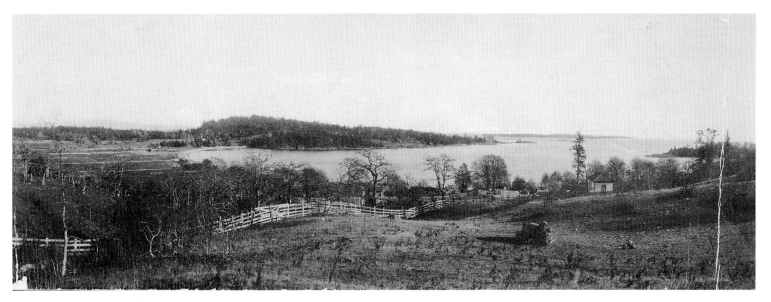

View from the site of Uplands Farm, Cadboro Bay, 1859. The historic village of the Samas people, on the eastern shore of the bay (left), has an archaeological component dating back 1800 years. Another archaeological site on the foreshore (centre) dates back 1900 years. This is the oldest known photograph of the Victoria region taken outside the harbour. Royal Engineer photograph; BC Archives HP8667.

found by archaeologists suggest that aboriginal populations in the past were much higher than those accounted for in the historical record. With larger populations and more villages, annual movements to obtain food and other resources may have been more restricted to local territories. As populations increase, people are forced to intensify the use of smaller and smaller segments of their habitat. Travel outside a home-village territory may have been limited to individuals with social connections in neighbouring groups, which gave them rights to resources.

The arrival of Europeans certainly changed the nature of Songhees resource gathering: first by the process of depopulation (from disease and other introduced factors) and the amalgamation of surviving family groups at fewer locations; and second, through the changing relationships between neighbouring groups. Food gathering for commercial purposes began to take precedence over gathering for basic subsistence and trade.

2
Before European Settlement

The 1790s

The journals of Spanish explorers contain some of the earliest written observations of First Peoples living around Juan de Fuca Strait. In 1790, while exploring the south shores of the strait, Don Manuel Quimper wrote that the people "recognize no superior chief" and "carry on continual warfare" with those on the north shores. He observed the beaches "strewn with the harpooned heads of their enemies".

Oral traditions record that this fighting was mainly between the Clallam and Chemakum on the Olympic Peninsula and between the Clallam and the peoples of the west coast of Vancouver Island, including the T'Sou-ke. Around the time of Quimper's arrival and earlier, the Cowichan, from the Duncan area, raided groups south of them, and the Lummi and Samish from the American Gulf Islands occasionally raided villages on the Saanich Peninsula. The Clallam, T'Sou-ke, Songhees, Saanich and Cowichan organized frequent raids against the Skagit, Snahomish and others around Puget Sound, who retaliated in kind.

By the time Europeans began making observations of aboriginal peoples around Juan de Fuca Strait, the events most devastating to their way of life had already occurred. Smallpox scars observed on people in the 1790s and early 1800s indicate that smallpox had reached this area before direct contact with Europeans. Smallpox appears to have spread overland from the eastern part of the continent in the early 1780s. The documented death tolls in other areas suggest that populations must have been devastated throughout the Gulf of Georgia and Puget Sound. In the 1920s Saanich Chief Tommy Paul recalled the stories of the "great plague … six generations back", where so many died there was "nobody to nurse the sick or bury the dead".

Written Spanish observations of First Nations in this area are few. While continuing his exploration of Juan de Fuca Strait in 1790, Don Manuel Quimper stopped at several places along the north shore. On June 18, he anchored his ship, *Princesa Real*, outside Sooke Inlet. Over the next five days, canoes came out to trade fish, salmonberries, cooked camas bulbs and shellfish. Quimper gave the "chiefs of the port" pieces of copper, and also exchanged the "King's copper" for six sea-otter skins brought by people in two canoes coming from the south. He was the first to note the large harvest and trade in camas bulbs, and how those outside the strait "come here in great canoes to provide themselves with them". The ship's longboat surveyed Sooke Harbour, saw three canoe burials at the mouth of the Sooke River, located bird-net poles on Whiffin Spit and observed two villages.

Quimper estimated the population of Sooke Inlet to be about 500 people. They dressed the same as the people on the west coast of the Vancouver Island, "with a woollen cloak hanging from the neck covering half the body", but differ in "having many woven with the hair of sea otters and seals, and gull and duck feathers. Their hats are not of pyramidal form … but like those the Chinese wear in Macao."

Quimper stopped next in Pedder Bay, where several canoes came out to greet him, but he does not mention a village. More canoes visited every day and Quimper gave presents to some and traded with others. He observed that these people, in contrast to outside groups, were poor: "they have no sea otters. They have, however, the advantage that their country consists of level thickets with few trees and is very prolific in roots and fruits on which they all maintain themselves."

The *Princesa Real* moved on to Parry Bay, and on July 19, the longboat entered Esquimalt Harbour. There Quimper made the first written record of people who were likely ancestors of the Esquimalt and Songhees nations. Unfortunately, it was only a short note in his diary, saying that the harbour was "inhabited by Indians" who were happy to see him.

In the following year, 1791, the *San Carlos* anchored in Esquimalt Harbour on May 29. The vessel's pilot, Don Juan Pantoja y Arriaga, wrote that the harbour had "but few inhabitants". But near the entrance to Haro Strait, one of the ship's longboats was attacked by six large canoes with "16 to 20 Indians in each one". According to census reports from the 1850s, the ratio of men to women and children is 1:5.7. From this we can estimate that the men who attacked the Spanish longboat represented a population of about 550 to 780. This size of a population would require at least three large villages in the area, unless some of the attackers were recruited from outside groups. Pantoja wrote: "To the south of the first inlet in the interior of the forest, there is a large settlement of Indians, very warlike and daring, but with the loss of some of them our longboat which was fully armed, made them retreat." His vague description of the village places it somewhere between Gonzales and Ten Mile points. But the longboat could have been farther into Haro Strait, and the attackers may have come from villages at Gordon Head.

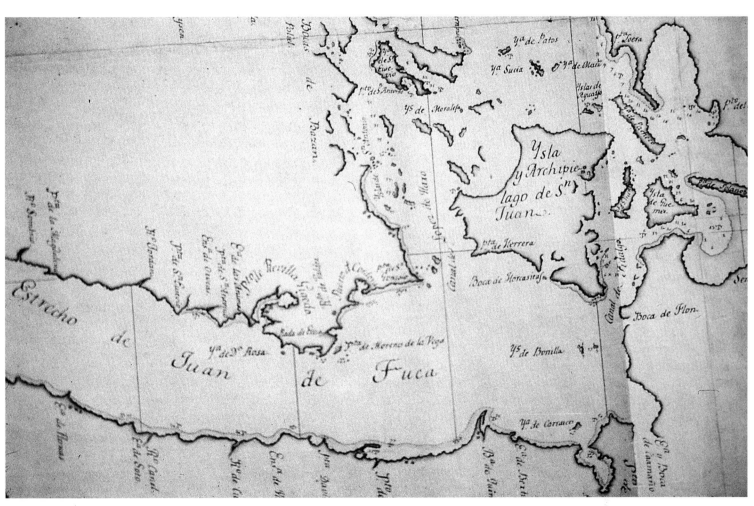

Carta que comprehende: portion of a Spanish map produced under the direction of explorer Don Fransico de Eliza in 1791. Small rectangles at Parry Bay, Gordon Head and Cordova Bay represent First Nations villages (marked as "*Rancherias de Indios*"). Copied from the original in Museo Naval de Madrid.

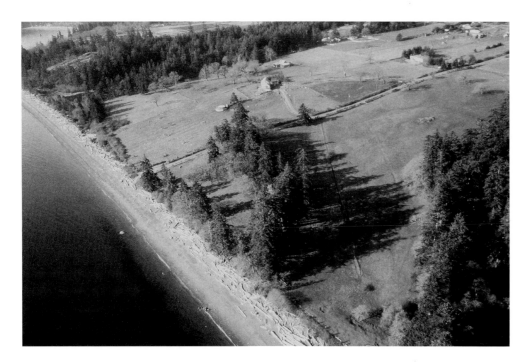

At the mounded area (centre) lie the remains of an aboriginal defensive site at Parry Bay. It appears to be one of the villages marked on the Spanish maps of 1791–92 (possibly abandoned at the time). Grant Keddie photograph.

By 1791, European goods had already reached First Nations around Juan de Fuca Strait. Pantoja noted that goods made from iron and copper as well as blue beads had arrived on horseback in the Point Roberts area. This is supported by Northwest Company explorer Simon Fraser's observation of aboriginal peoples with full packhorses coming down the Fraser River in 1808. Even in 1790, the Spanish saw aboriginal people in the Port Angeles area of Washington wearing English and Portuguese coins as earrings. Archaeological finds clearly indicate that iron goods were reaching this area long before the 1790s.

The Early 1800s

From 1790 to the 1840s the area around Juan de Fuca Strait and the Gulf of Georgia experienced many changes. There are few records of the Songhees, so we can reconstruct only a general picture of life here, based on the local oral tradition and the written observations of early European visitors.

In the 1790s the Lekwiltok people of the Johnstone Strait area acquired European guns by trade from the west coast of Vancouver Island. From the early 1800s until about 1849, warfare increased between the Lekwiltok and Salish speaking groups to the south.

David Latasse, of Songhees and Saanich heritage, gave his Songhees father's account of the battles:

> For many years, all in the bright summer weather, they have come down upon us, those Ukultahs [Lekwiltok] of the north. They have killed our men and taken away our women to slavery. Every year they come and nobody knows whose house shall be left desolate with the ending of summer. They are many and strong and their canoes upon the sea are as the salmon in the spawning season at the river's mouth. We cannot stand against them. We are too few. We are not united as they are. Year after year we wail the loss of our champions, the loss of our wives and children.

The Lekwiltok raided far to the south, and warriors from as far away as Puget Sound joined forces in retaliatory raids. Both sides suffered heavy losses and both sides claimed victories.

With the establishment of Fort Langley on the lower Fraser River in 1827 and Fort Nisqually in Puget Sound in 1833, aboriginal alliances shifted, through marriage and warfare, in efforts to gain access to European trade goods.

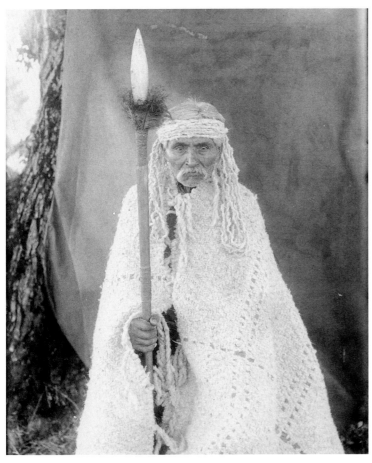

Chief David Latesse (ca 1857–1936), dressed in costume for a media photograph, about 1932. David passed on the stories of warfare told by his Songhees father. The name *Sxa-wal* ("whirlwind") belonging to his great grandfather at Sooke was given to him at age 14 and Steel-um, his mother's father's name, at age 50.
Trio Crocker photograph, RBCM, PN11781.

First Nations played one group of Europeans against another. In 1828, a Saanich man returning to Fort Langley from Puget Sound said that the people there were keeping their beaver skins to trade for the larger American blankets. More and more trading vessels entered Juan de Fuca Strait, causing further confusion in trade alliances. In 1829, visiting Reverend Jonathan Green wrote that the strait was becoming an important trade area where the locals were "unacquainted with the use of firearms".

The Hudson's Bay Company tried to control this trade from Fort Vancouver, on the lower Columbia River, and their other southern stations. Their competition with Americans for the aboriginal trade was so strong that they sometimes traded at a loss attempting to put their competitors out of business.

First Nations tried to adjust to the changing strategies of the fur traders and the effects of warfare. By the late 1830s, more and more of the Lekwiltok's northern neighbours were joining them in raids to Puget Sound and up the Fraser River, often causing heavy casualties. In 1838, the Lekwiltok made an alliance with the Musqueam in the Vancouver area and took control of part of the Fort Langley fur trade. The Nanaimo began taking their furs north to trade – a person could get twice as much for a beaver pelt at Fort Simpson than at Fort Langley.

In the 1840s, the Lekwiltok took over Comox territory in the northern Strait of Georgia. With help from their neighbours, they continued raiding the southern groups, destroying some Saanich and Songhees villages. These wars inspired some of the tribes on Vancouver Island to move their traditional villages from exposed locations to more protected areas. Some moved to the upper part of the Cowichan and Nanaimo rivers while others went to the mainland. Other southern villagers sent their women and children to secluded spots during May and June – the usual season for raids. Some of the Songhees were forced to retreat up the Gorge, where they fought with their enemies at Kosampson Park.

About 1824, the Lekwiltok and their Comox allies raided a village on the west side of Esquimalt Harbour when most of the older people were away fishing. They captured a nine-year-old Songhees boy – later known as Marston. He was taken to Comox and sold by various owners until he ended up in Alaska. After 60 years of slavery, he escaped to Victoria in 1884. The older Songhees remembered the raid and his capture. Marston remembered the names of his relatives and learned he was related to George Cheetlam, who the *Colonist* referred to as "one of the richest and most powerful" Songhees. Marston was welcomed back and lived on the reserve until his death in 1893.

3
Settlement Among the Songhees

A Very Fine Harbour

The Hudson's Bay Company feared losing their trading establishments on the Columbia River due to the settlement of the boundary line between British and American possessions. The area in dispute, referred to as Old Oregon, included all of what is now Oregon and Washington, as well as southern British Columbia, and was owned jointly by Britain and the U.S.A. The Company's fears became reality in 1846 when the Oregon Treaty established the boundary along the 49th parallel from the Rocky Mountains to the Gulf of Georgia.

A decade earlier, in late 1835, the Company asked Chief Factor John McLoughlin in Fort Vancouver, on the lower Columbia River, to search for a safer base of operations in the north. McLoughlin wrote to Chief Trader John Work at Fort Simpson, suggesting he send Captain William McNeill the following summer to explore the south end of Vancouver Island and select "a convenient situation for an Establishment on a large scale, possessing all the requisites for farming [and] rearing of Cattle together with a good harbour and abundance of timber." The new post would serve two purposes: a trade depot for the many whaling ships in the North Pacific and the main supply depot for

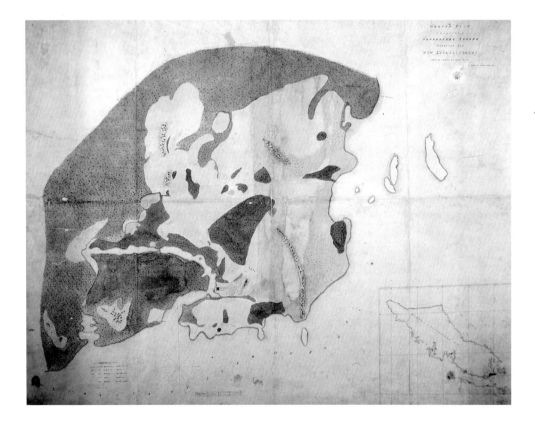

Ground Plan of Portion of Vancouver Island Selected for New Establishment taken by James Douglas Esqr. The oldest detailed map of the Victoria region was drawn by Adolphus Lee Lewis in 1842. Lewis accompanied James Douglas on his first visit to Victoria Harbour, which he named "Port of Camosack". Only two aboriginal villages appear on the map: an "Indian Fort" of two houses on the northeastern shore of Cadboro Bay and one house at the northeastern corner of Esquimalt Harbour (at the old village of Kalla on the present Esquimalt Reserve). It shows no villages in Victoria Harbour; the rectangle is Douglas's proposed location for the Hudson's Bay Company fort. Lewis called the dark areas "woods and forests" and the lighter areas "plains", which were open parkland resulting from the Songhees burning off the trees and shrubs to promote the growth of edible plants. Hudson's Bay Company Archives, Provincial Archives of Manitoba, Map Collection, G.2/25 (T11146).

Russian fur-trading establishments in Alaska.

In the early summer of 1837, Captain McNeill sailed the Hudson's Bay Company ship *Beaver* to the southern tip of Vancouver Island. He and his crew were the first Europeans to enter Victoria Harbour (the Spanish explorers had passed it by). McNeill declared the harbour a fine place for settlement, but no report of this trip exists to tell us about the First Peoples he may have encountered. He returned to the harbour on December 12, 1839, this time with McLoughlin and Work. McLoughlin later wrote: "It is a very fine harbour accessible at all seasons, but is not a place suitable to our purpose."

In 1842 the Hudson's Bay Company resolved to abandon the northern fur-trading posts and establish a depot on southern Vancouver Island. Chief Factor McLoughlin had already assigned James Douglas the task of re-examining the southern tip of the island, and on July 12, Douglas reported that he had surveyed the most promising points. He had disembarked from his schooner *Cadboro* with six men and a couple of horses and mapped the coast from "Point Gonzalo [Ten Mile Point],… at the south-eastern extreme of the Island, and about six miles interiorly".

Eight months later, Douglas returned to Vancouver Island aboard the *Beaver* to begin the construction of a new trading establishment. He landed at Clover Point with a party of men and walked through the area of Beacon Hill Park to Victoria Harbour. Captain McNeill took his ship around to the harbour and anchored there to meet the landing party. Douglas slept aboard the *Beaver* that night and went out the next morning in a boat to examine "the wood of the north shore of the harbour".

Also on board the *Beaver* was Father M. Bolduc, part of the Quebec mission to the northwest coast. He described his first meeting with the Songhees people:

> We headed for the southern point of Vancouver Island. It was about four o'clock in the afternoon when we arrived there [at Shoal Point]. At first we saw only two canoes, but, having discharged two cannon shots, the aborigines left their retreats and surrounded the steamboat. The following day canoes arrived from all sides.… I landed with the commander of the expedition and the captain. Yet it was only after several days … that I went to their village, situated at six miles from the harbour [Victoria Harbour] at the base of a charming little bay

> [Cadboro Bay]. Like almost all of the surrounding tribes, this one possesses a stockade fort of about 150 feet square. They fortify themselves thus to provide shelter from the Yougletas [Lekwiltok].… These ferocious enemies fall, usually at night, on the villages … kill and massacre as many of the men as they can, and take the women and children as slaves. On top of posts in the fort one sees many human heads sculptured in red or black, and occasionally both colours together. On my arrival the whole village, men, women and children, arranged themselves in two lines to shake hands with me, a ceremony which they would not omit.… I counted 525 individuals, apart from absent ones. I assembled them all in the largest lodge, the chief's.

Father Bolduc aimed to baptize the Songhees, but they showed some reluctance. They had heard about some Kwantlen and Cowichan peoples on the Fraser River who had all died almost immediately after being baptized. The determined priest promised to return in a few days to baptize the children.

> Meanwhile the rumour of my arrival having spread, several neighbouring tribes came en masse. The 18th [of March] being Sunday, I employed it for constructing a temporary alter [near Victoria Harbour] for celebrating on land the Lord's day. On Sunday early in the morning, more than 1,200 natives from three great tribes, Kawitshins, Klalams, and Tsamishes [Cowichan, Clallam and Songhees] assembled around the modest temple.… That day being the one I had set for the baptism of children, I went to the principal village [Cadboro Bay] accompanied by a Canadian named Gobin and all the crowd that had been present at the divine service. On arrival, I had again to submit to the terrible ceremony of shaking hands with more than 600 persons. The children were placed in two lines at the seaside. I distributed to each one a holy name on a bit of paper, and I began the ceremony. It may have been about ten o'clock, and when I had finished it was almost nightfall; then I counted the new Christians and found 102 of them. On top of that I had to go more than two leagues on foot to return to the steamboat.

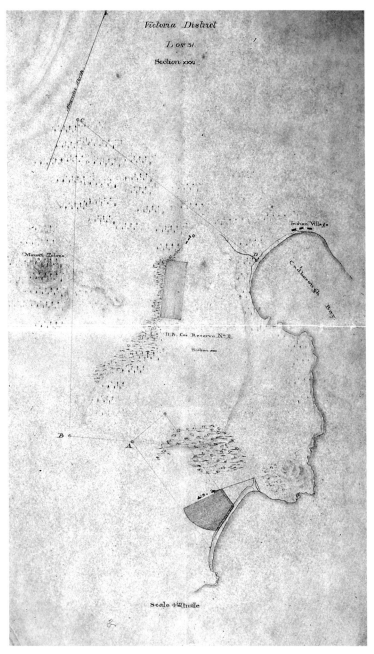

Joseph Pemberton's 1855 map of
"Cadborough Bay" shows an "Indian
Village" of three houses on the shore of the
bay. The rectangle to the west is Uplands
Farm and the dark patch to the south is the
Tod property on part of an old village site at
Willows Beach.
Hudson's Bay Company Archives, Provincial
Archives of Manitoba, H.1/1 fo. 79.

Building the Fort

On March 16, 1843, James Douglas wrote that he "spoke to the Samose [Songhees] … and informed them of our intention of building in this place which appeared to please them very much and they immediately offered their services in procuring pickets for the establishment." Douglas paid a 2-1/2-point blanket for every 40 pickets of 22 feet long by 36 inches in diameter (6.7 m x 91 cm).

On June 1, the *Beaver* landed with materials taken from two abandoned fur-trading posts in the north (Fort McLoughlin and Fort Taku). Forty-three men built a few log huts for their own accommodation and the storage of goods, then began building the fort in an open glade of Garry Oak trees. One of the Company officers, Roderick Finlayson, later noted: "A large number of the natives then encamped around us, all armed, without any of the wives or children, which looked suspicious."

On June 9, Douglas left Chief Trader Charles Ross in charge. Finlayson, who was second in command, later stated,

> Among the tribes we met at Camosun on our arrival
> were the Clallams, the Songhees and the Cowichans.
> The last-named tribe was at that time a very trouble-
> some one. They bullied the other tribes whom they had
> beaten in war, and were generally overbearing to every
> one, ourselves included.

He wrote that the Songhees "began to remove from the village on Cadboro Bay and erect homes for themselves along the bank of the harbour as far as the present site of Johnson Street." He also reported that, during the building of the fort, they "got some of the young natives to assist, paying them in goods, and found them very useful as ox drivers in ploughing the land."

Within three months the crew succeeded in putting up stockades with two bastions mounted with heavy guns, blunderbusses and muskets, as well as storehouses and dwellings for the employees. On November 16, James Douglas described the completed fort in a letter to the Hudson's Bay Company:

> A quadrangle of 330 x 300 feet [100 x 91 m] intended
> to contain 8 buildings of 60 feet [18 m] each, disposed
> (2 facing harbour in rear and 3 on each side).… The
> summer returns from June to September amount to 300
> Beaver and Otter, with a few small furs, and probably the

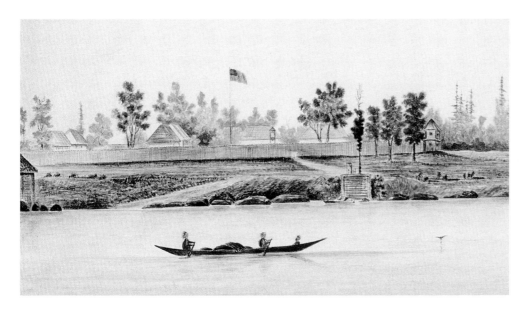

This watercolour by James Madison Alden shows an aboriginal fishing canoe passing Fort Victoria. Alden labelled the painting, "H.B. Company's Fort at Victoria, Vancouver's Island, Sept. 1854". BC Archives PDP2143.

trade will increase when the Cape Flattery Indians and the people inhabiting the west coast of Vancouver's Island begin to frequent the establishment.... The resources of the country in fish are only known as yet through the supply procured in trade from the Natives, which was abundant after the arrival of the salmon in July; other kinds of fish were not regularly brought in.

The trading post at Victoria Harbour was first called Fort Camosun, after the name given to the general area, though it actually pertains specifically to the reversing falls on the Gorge Waterway, now under the Tillicum Road Bridge (see the photograph on page 159). Hudson's Bay Company Chief Factor John McLoughlin proposed "Fort Victoria" on April 14, 1843, and the Company made it official on June 10. Others in the Company proposed "Fort Albert", after Queen Victoria's new husband, and this name appeared in ships' logs and correspondence between August 6 and December 4; but officials in Britain favoured "Victoria", and so the name stuck. The first local use of "Fort Victoria" appeared on December 18, 1843, in the log of the Company ship *Cadboro*, which makes reference to "Fort Victoria Camosun Harbour". But shipping documents continued to refer to "Port Camasum" as late as 1847.

Ku-sing-ay-las: the Place of the Strong Fibre

One Company man who learned much about the local First Nations was Joseph MacKay. In a letter, MacKay recorded the Songhees name for the area around Fort Victoria – *Ku-sing-ay-las* – and explained its meaning: "... the root of the word being the name of a species of Willow [Pacific Willow, *Salix lucida*] which grew in abundance on the ground, the inner bark of which was inset to fasten the stone sinkers to their fishing nets and hooks."

He gave more details in another letter:

The inner bark of the willow was used for strapping stones for sinkers in deep-sea fishing. Some willows yielded a stronger and much more pliable fibre than others. The present site of Victoria, particularly that portion which lies between Wharf and Douglas Street and in the neighbourhood of the junction of Cook Street and Belcher Street [now Rockland], yielded a willow with very strong fibre, hence the Indian name for the city of Victoria is Ku-sing-ay-las, meaning the place of the strong fibre.

4
Life in the 1840s

Origin of the Songhees Village

Everything went smoothly at Fort Victoria until 1844. On June 27, Chief Trader Charles Ross died and Roderick Finlayson took command. Several months later, while Songhees Chief Tsil-al-thach was away, Finlayson faced the first aboriginal resistance to the Hudson's Bay Company's presence on Vancouver Island. The visiting Cowichan chief, Tzuhalum, instigated a rifle attack on the fort. Tsil-al-thach returned but did not interfere with Tzuhalum's actions. Finlayson fired the fort's cannons on the Songhees chief's empty house and at a canoe in the harbour – this was enough to stop the hostilities.

Later in the year, Finlayson recalled: "the belt of thick wood between the Fort and Johnson Street, in front of which the lodges were placed, took fire … having been caused by the Indians I wanted them to remove to the other side of the harbour…. This was the origin of the present Indian Reserve."

In June 1846, while visiting Fort Victoria, naturalist Berthold Seeman observed:

On the opposite side of the harbour is a large native village; the distance across is only 400 yards [370 m], and canoes keep up a constant communication between it and the fort. Certain supplies to the chiefs keep them in good humour…. [The houses are] arranged with some degree of order in streets and lanes with passages running up between them. Several families occupy the same house – one large shed … the compartments or walls hardly excluding the sight of one family from

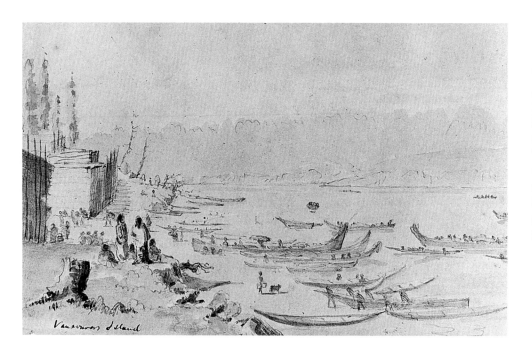

The canoes returning from gathering camas to the Esquimault – watercolour by Paul Kane, 1847 (April 8 – June 10). Songhees Village, looking north from Songhees Point. Before the creation of the community of Victoria West in 1862, this side of Victoria Harbour was referred to as "the Esquimalt", referring to the Esquimalt Peninsula. Kane would have observed the gathering of camas bulbs at the time of his spring visit.
Stark Museum of Art, 31.78/58, WWC58.

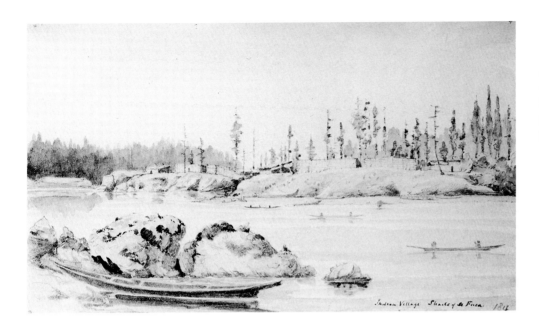

Sangeys Village on the Esqimault
– watercolour by Paul Kane, 1847.
Songhees Village looking southwest toward
Songhees and Laurel points (upper left).
Stark Museum of Art, 31.78/66, WWC66.

Interior of a Lodge, Vancouver's Island
– watercolour by Paul Kane, 1847. In his
landscape log, Kane called this painting,
"The inside of a Clallum Lodge"; it was one
of the Clallam houses next to Fort Victoria.
Most of these large cedar-plank houses were
occupied by several families, separated from
one another with partitions made of planks
and woven mats.
Stark Museum of Art, 31.78/80, WWC80.

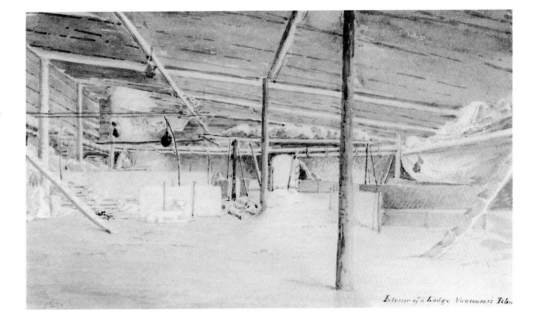

another. There are chests and boxes ... in which blankets, furs and smaller fishing gear are kept.

On June 11, 1849, a visiting missionary, Timothy Lempfrit, noted: "Here there are real Indian Villages. They have streets in rows and houses built side by side. But what gives me the most pleasure is that there is not one flea in their lodges". Father Lempfrit also commented on the effort of the missionaries to have the Songhees give up the practice of having more than one wife: "Many of them have sent away three, and up to five wives in order to keep only one."

The early Songhees Village consisted of a double row of houses. In 1845, Henry Warre, a British military spy, observed that the village had "about 25 houses containing about 70 families". (With an average of 4.5 persons per family there would be about 315 people in the village.) The houses were traditional shed-roof houses consisting of a permanent framework of posts and beams with removable roof and wall planks. They lacked a central ridge-pole, but the roof had a gentle pitch for the shedding of rain by constructing the front wall higher than the rear.

The Songhees built their houses parallel to the shore. They were 6 to 18 metres wide and at least twice that in length; some may have been much longer due to the 19th-century practice of joining two houses together. Some house posts were carved or painted, but totem poles did not exist here.

Coming and Going

In the early years of the fort, its official log, the *Victoria Post Journal*, reported the activities of local First Nations. On May 22, 1846, the "Cape Flattery Indians ... [brought] two small sea otter with 3 beavers & otters, other small furs & whale oil" to trade. On June 7, a large party of Swinomish and Skagits from Puget Sound arrived "by way of Clover Point, [and] one ... put a bundle of furs into the shop for security.... In consequence of some old quarrel between them & the Sanges [Songhees]. The latter began to fire upon them from the opposite side, some of the balls falling amongst our people in front of the Fort. We had to therefore interfere & put a stop to such bold proceedings."

An oral history recorded from a Skokomish Twana man said that in the early 1840s the Cadboro Bay chief, Chaythulm, made a slave raid to Puget Sound, taking two women and a young man. The Skokomish asked for them back through relatives of the Songhees among the Clallam at Dungeness. The young man, Solomon Peter, was obtained by the Hudson's Bay Company as a paid worker, and he willing remained at the fort. Chaythulm returned one of the women and married the other, whom he agreed to buy with guns and blankets. He then held dancing ceremonies to bring the events to a peaceful end.

On July 17, 1846, the *Journal* noted that 13 canoes from Cape Flattery arrived to trade "sea otters & oil". First

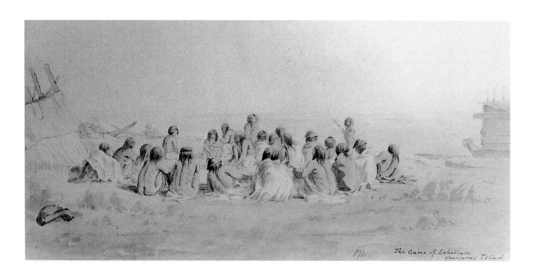

Paul Kane's drawing of men playing *Slahal*, a gambling game, on the old Songhees Reserve, 1847.
Stark Museum of Art, 31.78/25, WWC25.

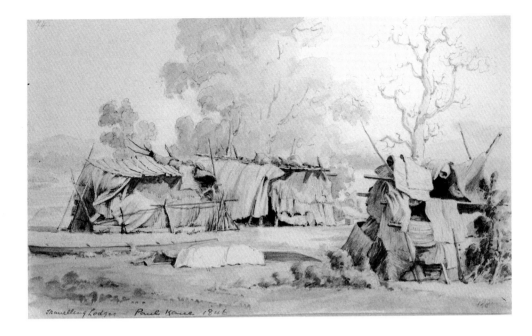

Temporary tule-mat lodges used at fishing camps, 1847.
Paul Kane watercolour;
Stark Museum of Art, 31.78/4, WWC4.

Nations employees were gathering and turning hay on July 23, and dusting down furs on August 31. On November 6, 1847, a fort dispatch said: "The natives continue quiet and well disposed, being at all times willing to assist in the labours of the Establishment and in protecting the farm.... The Sangus [Songhees] ... whose lands we occupy consider themselves as specially attached to the establishment and lately gave a ... proof ... by taking up arms against ... Cape Flattery Indians who threatened to attack the Post."

The Clallam Villages

Although the main Songhees Village was across the harbour from the fort, two more villages were located on the shores of the Inner Harbour: one on the southern shore just east of Laurel Point and the other on the eastern shore adjacent to the fort. Both were occupied mainly by Clallam visitors from the south side of Juan de Fuca Strait. These Clallam were married to Songhees people or had relatives among them. The village next to the fort had several large wooden plank houses, as pictured in a 1845 drawing by Captain Henry Warre. Paul Kane's 1847 drawings and paintings of First Nations habitations feature the interiors of these houses, as well as those on the west side of the harbour.

In 1849, Robert Staines, Fort Victoria's resident teacher and clergyman, commented on the Clallam people living at the northwest corner of the fort: "They have settled here apparently for the convenience of trading & are very peaceable. A great many of the Indians are occasionally employed by the company. I have had one of them, a son of one of the Clallam chiefs, by name of Yoletan who is a great friend of mine, in my service ... he is a boy of about 15." The houses of this village seem to have been removed in late 1849 or early 1850.

The other Clallam village was east of Laurel Point. On August 28, 1858, the editor of the *Weekly Victoria Gazette* wrote:

The Indians, as soon as the white traders made a permanent location in Victoria harbour, shifted their encampment to where they are at present. Their first location [Johnson Street ravine to the Rock Bay area] is still called Old Camp by the whites. Numbers of the Clallams from the opposite shore also migrated about that time to Victoria, and for many years had an encampment near where Capt. Mouatt's residence is; but within these last two years they have entirely disappeared.

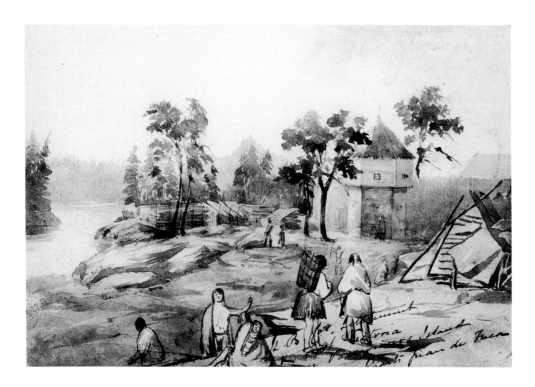

Henry Warre's drawing of the Clallam village next to Fort Victoria, September 27, 1845.
American Antiquarian Society.

Captain Alexander Mouatt owned the property just west of what later became the site of the provincial Legislative Buildings. Rectangular outlines of what could be plank houses are seen on an 1855 map in a location east of Mouatt's property. Today, this location would be along the shore between Oswego and Pendray streets near the southeast corner of Laurel Point (see "The Clallam Village...", pages 53–54).

Father Timothy Lempfrit noted in 1849, "both shores of the Bay are covered with lodges". Many of the Songhees had not yet moved onto the main village at the Songhees Reserve. Lempfrit says that he "went to their village beyond the bay and ... baptized 186 of them on a single occasion and on another, 56". It is uncertain which village Lempfrit was referring to, but his use of the term "beyond the bay" suggests the village of four big houses at a bay just south of Camel Point. This village may have been occupied by the Swengwhung family of the 1850 treaty. Joseph Pemberton recorded it on a map in 1851 and on another in 1854 (shown here), though the village was abanodoned in 1853.

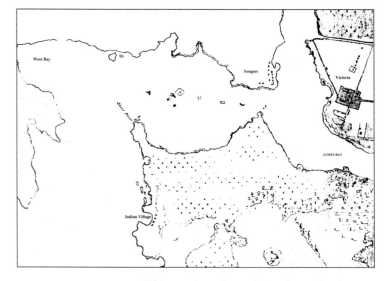

This portion of Joseph Pemberton's 1854 map of Victoria shows 13 houses on the Songhees Reserve and 4 houses in an "Indian Village" at the bay south of Camel Point.
Victoria & District Puget Sound Districts Sheet No.1, Ministry of Crown Lands, Hudson's Bay Company map G.1/131 (N8362).

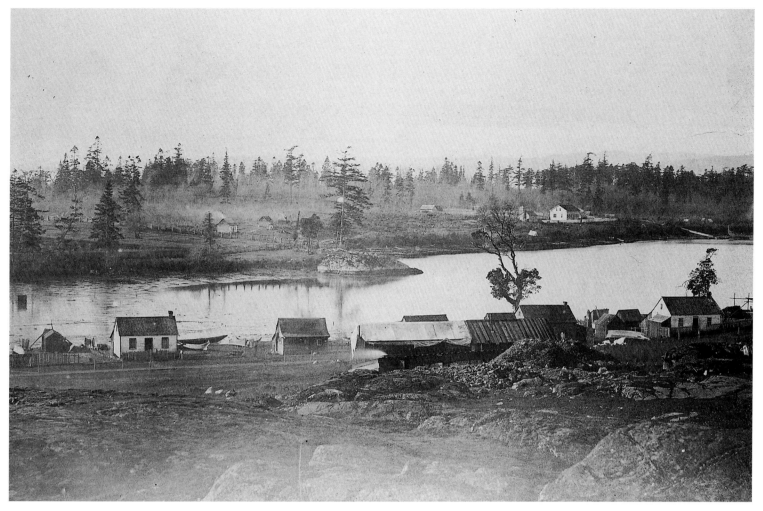

Looking southwest across James Bay in 1858. The large white house in the background is Captain Mouatt's. The rock at the centre would become the south footing for the first James Bay Bridge built the next year, to access the first Legislative Buildings, started the same year on the land just beyond it.
BC Archives HP97971, H-01492.

The Paul Kane Visuals

A great deal of confusion has surrounded the locations of the villages in Paul Kane's paintings of First Peoples around Fort Victoria. This is due to a lack of knowledge of the Inner Harbour Clallam villages, the misuse of names, editorial errors in Kane's book, *Wanderings of an Artist*, and his practice of painting composite scenes based on earlier drawings.

Kane's original drawings were accurate, but he would later combine two or more drawings into a single oil painting. For example, he combined two drawings of the same village (see paintings on page 24 and 25, top) to create a composite painting of two villages on opposite sides of the harbour. In his landscape log, Kane described one of these drawings as "The canoes returning from gathering camas to the Esquimalt" and the other as "Sangeys Village on the Esquimault". Like others of his time, Kane referred to the area across the water from Fort Victoria as "the Esquimalt", in reference to the Esquimalt Peninsula. (Even today, many people mistakenly refer to the community of Victoria West as Esquimalt.) Several interpreters of Kane's work have mistaken some of his paintings as those of a village at Esquimalt Harbour.

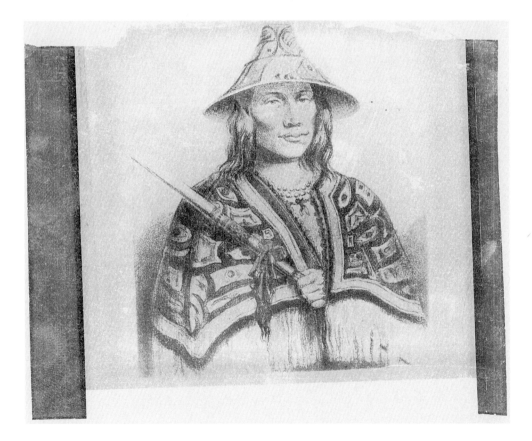

Sketlesun, a Songhees from the old Cadboro Bay village, was named on the Chekonein treaty of 1850. In his portrait log (April 18 to June 10, 1847), Paul Kane called him "Ska-tel-san" a "Samas Tillacum". He is wearing a woven cape and hat acquired through trade from the northern coast. Lanternslide of original made in 1906 for Charles Newcombe; RBCM PNH104.

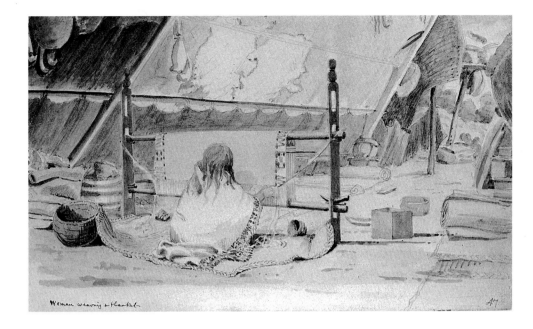

Woman weaving a blanket
– watercolour by Paul Kane, 1847.
Stark Museum of Art, 31.78/73, WWC73.

Clallam Indian woman basket making
– watercolour by Paul Kane, 1847.
The small dog is the type sheared for its
inner hair, which was used to make capes
and blankets.
Stark Museum of Art, 31.78/45, WWC45.

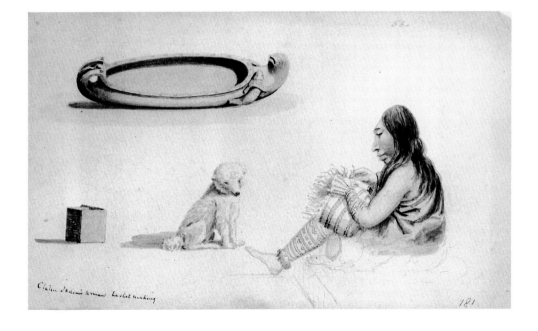

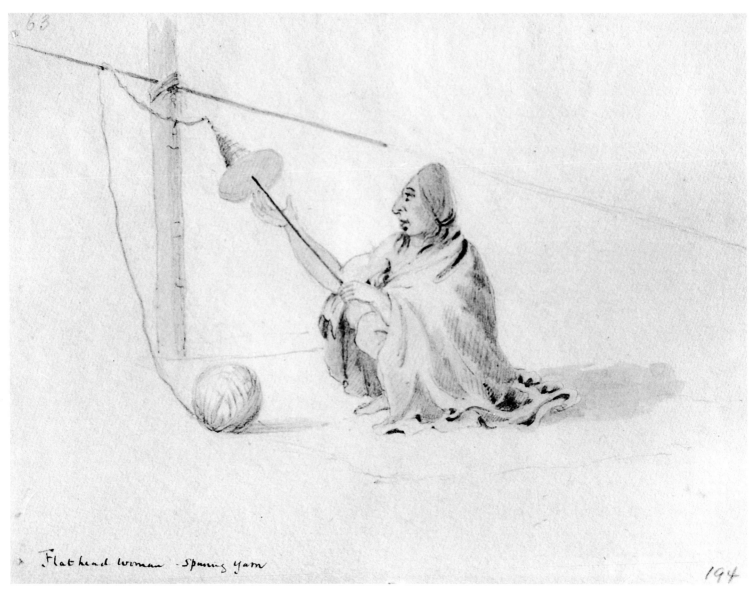

Flathead woman - spinning yarn

194

Paul Kane watercolour of a Songhees
woman spinning what is probably dog
hair, 1847.
Stark Museum of Art, 31.78/96WWC97.

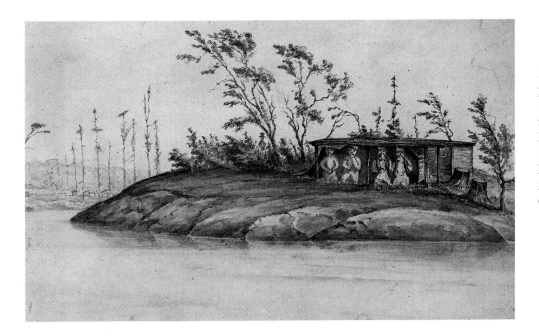

Indian Graves, Victoria – watercolour and pencil drawing by William McMurtie, 1854 or 1857. Burial houses and grave figures at Laurel Point. The faintly drawn European-style houses in the background (left) are west of where the Legislative Buildings are today.
Museum of Fine Arts, Boston, C18868, Acc.# 59.153.

Burial Grounds at Laurel Point

During the early settlement of the old Songhees Reserve, First Peoples buried their dead at several locations around Victoria Harbour. Some of these burial grounds still exist and should be respected as such. The Cemeteries Act and the Heritage Conservation Act provide for heavy fines to anyone caught disturbing these locations.

One of these sites was at the tip of Laurel Point, where the Songhees erected several burial shelters and large carved wooden human figures representing the dead. On October 15, 1858, the *Victoria Gazette* described the site:

> The burying ground ... of the chiefs of the Songhish tribe is located on Deadman's [Laurel] Point.... Subsequent to the migrations of whites hither in 1848–9, this burying ground has not been used.... Since that period none of the deceased have been considered worthy of interment there. The four figures placed on the spot are rude carvings of wood, as large as life, each one representing the chief against whose grave it is placed. They are arranged in line, and are about two feet apart, facing the entrance of the harbour, and formerly struck the eye of the stranger ... as a body of military sentinels on duty, guarding the inner harbour.
>
> At one time they were very conspicuous, being painted in bright colours and with much taste, vermilion, black, &c, being the predominant hues. The old Laurel [Arbutus] trees were well chosen by the Indians to shade their great dead.
>
> One of the figures holds between his hands the skull of a dead enemy and rival chief, whom he killed in deadly fight.... He in his life was a warrior of renown, and the tradition with his deeds ... in the memories of his descendants of the present generation, would make him a Songish Caractus [Caratacus, a British king who resisted the Roman invasion in the first century AD].
>
> The next to him was ... a celebrated warrior ... famed as a spokesman, sagacious advisor, seer and statesman. He is represented as addressing the tribe, in an attitude of imperative command. The two others were renowned hunters revered in the oral annals of the tribe for daring feats in slaying the black bear, panther and wolf.... One is represented as holding in each hand a live wolf, rampant, the other is also grasping in either hand a wolf inverted.

5
Wage Economy and Warfare

Changing Labour and Trade

The aboriginal economy went through enormous changes in the 19th century due to depopulation, changes in marriage patterns and family movements, access to resources, and the influences of the powerful European economy.

Before contact with Europeans, food resources likely fluctuated over time. Family groups may have focused more attention on certain resources or only had rights to them. In almost every regional group on the coast the majority concentrated on marine resources, but there were always a few families who gathered food from the land for themselves and others. Each family had its place in the resource economy. But the influence of European trade dissolved many of the old ways.

Captain George Courtenay of HMS *Constance* described the Hudson's Bay Company's operation around Fort Victoria in 1848: They had 125 hectares under tillage, a dairy farm of 80 cows and other cattle, and 24 brood mares. Chief Trader Roderick Finlayson had about 30 men working for him; they would finish building a sawmill at Millstream that year. Courtenay noted his "agreeably surprised" discovery that the Songhees were "not so thievish as represented, scarcely a single instance of dishonesty occurred … but they will not do you a hand's turn, or give you a drink of water without payment".

William Cook came to Fort Victoria as a labourer in December 1848, and left his reminiscences: "There were Indians encamped all about the fort and along what is now known as Humboldt, Wharf and Belleville streets, and in the Johnson Street ravine and James Bay, while on the reserve opposite the Fort they were as thick as the hairs on your head." Cook remembered the Songhees keeping white dogs that they sheared for the hair and used to weave blankets, but when the Europeans came with their blankets, "the Indians no longer kept the breed pure".

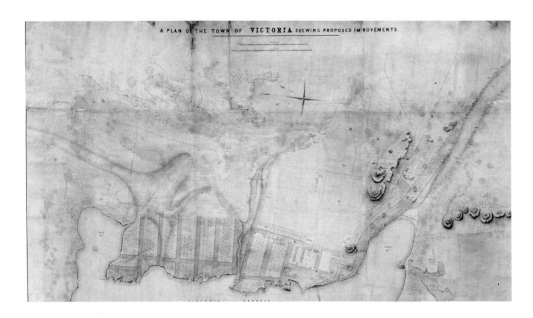

Joseph Pemberton's 1852 map of the east side of Victoria's Inner Harbour. Three creeks pour into the harbour, from left (north) to right: Rock Bay Creek drained a large area around Bay Street to the north of Fernwood Street; the creek through the Johnson Street ravine drained the swamps in the downtown area; and the creek feeding James Bay drained the Fairfield swamps. Hudson's Bay Company Archives, Provincial Archives of Manitoba, G.2/38 (T13107).

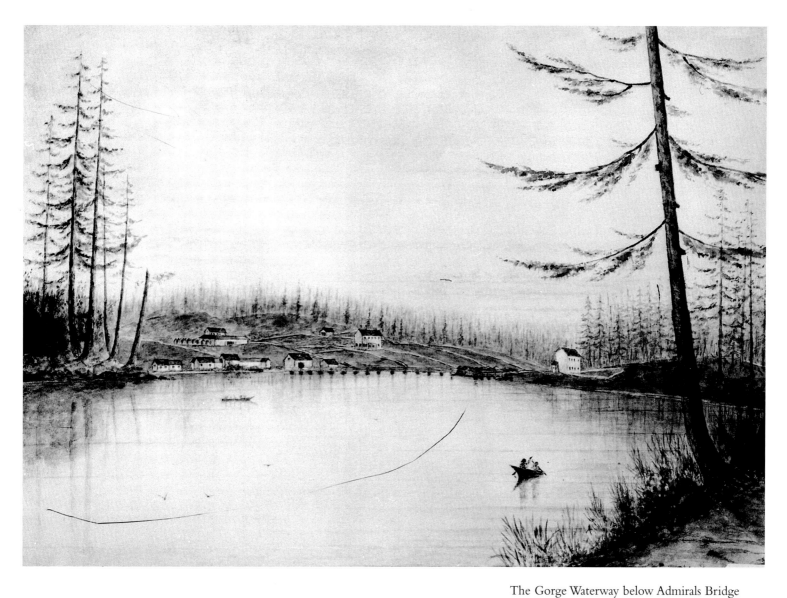

The Gorge Waterway below Admirals Bridge
in 1861. On the left is the McKenzie farm that
employed First Nations workers. On the right
the Old Craigflower Schoolhouse on the site of
an old Kosampson village.
Painting by Alexander Rattray, 1861;
BC Archives PDP00169.

Finlayson put Cook to work in the mess-house: to look after the Indian boys and see that they kept the quarters clean and made the beds properly. There were about twenty-five white men employed in the Fort, mostly French Canadians. Outside of the Fort were farms, all owned by the Hudson's Bay Company.... Uplands, North Dairy at Cloverdale, Beacon Hill farm and the Fort farm.... The remaining four, McCauley's Point, Skinner's, Craigflower and Langford Plains, were managed by the Puget Sound Agricultural Company.... The farm hands were mostly Indians.... We had to employ Indian boys to keep the crows from picking the sheep's eyes out.

Almost the only amusement was to go out shooting grouse or deer, up Fort Street way or around Beacon Hill.... The first lock-up ... in Victoria was just outside the north entrance of the old Fort.... The Indians were often put in this lock-up for shooting the Hudson's Bay cattle, but they lifted the floor and got out.

In 1849, the British government granted the Hudson's Bay Company the new colony of Vancouver Island. That same year James Douglas returned to Victoria as the new Chief Trader; Finlayson stayed on at the fort as the Company's accountant.

Douglas noted that many of the Company ships, upon arriving at the fort, had insufficient crews, but the situation was "partially remedied by employing Indians on board in the coast shipping". On September 3, Douglas noted that Fort Victoria was "dependent on Indian labour" for salmon and potatoes. Soon after, the fort hired more First Nations labourers because Company men were deserting to join the California gold rush.

When Eden Colville, governor of the Hudson's Bay Company's Rupert's Land, visited the fort on October 15, he wrote:

I think it will be necessary to break in Indians at the different posts to do a great part of the work now done by white men.... The Indians in this neighbourhood are very well disposed & seem more inclined to agriculture than most I have seen. They raise a good many potatoes on their own account & are always willing to work for the Company.

By the spring of 1851, the Hudson's Bay Company had sold more than 400 hectares of land to eight colonists who required aboriginal labour to clear the land and build fences and houses. A new road to Sooke employed mostly aboriginal workers. Douglas noted on October 31 that the Songhees were also engaged in "the manufacture of shingles and laths". By September of 1852, the Songhees at Metchosin specialized in making shingles. The Puget Sound Agricultural Company, a subsidiary of the Hudson's Bay Company, employed aboriginal people (mostly northerners) at several Victoria-area farms and at its fisheries and farm on San Juan Island. The purchasing power of First Peoples became an increasingly important part of the economy.

The Songhees became part of the wage economy, obtaining food and building materials for the Hudson's Bay Company's operations, putting up fences and ploughing the fields. Anticipating the arrival of colonists in the early 1850s, James Douglas, now as governor of Vancouver Island, ordered Finlayson to encourage the Songhees to "plant more potatoes and bring in more fish and game".

Fish remained an important food source for the Songhees, but the specific ownership rights, social obligations and associated rituals began to erode as the goals of the new foreigners took precedence. More and more, the Songhees were gathering resources for others. James Bell, a visitor to Victoria, described the situation in 1858:

We are indebted to the Indians for a supply of everything in season ... at very reasonable rates. They collect great quantities of Berries.... For a back load of Potatoes they charge one shilling,... a fine salmon ... one shilling,... Cod, Herrings, Flounders, &c are always to be had cheap,... a large Basket of Oysters one shilling. The market is also supplied with plenty of venison. Deer are quite plentiful, until the arrival of the American Hunters.

Women played an important role in the sale of goods such as potatoes, clams, fish, mats and baskets. These women were a common subject of staged photographs.

Weakened by Disease

In the summer of 1844, dysentery killed many people on the southern coast, though its affect on the Songhees is unknown. In 1847, measles was prevalent for some time on the middle Columbia River. By year's end, it had spread to

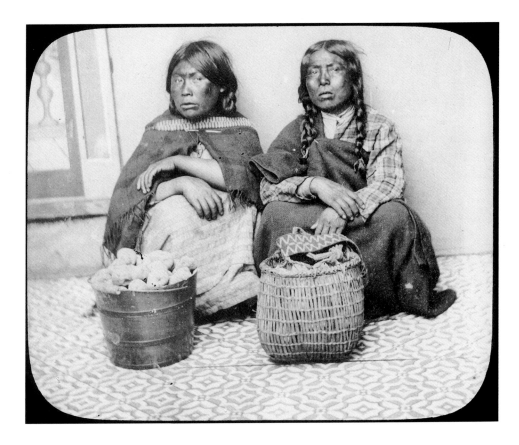

Hanna Maynard made this photograph in about 1870 to show the difference between Nuu-chah-nulth (left) and Salish women. She posed the women as sellers of potatoes and clams.
Lanternslide; RBCM PNX306.

Fort Vancouver on the lower Columbia River and to Fort Nisqually at Puget Sound, where it was followed by outbreaks of influenza.

Measles hit Victoria in March 1848. Two thirds of the fort employees fell ill, mostly Hawaiians. Over the next few months, measles and influenza spread among the Songhees. Many recovered – Finlayson reported on April 12, that Songhees Chief Chee-ah-thluc (King Freezy), who caught dysentery after recovering from the measles, "is now I am happy to say getting better".

Various reports indicate that small numbers of Songhees and Hawaiians died from these diseases. When the same epidemic reached Fort Simpson on the northern mainland coast, ten per cent of the aboriginal population died, suggesting that a similar proportion died near Fort Victoria. Captain Charles Wood, who arrived in Victoria on August 27, 1848, suggested a higher death rate. Referring to the 1845 census for the area, Wood reported, "a decrease of 1/5th for the effects of the late mortality ... from the

measles, Influenza, etc. which has made great havoc this year." His estimate reduces the Songhees population to about 560, based on the 1841 and 1845 census figures of 700.

In 1849, the Hudson's Bay Company teacher Reverend Robert Staines called the Songhees "a weak tribe, (once powerful, but of late years much thinned by disease) & they are glad of the protection afforded them against their stronger neighbours by the presence of the white man. The tribe numbers from 150 to 200 men & perhaps 500 or 600 in all."

Tensions on the Local Scene

In the spring of 1848, Songhees men killed Cowichan Chief Tzuhalum's nephew in revenge for the killing of a Songhees man. Then the Clallam accused Tzuhalum of killing one of their men who worked on the Hudson's Bay

Company's dairy farm. The dispute escalated sharply when a T'Sou-ke chief led about 150 T'Sou-ke, Songhees, Clallam and Skagit men, against Tzuhalum and his people, who were living in a fort at Cowichan Bay. The attacking party landed at night and attempted to set the palisades on fire. They nearly succeeded, but the Cowichan discovered them and shot the T'Sou-ke chief and two others. The two other men escaped, leaving the chief to die. Tzuhalum came out and cut off the dying man's head. Without a leader, the rest of the attackers fled.

James Douglas later reflected on the incident and its repercussions around Victoria:

> A quarrel took place between the Indians of this post and the Cowichan tribe which nearly involved us and disturbed the peace of the settlement. The immediate cause … was the murder of a young Cowichan nephew of a principal chief by an Indian of this place. The Cowichan tribe … set out war parties to avenge his cause. These hovered about this place for several weeks keeping us in a constant state of alarm and not one of our labouring Indians could be induced to leave the Fort or attend to any outdoor occupation without an escort.

Tensions between First Nations continued to simmer over the summer, and fearing an "Indian uprising", the Royal Navy staged a show of strength for local First Nations in August. They held a special armed performance behind the fort, with more that 200 Royal Marines and sailors participating.

The Voltigeurs

In March 1850, Richard Blanshard arrived as the first governor of the colony of Vancouver Island. On May 21, James Douglas, then Chief Trader for the Hudson's Bay Company, wrote to his superior, George Simpson, to explain that he disagreed with Blanshard's proposal to station a military force at Victoria. He agreed that it was a "proper measure", but thought that it would be too expensive for the Company to maintain. As a compromise, Douglas:

> took the liberty of recommending the formation of a rural police to be effected by granting a certain number of 20 acre lots … to the Company's retiring servants … as it will meet the demand for protection at very small expense…. Petty depredations are occasionally committed by the Indians … but no overt attempt at violence has been made on the persons or property of the white inhabitants.

This "rural" police force was composed of people with French Canadian and First Nations ancestry, and became know as the Victoria Voltigeurs (named after the French

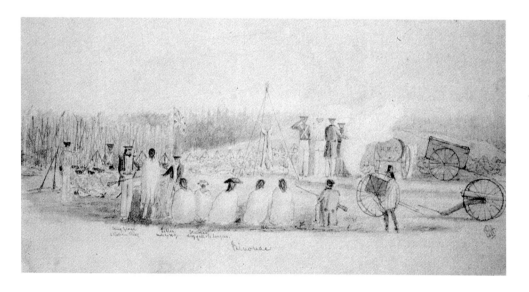

Bivouac near Fort Victoria – watercolour by J.T. Haverfield of HMS *Constance*. Songhees and Clallam leaders (with blankets in the foreground) observe a show of Royal Naval military force on August 29, 1848. Wearing the officer's hat (centre of those sitting) is "Chealthac, Chief of all the Songees" (King Freezy). The man standing (left) is "King George, Clallum Chief", who is handing the officer a "Letter wrote to King". BC Archives PDP01185.

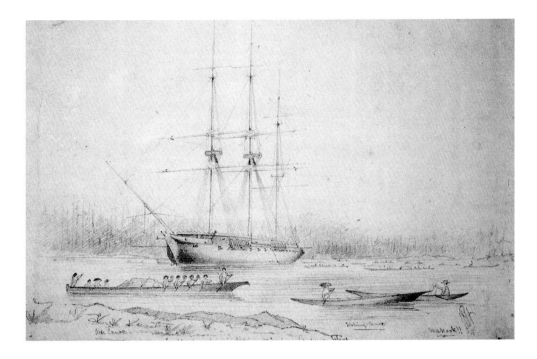

This pencil drawing by J.T. Haverfield of the Royal Marines shows HMS *Constance*, the first British warship to enter Esquimalt Harbour on July 25, 1848. The men from this frigate performed the military exercises to impress the local First Nations. Captain George Courtenay came to report on the state of British interests and to maintain peaceful relations with First Nations. The next year the Frigate *Inconstant* arrived to help prevent a possible "Indian uprising" by visiting northerners.
BC Archives PDP01182

light infantry). They lived in a village on Colquitz Creek near its junction with Swan Creek.

The Voltigeurs first major encounter with the Songhees was in March 1852. Several exaggerated versions reported a force of 800-armed First Peoples, cannon firing and the destruction of houses. But the actual incident was not nearly as large or violent.

By this time, Douglas had replaced Blanshard as governor, and on April 15, he wrote to the Colonial Office, explaining that the Voltigeurs went to the Songhees village to arrest a Songhees man "accused of having slaughtered several head of meat cattle and sheep belonging to a settler". There, the chief constable and his men

> were surrounded by a tumultuous throng of armed Indians, who ... were only restrained at the point of the Bayonet from rushing in, and disarming his party, who were ... compelled to retire ... with the loss of two muskets and a Boat.... I sent a second party to demand ... the Boat and Muskets they had so lawlessly seized, on pain of being punished.... They refused to give up the property unless the Indian, who had been apprehended ... was set at liberty.... Before resorting to coercive measures I ... resolved to try the effect of a

demonstration, and ... ordered out a few guns, and directed the Hudson's Bay Company's Steam Vessel *Beaver* to be anchored abreast of the village....

> In the mean time there was much excitement and alarm among the Indians, the women and children were flying in all directions while the men appeared to look unmoved ... but they ... had time for reflection.... [They] resolved to end the dispute by restoring the Boat and Muskets, which were immediately given up.... The following morning the Songies Chief, a well disposed Indian, made proffers of compensation for the cattle ... which were accepted and quiet was restored.

In the same letter, Douglas suggested that a naval ship be stationed in the area to deal with any future incidents.

6
Northern Invasions, 1853-59

The lives of the Songhees people changed even more in the fall of 1853, when about 3000 First Nations visitors from the north began arriving in their territory. They came to Victoria in large groups, many having paddled over a thousand kilometres, with hopes of finding work or trade at the fort.

While visiting Fort Victoria, James Lowe wrote on September 15, 1853: "the Indians, being very numerous and inoffensive, work when asked to do so, the payment being in blankets or other merchandise, on the sale of which the Company of course gets good profits."

On August 26, 1854, Governor James Douglas stated that he was paying aboriginal labourers $8 a month to build a road to Sooke. He said, "White labourers cannot be procured under the rate of … 2-1/2 dollars a day, so that we cannot afford to employ them."

But not all northerners journeyed south for work and trade. On May 26, colonist Thomas Grenham arrived at the fort in a panic, reporting that Cadboro Bay Farm had been attacked and taken by "several hundred Indians". A large group of Tongass Tlingit had come from Cape Fox, Alaska, seeking revenge for the killing of one of their chiefs in Puget Sound. By the time Douglas rode to Cadboro Bay with an armed party of six men, the invaders had already

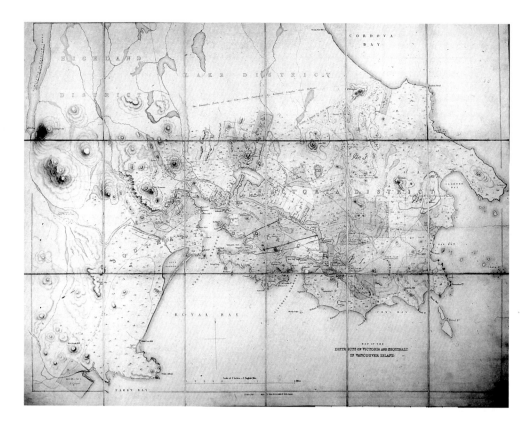

District of Victoria and Esquimalt, Vancouver Island, ca 1854.
This is the first comprehensive map of the area covering most of the territory belonging to the Songhees and Esquimalt nations. It was drawn from several smaller maps produced by Joseph Pemberton, starting in 1851. The shaded areas are properties of the Puget Sound Agricultural Company and private landholders. A line extending across the top, from Mount Finlayson to Mount Douglas bears the words, "The Peninsula North of this Line lately Purchased by Governor Douglas from Indians"
– this is the boundary between the South Saanich and Chekonein treaties.
Canadian National Archives, G.3/96 (N9301).

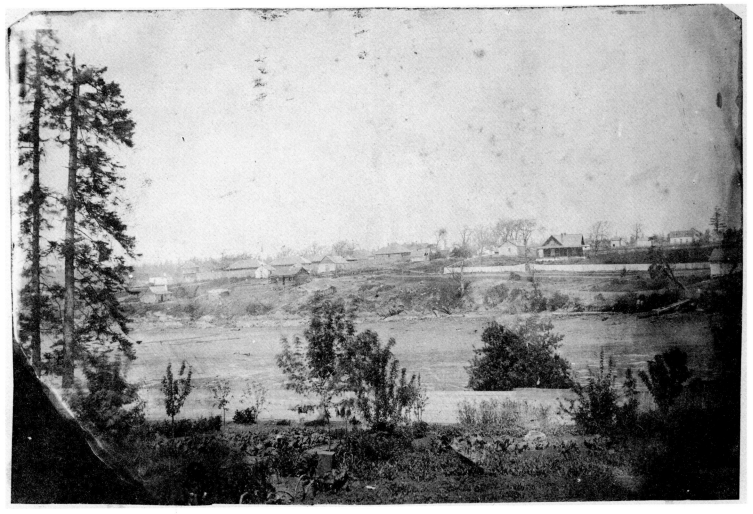

The oldest known photograph of Fort Victoria, taken in 1857. The fort is on the left, and the fenced property on the right is the home of Alexander Grant Dallas, James Douglas's son-in-law. The northern end of the James Bay Bridge was later built on the shore just below Dallas's house. BC Archives HP93855, E9925.

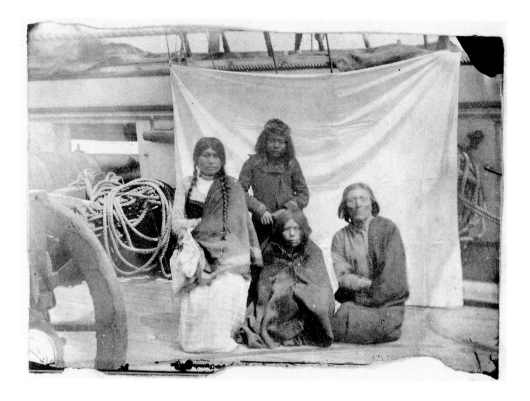

The earliest photographs of Songhees people include this pair taken aboard HMS *Satellite*, a naval vessel that came to survey the international border with the U.S./British Northwest Boundary Commission. These families were photographed between 1857 and 1859. The photographer was likely Captain Richard Roche, who took other photographs on board the *Satellite* in 1857, as well as a panorama of James Bay in 1859–60 (see page 67, top).
Yale Collection of Western Americana, Beinecke Rare Book and Manuscript Library. WA Mss-1817, Box 1, Folders 1 and 2.

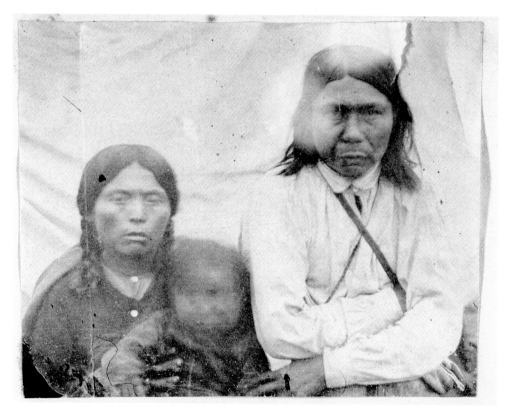

departed; but Douglas found the farm's manager, Mr Baillie, severely cut up. This violence upset the whole settlement. Other tribes took up arms and had to be restrained from killing each other. Douglas felt the settlement was never placed in a more critical position and was thankful when about 500 northerners left the next morning. On their way home the Tongass attacked a group of Cowichan and were defeated with severe losses.

On July 13, Douglas noted the arrival of about 100 Haida attracted "by the reported high price of labour". He advised the chiefs to return home, because he could not "protect them against the hostility of the native tribes in this vicinity".

By August 4, most of the Haida had left, but on the way home they nearly destroyed a party of Cowichan. Douglas said that the Cowichan "will not fail to retaliate" and nine days later nearly all the northern groups left in consequence of the Cowichan commencing a "retaliatory warfare upon them" and killing "one principal man".

Fifteen days later, the steamer *Otter* had returned after towing some of the northerners about 20 miles past Nanaimo. This group attacked and nearly destroyed a small party of Nanaimo, who killed a larger number of their assailants. On October 9, the Nanaimo fort journal reported that northerners had "massacred all the No-noo-as, a part of the Nanaimo tribe"; but four days later, the journal corrected its records, saying that it was the Mamalilikulla from Knight Inlet who had attacked the Nanoose and had killed only five people.

Troubles to the South

On October 16, 1854, Douglas reported: "The native tribes have been quiet and well conducted in every part of the Colony." The situation was not as peaceful just to the south, where there were several reports of First Nations attacking American settlements. On December 14, the Washington House of Representatives passed a resolution requesting the United States Congress "to authorize the Governor of Washington territory to accept the services of two companies of mounted volunteers ... in quelling Indian troubles, recovering stolen property," and protecting immigrants.

The following winter, in a letter to James Douglas on

February 17, 1856, Governor Isaac Stevens of Washington complained that the "Northern Indians" were planning an attack on American settlements: "The tribes concerned in the operation are the Hyders, the Bella Bellas, the Chimseyans (Fort Rupert), the Stick Inns, and the Tomgass.... I will request that you will keep one of your steamers plying in the vicinity of these Indians, and will communicate any information you may learn of their movements."

Meanwhile, John Nugent, an American special agent stationed in Victoria, accused Hudson's Bay Company employees of encouraging First Nations in Washington Territory "to commence a war of extermination against our citizens". He reported that the Company was purchasing stolen American goods and supplying First Nations with British guns. Contrary to these accusations, Douglas advanced the Americans $7,000 worth of Company funds for the purchase of "powder, lead and other munitions of war".

On March 5, Douglas wrote to England about the "Indian wars" in Washington and the looting of settlers homes by northerners who were using Victoria as a staging ground for these raids: "Thirty eight canoes with upwards of 300 Northern Indians, arrived at this place a few days ago, & a very large number are reported to be on the route.... I have ... commenced raising a Militia force of 30 men and Officers, who will remain embodied during the presence of those savages ... with respect to the Northern Indians, I presume Her Majesty's Government will have to take one of two courses, either to compel those savages to remain in their own Country or to permit the United States Government to levy war against them within the limits of the British dominions."

He ordered Joseph McKay to take a party of men, including 25 "Victoria Indians", to one of the San Juan Islands "to disperse a body of northern Indians ... who were plundering the deserted habitations of American settlers.... McKay, guided by the Victoria Indians, landed with his men near their hiding place, and by a rush into their camp, took it without a casualty. The remains of several oxen were found in their huts, supposed to have been at least in part, the property of persons residing in this Colony. Two of the number were in consequence seized, and brought to this place for trial."

Northern First Nations continued to come south in 1856. In mid March, the Company fort in Nanaimo recorded the arrival of 44 northern canoes stopping by on their way to Victoria. Later in March, Douglas reported a "serious affray" in Victoria between the Stikine Tlingit and Haida in which one man was killed and several wounded. On May 28, the Nanaimo fort journal reported, "Five canoes of Ft Simpson Indians called here on their way home … three of their tribe had been shot by the Cowitchins at Victoria".

On June 7, Douglas noted the arrival of a large number of Haida in Victoria:

> The chief of this party is accompanied by his son, who was committed to Jail, and afterwards whipped at this place, about two years ago for theft. It is reported that the father, has made a vow to avenge the indignity to his family, by making a hostile attack on the settlements. He was yesterday brought before me, and I taxed him roundly with entertaining evil designs against the whites, which he strenuously denied. I … charged him to look well after his people,… and to keep them from stealing, quarrelling, drunkenness & riotous behaviour warning him that for any of those offences, they will be publicly whippet or imprisoned.

On February 18, 1857, Douglas reported that visiting First Nations had become "restive and insolent in consequence of the native successes over the United States troops in Oregon." At the end of October, he noted that the visitors have had "many serious affrays" and "an unusual amount of murders and assassinations among themselves, and one instance of open warfare", but they have respected the "lives and property of the whites". He expressed his belief that "a proper system of laws, under the direction of native Magistrates with the support of a moderate Police Force … [would bring] peace and order". At this time, a government report stated that the "number of Indians frequenting Fort Victoria for trade" was 5000.

Invasion from the South

In the final two years of the 1850s, great numbers of people arrived in Victoria. In 1858, twenty thousand people came through Victoria from California on their way to the gold

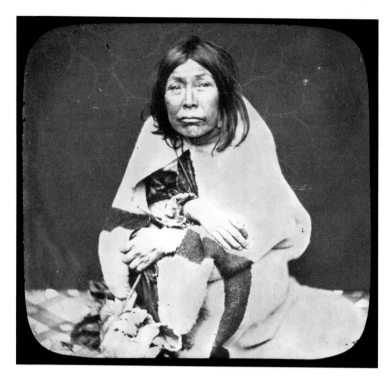

Studio portrait of a Haida visitor to Victoria wearing a Hudson's Bay Company blanket over her European-style dress.
Rod Mitchell private collection

rush on the mainland. New businesses sprang up and many foreigners stayed and settled in the region. On September 4, the *Illustrated London News* called Victoria's expansion a "sudden metamorphosis from a quiet little hamlet of some 400 souls to a huge hive of … 6000 to 7000 brigands". For the first time, local First Nations did not comprise the majority of the population.

The Songhees and other First Nations took advantage of the situation, charging high prices to transport goods and provide food for the new visitors. Shiploads of miners arriving at Esquimalt Harbour were greeted by First Nation's men and women eager to haul them and their belongings ashore in canoes. Meanwhile, northern First Nations continued coming to Victoria seeking trade and employment. Victoria resident Edgar Fawcett noted in his reminiscences, that the Victoria shores were "thickly populated" by northern aboriginal peoples "who moved to Victoria for

commercial purposes". Their camps stretched from Barnard Park near the Esquimalt border to the south side of Rock Bay, just north of the Johnson Street ravine. First Nations from Washington came to Victoria in large numbers to spend the money that they had earned back home.

Growing violence among aboriginal people became a major concern in the latter months of 1858: on September 14, Songhees men fired on a canoe of Saanich and Cowichan; just four days later a Kwakiutl man was found murdered; and on November 16, a "drinking spree" at the village resulted in two people being killed and five wounded. The *Victoria Gazette* called for more enforcement: "The law against selling liquor to Indians should no longer be allowed to remain practically a dead letter statute."

On February 5, 1859, a "white man" shot a Haida. "Edensaw", a powerful chief from the Haida village of Kung, demanded compensation. This was Albert Edward Edenshaw, the chief who later gained international fame as an artist. Governor Douglas gave him a bill worth 25 five-point blankets – a large compensation that probably included extra payment for a previous slight.

On March 16 the newspapers reported that the sheriff had removed "the last batch" of Haida from the city. The naval ship *Tribune* towed 16 canoes carrying 200 people as far as Johnstone Strait, where they cut the toe lines and

scattered. But two weeks later, the Haida began returning in large numbers: 70 canoes arrived on March 31, with up to 700 people who occupied the huts abandoned by those who had just left; then on April 21, another 46 canoes arrived loaded with more than 600 people; and two days later, nearly 1000 more arrived in about 80 canoes.

The Battle of Rock Bay

Fighting among First Nations continued throughout 1859 and killings occurred regularly. On May 14, the Tsimshian and Haida engaged in a gunfight at what the settlers called the "Siwash" camp on the shores of Rock Bay, killing seven people and wounding many more. Some reports estimated that 4000 spectators witnessed the battle, many within range of the bullets.

There are two eye-witness accounts of this incident. One from Captain Charles Wilson of the British Boundary Commission:

> I noticed a great excitement amongst the Indians, who were all rushing to one place in their war paint & loaded with guns.... Soon I saw some shots fired & then a regular fight commenced between the two tribes.... After a good deal of fire … the [Tsimshian] made a very pretty movement round a small hill & attacked the Hydas in the rear when some shots coming inconveniently close to my cranium,... I beat a retreat.... The firing went on till nearly dark & ended in the Shimpshians gaining a complete victory.... Next day I went to see the mummery over the dead bodies. They had them all dressed & seated up on stools as if alive; with their war paint on it was a most disgusting sight as many of them had been shot in the head, one of them through the eyes; round the bodies all the tribe were dancing, hooting & performing.

John Woolsey, a visitor to Victoria, wrote on May 18, that the Tsimshian sought revenge on the Haida for the murder of one of their chiefs. A previous attempt was prevented by Hudson's Bay's Company personnel. With the two groups living so close to each other at Rock Bay, hostile feelings simmered below the surface until, on May 14, a Haida struck a Tsimshian with a bottle and cut his head. A Tsimshian chief intervened and another Haida knocked him

Police Commissioner Joseph Pemberton conducted a census of the "Northern Indians" encamped near Victoria on April 15, 1859. He listed them, as follows:

Tribe	Huts	People
Haida	32	405
Tsimshian	34	574
Stikine River Tlingit	17	223
Duncan Cowichan	9	111
Bella Bella (Heiltsuk)	11	126
Pacheenaht (Pacheedaht)	4	62
Kwakiutl (Kwakwaka'wakw)	4	44
Total	111	1545

Then he added 690 late arrivals (the first fleet of Haida canoes on March 31) and estimated 600 Songhees for "a total Indian population … of 2835".

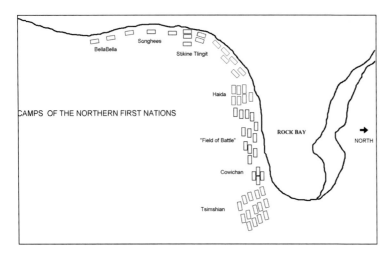

CAMPS OF THE NORTHERN FIRST NATIONS

BellaBella
Songhees
Stikine Tlingit
Haida
"Field of Battle"
ROCK BAY
NORTH
Cowichan
Tsimshian

The Rock Bay camps in 1859. This was
the main camping area for northern
visitors until June 1860, when some
groups relocated on the Songhees
Reserve or farther up the Gorge Waterway.
Grant Keddie, redrawn after a sketch by John
Woolsey.

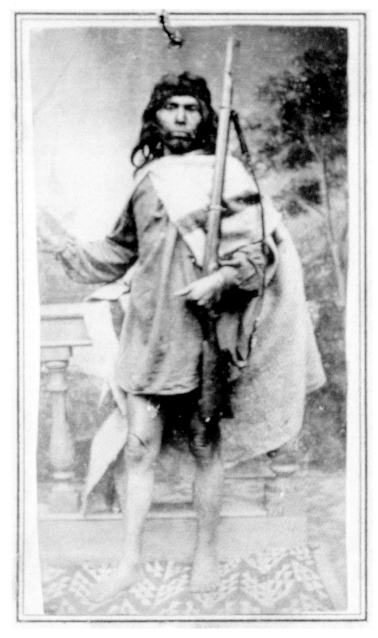

This man posed in Charles Gentile's Victoria
studio, 1860–63.
RBCM 11628.

down with a clubbed musket. The chief's people fired on
the Haida, killing one woman and two men. The Haida
retaliated and more people joined in wielding knives and
axes, inflicting "severe cuts … on both sides". Before long
they were firing guns "from behind every tree, or rising
ground".

The Stikine Tlingit, Songhees and Bella Bella (Heiltsuk)
did not take part, but according to Woolsey, were "all out in
full paint and feathers, armed to the teeth with knives, axes,
muskets" and waiting for a request from the Tsimshian to
aid them against the Haida, who "are disliked by almost all
the other tribes and are at the present moment at war with
several of them".

After the battle raged for about an hour, Police
Commissioner Joseph Pemberton succeeded in stopping
the fighting and "effecting a truce". Woolsey wrote that the
group of about 600 Haida "suffered the most severely", with
5 killed and 13 or 14 wounded, 2 of whom died later. Of
about 200 Tsimshian only 3 or 4 were "slightly wounded".
One innocent Cowichan suffered minor injuries from "a
discharge of buckshot in his face and chest", and the
Cowichan moved their camp to another part of the bay.

Several Haida canoes left that night and more left every day until nearly all had gone. In all about 300 northerners left the camp after the fight, including many Stikines. But soon after, ten canoes of new people arrived "the advanced guard of another horde on their way." Because of the Battle of Rock Bay, Pemberton started a series of police patrols to enforce a curfew in which First Nations had to be in their camps.

On June 19, despite the curfew, Songhees sharp-shooters in the Hope Point area opened fire on the Haida and Stikine on the opposite bank at the Siwash settlement, wounding three. The Haida returned fire and wounded a Songhees. Then the Songhees captured a Stikine woman. Soon after, the police began disarming all aboriginal people in town. On July 29, after the stabbing of a Stikine woman by two Cowichans in Victoria, the *British Colonist* complained about "the great number of natives being killed by other natives". It concluded: "Our town has been made a human slaughter house."

Songhees Village, 1861. The naval ship *Forward* is being repaired at Scorgie and Bolton's Shipyard – then located on the reserve.
BC Archives HP1184, A-530.

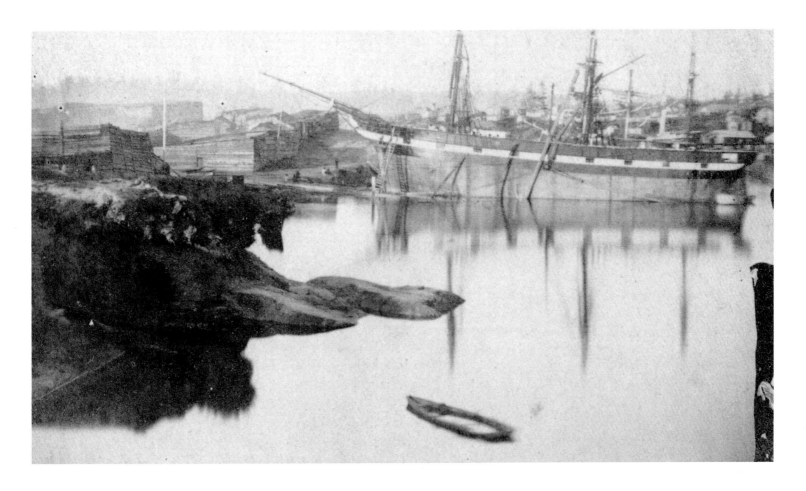

7
Aboriginal Title and the Victoria Treaties

In 1849, the British government declared Vancouver Island a Crown Colony and granted the land to the Hudson's Bay Company on the condition that they promote settlement. James Douglas, as a representative of the Crown, was authorized to undertake treaties to extinguish the proprietary rights of aboriginal people.

On September 3, 1849, Douglas advocated the creation of reserves for First Nations around their fisheries and wrote to Britain regarding the purchase of aboriginal lands. The Hudson's Bay Company authorized him to confirm the aboriginal peoples in the possession of only those lands that they had cultivated or built houses on by 1846. All other land was to be available for colonization. The Company's secretary, Archibald Barclay, gave instructions to Douglas: "The right of fishing and hunting will be continued to them and when their lands are registered, and they conform to same conditions with which other settlers are required to comply, they will enjoy the same rights of privileges."

That year, British administrators developed a policy recognizing aboriginal possession, so the extinguishing of aboriginal land title had to precede settlement by colonists – this was the intention of the Victoria-area treaties of 1850 and 1852.

On May 7, 1850, Douglas wrote to James Yale, the Company's trader at Fort Yale:

> I have been lately engaged in buying out the Indian right to the lands in this neighbourhood and to the westward. It is rather a troublesome business, but we are getting on very well. The price paid will come, on an average, to about 15 (shillings) in goods to each individual of the tribe. I mention this circumstance as your Indians will no doubt be claiming payment for their lands also, but that can be settled by and bye.

Between April 29 and May 1, 1850, Douglas had made agreements with six extended family groups of Songhees and a seventh with another group that he referred to as Clallam, but were more related to Songhees peoples. In

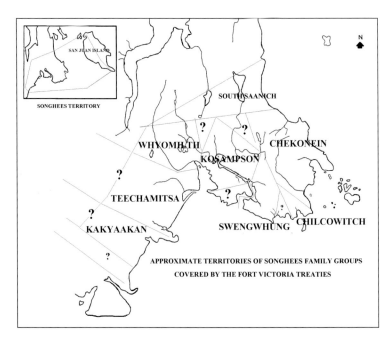

The 1850–52 Fort Victoria treaty territories. The question marks denote uncertain areas or boundaries.
Grant Keddie drawing.

1852, he made another agreement with the "South Saanich" in what appears to have been a territory not clearly identified as being either Saanich or Songhees. The people living there may have seen themselves as a different group of people who were related to both Songhees and Saanich groups, but whose prominent members later moved to the Songhees Reserve.

Douglas reported on May 16 that he summoned to a conference, the chiefs and influential men of the Songhees Tribe, which inhabits and claims the District of Victoria, from Gordon Head on Arro [Haro] Strait to Point Albert on the Strait of [Juan] De Fuca as their own particular heritage. After considerable

discussion it was arranged that the whole of their lands … should be sold to the Company, with the exception of Village sites and enclosed fields, for a certain remuneration, to be paid at once to each member of the Tribe. He paid the 122 male heads of families blankets worth 17 shillings each, equivalent to about two weeks of a labourer's wages at the time. And he

informed the natives that they would not be disturbed in the possession of their Village sites and enclosed fields … and that they were at liberty to hunt over the unoccupied lands, and to carry on their fisheries with the same freedom as when they were the sole occupants of the country.

In 1888, when there was a re-examination of the Victoria Treaties, the Company doctor, John Helmcken, wrote a letter to one of the treaty witnesses, Joseph MacKay. Helmcken noted that Douglas had called the Songhees to the fort to give them blankets for land, but he thought Douglas had not given them a choice, just the blankets to appease them

in order that no trouble might arise in case settlers arrived upon the land. Why Douglas should have given such a document as he did is a conundrum. I suppose he had no legal advisor! My impression is, the whole thing had a twofold object: first to gain the good will of the Indians; second to give a quasi title to the Fur trade – for their claims of the ten mile belt around Victoria.

In his reply, Joseph MacKay defended Douglas's actions:

The arrangements entered into … respecting their claims … were made [by] … the Home Government. During Governor Blanshard's incumbency Mr Douglas was Land Agent for the Crown Lands of Vancouver Island. The then secretary for the colonies sent to Mr Douglas … instructions as to how he should deal with the so called Indian Title…. Douglas was very cautious in all his proceedings. The day before the meeting with the Indians. He sent for me and handed me the document [the legal wording of the treaties] … telling me to study it carefully and to commit as much of it to memory as possible in order that I might check the Interpreter Thomas should he fail to explain properly to the Indians the substance of Mr Douglas' address to them.

The South Saanich or Cordova Bay Region

On February 7, 1852, James Douglas wrote up the South Saanich Treaty "between Mount Douglas and Cowitchen Head on the Canal de Arro [Haro], and extending thence to the line running though the centre of Vancouver's Island, North and South". Joseph Pemberton's 1854 map identifies the southern boundary as a line between the summit of Mount Finlayson and the north side of Mount Douglas.

On March 18, 1852, James Douglas wrote the Hudson's Bay Company:

The Steam Saw Mill Company having selected … the section of land marked on the accompanying map north of Mount Douglas, which being within the limits of the Sanitch Country, those Indians came forward with a demand for payment, and finding it impossible, to discover among the numerous claimants, the real owners of the land in question … I thought it advisable to purchase the whole of the Sanitch Country, as a measure that would save much future trouble and expense.

But 80 years later, on April 4, 1932, the Saanich chiefs sent two legal documents to the provincial government stating that they did not recognize the North Saanich Treaty and that the South Saanich Treaty did not pertain to them. The first document was from Chief David Latasse of the Tsartlip Reserve denying any knowledge of the treaties:

The only Knowledge we Know was in regards to a dispute … at the time of James Douglas – that there was a settlement of that dispute (in regards to timber matter) that James Douglas gave four bundles of Blankets, one bundle to Tseycum, one bundle to Tsartlip, 2 bundles to Tseaut…. It was not to sell land or surrender any Territory rights.

The second was a letter signed by all the Saanich chiefs and councillors supporting Chief Latasse's statement:

The four Bundles of Blanket was merely for peace purpose…. The Indians fully understood what was said As it was Interpreted by Mr McKay, who spoke the Saanich language very well…. Mr McKay,… saying these blankets is not to buy your lands, but to shake hands … in good Harmoney and good tumtums (heart). When I get enough of your timber I shall leave the place…. When James Douglas knew he had enough of our timber he left the place.

Referring to the South Saanich Treaty, the letter stated, "We fully know that the parties mentioned on said treaty, What-say-mullets and Holutstun were not members of the Saanichs. Said What-say-mullet comes from Cowichan head, outside of the Saanich Territory. Holutstun comes from the Ganges Harbour." The third person who signed this treaty, listed as "Comey-uks", was James Sqwameyuqs, who moved to Victoria at the invitation of Chief Freezy and later became the Songhees chief.

The Esquimalt Harbour Region

The extent of the territory defined in the Kosampson Treaty depends on what Douglas meant by "Esquimalt". The name is an anglicized version of the name and location of a subgroup of the Songhees peoples, called the Whyomilth, who occupied the head of Esquimalt Harbour near Millstream. Eventually, the name became associated not with the Whyomilth but a group of people in the village of Kalla, which became a part of the Esquimalt Reserve. The present Esquimalt Nation represents of the signers of the Kosampson Treaty. The territory extended

> between the Island of the Dead [Halkett Island in Selkirk Waters] in the arm or Inlet of Camoson and the head of said Inlet embracing the lands, on the west side and north of that line to Esquimalt, beyond the Inlet three miles [5 km] of the Coolquits [Colquitz] Valley, and the land on the east side of the arm, enclosing Christmas Hill and [Swan] Lake and the land west of those objects.

Joseph McKay gave the origin of the word Esquimalt as "from "Swi-mehl-ihl – a place gradually shoaling", first referring to the flats at the mouth of Millstream and later "applied to the harbour". In 1842, Douglas named the harbour "Is-whoy-malth"; the British spy Lieutenant Mervin Vavasour, in 1846, called it "Squimal"; and in 1850 Douglas referred to it as "Esquymalth". In the treaty with the Whyomilth, Douglas said they claimed the territory

> between the north west corner of Esquimalt, say from the Island [Cole Island], inclusive, at the mouth of the Saw Mill Stream and [to] the mountains lying due west and north of that point this District being, on the one side bounded by the lands of the Teechamitsa and on the other by the lands of the Kosampsum family.

The debate continues today on just what Douglas meant by "Esquimalt". It may be that he intended to draw a line from Halkett Island, in Selkirk Waters, west to the entrance of Esquimalt Harbour where military ships had anchored, or to include all of the Esquimalt Peninsula.

This watercolour by James Alden shows Esquimalt Harbour from Mill Hill in 1857. The territory of the Whyomilth family is in the foreground and the Kosampson family above the far shore.
Washington State Historical Society.

The mouth of Millstream Creek – watercolour by James Alden, 1857. To the right of the creek mouth is an archaeological site, likely the village of the Whyomilth people. The roof of Six Mile House peers over the hill above it.
Washington State Historical Society.

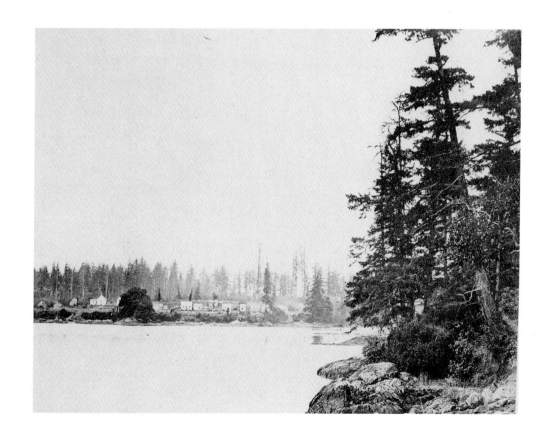

Frederick Dally made this photograph of the Esquimalt Reserve in about 1868 to show the Roman Catholic "Indian Mission".
BC Archives HP94527, F-08503.

VIEW OF ESQUIMALT, VANCOUVER ISLAND, JULY, 1858.

View of Esquimalt: The foreground area is now under CFB Esquimalt naval dry docks. The house in the far background above the beach was a Hudson's Bay Company fur-trading house in the 1850s.
Victoria Gazette; BC Archives PDP000262.

The Swengwhung Treaty

Bordering the territory of a prominent Esquimalt family group, the Kosampsons, is Swengwhung territory, which extended, according to the treaty, "east to the Fountain Ridge, and following it to its termination on the Straits of [Juan] De Fuca, in the Bay immediately east of Clover Point, including all the country between that line and the Inlet of Camoson." In Douglas's earlier prologue is says: "extending east to the Fountain ridge, which their line follows to its termination on the sea coast in the sandy Bay on the east side of Clover point." Fountain Ridge can be seen on Joseph Pemberton's 1854 map (page 28), represented by Smith Hill to the north of Hillside Avenue and west of Cook Street, the high area east of Craigdarrock Castle, and Gonzales Hill.

Problems with the interpretation of this treaty rise from trying to understand what Douglas meant by "the sandy Bay" east of Clover Point. He was probably referring to a large bay then called "Fowl Bay" with two unnamed sub-bays that today we call Ross and Gonzales. Maps of the region by Pemberton (1851–55) show "Fowl Bay" (sometimes "Foul") as including the large bay between Clover Point and what was then called Fowl Point (now Harling Point). It was not until eight years after the Douglas treaties that Fowl Bay was divided and renamed as two smaller bays.

The Swengwhung Treaty also included "all the country between [Fountain Ridge] and the Inlet of Camoson" and

Victoria District. Section I.
LOT Nº 2.

Swamp

FOUL BAY.

Scale 6ⁱⁿ = 1mile.

The eastern part of Swengwhung territory purchased by James Douglas. This map shows the old Fairfield Swamp and creek north of May Street that extended west to James Bay. The large rocky area on the right is where Government House and Craigdarroch Castle are located today.
Hudson's Bay Company Archives,
Provincial Archives of Manitoba,
HBCA Map Collection, H.1/1 fo.6.

"Victoria Peninsula south of Colquits". It is clear that the Swengwhung treaty extends west to include the waters of Victoria's harbours. About 30 years later, Louise Falardeau of the Songhees explained that the Songhees Reserve "is made up of little tribes … the Skween-ghong [Swengwhung] alone originally lived on Victoria Harbour".

The Clallam Village and the Lot 24 Reserve

Today there is a debate about the relationship between two locations on the south shore of the Inner Harbour: the first a village of four plank houses a block west of the Legislative Buildings and the second a proposed reserve on the legislature property.

The group of plank houses was referred to as a "Clallam Village" by the editor of the *Victoria Gazette* in 1858. The village existed from about 1847 to 1855 and contained both Clallam and Sapsom (Kosampson Treaty) people. The Clallam may have located there by right of intermarriage with the Sapsom, or after the Clallam moved here from the Port Angeles area, the Sapsom may have joined them from a village at Esquimalt Harbour.

In 1854, Governor James Douglas intended to establish an "Indian Reserve" where the Legislative Buildings are located. Douglas attempted to define the borders of the reserve, only to have it removed by later government officials. On August 26, he wrote to Archibald Barclay, Secretary of the Hudson's Bay Company:

> I herewith transmit a letter from Mr Pemberton, with a tracing of an Indian Reserve, which has been accidentally omitted in Lot No. 24, Section XVIII, though reserved to them, on the general sale of their lands; they have since offered it to me for sale, but as the cost may be considerable, and I do not want the land for my own use, I declined their offer though I should have no objections to purchase it in part, if the company will take the remainder of the lot. I will probably make some arrangement with the Indians if they dispose of it, on reasonable terms, particularly if any other party should be tampering for the purchase of their rights.

Joseph Pemberton confirmed this in a letter to Barclay on September 1: "In the transfer of the Fur Trade of lot no. 24, Section XVIII. A reserve of 10 acres for the Indians

The four rectangles drawn on this 1855
lot map show the location of the Clallam
village near Laurel Point.

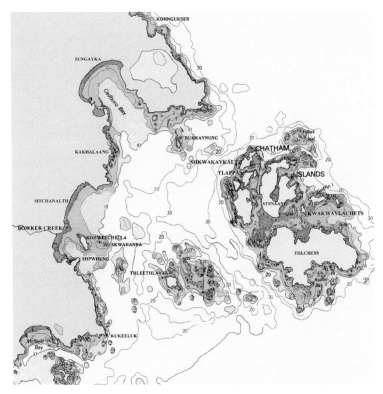

Place names in part of Chekonein territory.
Recorded mostly in 1960 from Songhees elders
Sophie Mary Cecelia Misheal (1891–1970) and
Edward (Ned) Williams (1879–1970). Sophie's grand-
father was Jimmy Chicken, owner of Jimmy Chicken
Island (*Kohweechella*; later called Mary Tod Island).
Ned's parents, Henry and Annie Williams were both
born on Discovery Island (*Thlchess*) around 1860,
where Ned spent much of his life.
Grant Keddie map.

should have been left, as marked on the enclosed tracing,
the lines enclosing this 10 acres are now marked on the
ground...."

An 1855 map also shows an "Indian Reserve (10 acres)"
at that site. Douglas never mentioned which First Nations
group he talked to, but it is obvious that Lot 24 was
reserved for a group of people "on the general sale of their
lands". Although the treaty for the area that includes this
site clearly pertains to the Swengwhung people, we cannot rule
out the possibility that Lot 24 had been set aside for the
occupants of the nearby village.

A rare account of this village was given by a woman
named Mary Anne James (Sitlamitza), who was born there
in the late 1840s. Mary Anne's uncle was Seesinak (Say-
sinaka), one of the signers of the 1850 Kosampson Treaty;
his descendants include Joe Sinopen (b. 1863) and Edward
Joe (b. 1885), both chiefs of the Esquimalt Nation.
According to James, her uncle asked Douglas for a reserve
in one of their old village sites at Esquimalt Harbour.

The Chilcowitch and Chekonein Treaty Areas

The Chilcowitch Treaty is one of the smallest. It includes
the lands "between the Sandy Bay east of Clover Point, at
the termination of the Swengwhung Treaty line to Gonzales
Point, and thence north to a line of equal extent passing
through the north side of Minies Plain". The Chekonein
Treaty is one of the largest, extending east and north of
Gonzales Point to Mount Douglas.

It is likely that a large group of people once living at
McNeill Bay splintered into two groups. One of these
moved to Gonzales Bay and became the Chilcowitch.
The remaining Chekonein later moved north, likely to
Cadboro Bay.

McNeil Bay on the southern shore of Chilcowitch territory. Archaeological midden deposits extend around the entire back of the bay. Village debris in the deeper deposits just beyond the house in the foreground are about 500 years old. Oral history states that the Chilcowitch people lived here, but later moved to Gonzales Bay. Their name derives from *Chikawich*, meaning "big hips", after the shape of the bay. Beyond Anderson Hill (centre) lies Gonzales Point, which was called *Kukeeluk*, the "place of war". BC Archives HP090809, G-05586.

This Songhees village on the northwestern corner of Discovery Island shows a mix of traditional and modified European-style houses and canvas tents. There are two villages on Chatham Island in the background. RBCM PN6838.

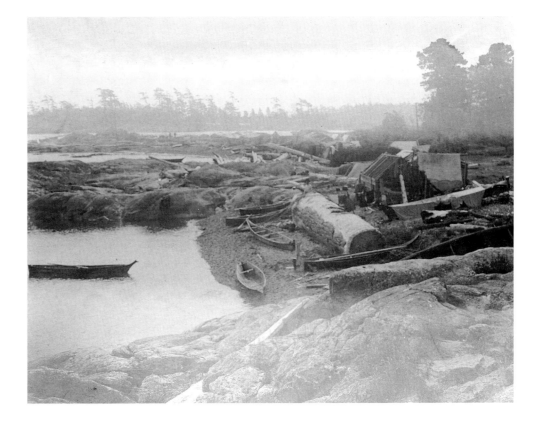

In 1856, the population of the Chekonein people was 190. Maps from the 1854–55, period show three big houses at Cadboro Bay at a time when many members of this group are assumed to have moved onto the old Songhees Reserve. This suggests that some outside groups must have moved into Cadboro Bay after 1842. The Chekonein had a high proportion of children to adults (125 of the 190) which could account for some but not all of the population growth. The Sitchanalth people of Willows Beach were within the treaty area and may have been one of the groups to move to Cadboro Bay. Other sources of new population may have been the village of Kwatsech at Gordon Head or related Skingeenis people from the Discovery and Chatham islands – the Chekonein boundary extended to Haro Strait and therefore included these Islands.

The Teechamitsa Treaty Area

The Teechamitsa Treaty of April 29, 1850, includes the area "lying between Esquimalt Harbour and Point Albert including the latter, on the straits of Juan de Fuca and extending backward from thence to the range of mountains on the Sanitch Arm about ten miles distant."

The census dated 1856, which may have been taken during the treaty of 1850, refers to a population of 51 "Teechamit": 11 "Men with beards", 10 women, 16 boys and 14 girls, all in the Teechamit family. One group of people known to exist in this area lived at Albert Head Lagoon. These may be all or part of the Teechamit family but there is no written evidence directly connecting them. It has been suggested that this is the group called the Stsanges from which the name *Songhees* derived. In 1893, elders did use "Songhees" to describe those at Albert Head.

Albert Head Lagoon is the only place the village of the Stsanges people would have been. There is evidence of an old village at the back of the spit and a neighbouring defensive site on a bluff at the northwest corner of Albert Head. In 1859, a saw mill at Albert Head Lagoon burned down and the *Victoria Gazette* reported that some aboriginal people "who camped there recently, had caused the conflagration by their campfires". This was likely a group of Albert Head Songhees who had moved elsewhere but returned seasonally to their old village site.

Portion of a survey map made in 1846 by Captain Henry Kellet. He marked one of the villages at Becher Bay ("Indian Lodges") of the people who were to become the representatives of the Kakyaakan Treaty of 1850.

The Kakyaakan and Chewhaytsum Treaties

The treaty places the Kakyaakan family between Albert Head and Pedder Bay. The archaeological evidence indicates that people living in this area would have concentrated in two locations: one in the Witty's Lagoon area where there is a large shell midden along the spit and two small middens at defensive sites; and the other at a defensive site above Taylor Beach, where the symbol for a village is marked on a Spanish map of 1791 (page 17).

The Kakyaakan were likely living in Victoria in the mid 1840s and appear to have moved to Witty's Lagoon in 1851 – the year a lodge first appears on a map of the lagoon spit. This same lodge can be seen on the high end of Witty's Lagoon spit on a map of the Metchosin District dated September 26, 1853, clearly marked "Indian Village". Local

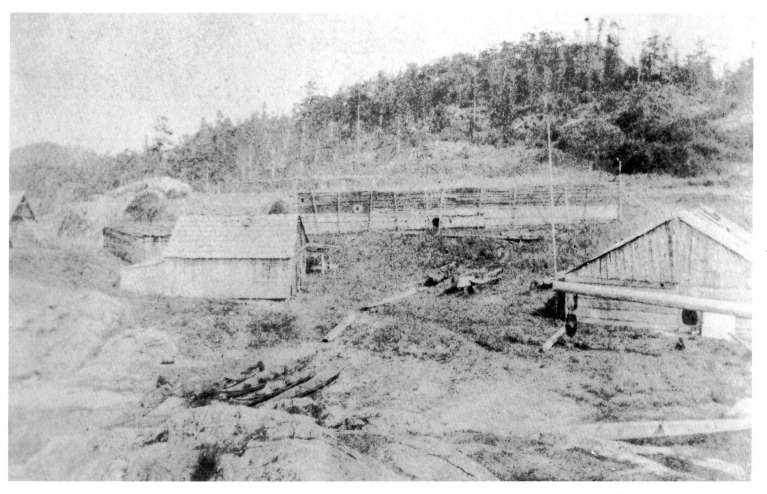

The Becher Bay village in 1865, later
known as Becher Bay Reserve No. 2.
Washington State Historical Society.

settler Martha Cheney mentions visiting this village in 1853–54. While living at Witty's Beach, Chief Klay-akum began sharing with a T'Sou-ke uncle a salmon reef-net location west of Becher Bay and, by 1858, established his main village north of the important Smythe Head reef-net station on the east side of the bay.

Henry Kellet's 1846 map (page 56) shows the location of this village, composed of two houses and potato patches near Smyth Head and further east near Church Hill. An 1870 map shows seven houses at this location – the increased population was likely due to the commercial salmon industry that developed in the area. William Banfield observed in 1858 that Becher Bay was one of the best salmon stations on Vancouver Island, with four to six hundred barrels of salmon taken every year, as well as dog-fish oil. He refers to an "Indian trail" at Becher Bay that "takes one to an encampment on the southern extremity … there are about one hundred and fifty Indians living here; a portion of the Clalam tribe".

At Becher Bay the Kakyaakan intermarried with Clallam visitors from Port Angeles, whose language dominated, and they became part of the band known as the Scia'new. When Indian Commissioner Malcolm Sproat visited the Smyth Head area in 1877, he confirmed, "these Indians are the representatives of the signers of the 1st of May 1850, between the Chiefs of the family, Ka-ky-aakan, Metchosin District and James Douglas".

The Kakyaakan had the right to move permanently to Becher Bay by right of their marriage relationships with the T'Sou-ke and appear to have made the Village Island village their main winter village before 1858.

The Kakyaakan once spoke a language more closely related to Songhees and T'Sou-ke than to Clallam. The Becher Bay people who call themselves Scia'new today are the representatives of this earlier population. Their history is confused by intermarriage with the T'Sou-ke and with Clallam people who settled in territory that was once part of the larger area controlled by the T'Sou-ke.

The Chewhaytsum people occupied the area between Pedder Bay and Sooke Inlet. They were a Clallam group called Tse-whit-zen, from the village of the same name near Port Angeles. Some of these people were related to the T'Sou-ke. Douglas's 1856 census shows 30 men with a total population of 177 people.

The T'Sou-ke People

In the early 1800s, all of Becher Bay appears to be in the territory of T'Sou-ke people. These related family groups lived in the area from Pedder Bay to north of Sooke Harbour. To the east of the T'Sou-ke lived the related families who spoke the Lekwungen language.

The Hudson's Bay Company records identify 50 "Soaks" men in 1827, making the actual population about 285 (based on the 1850s census ratio of 1:5.7 men to women and children – see page 17). This was a considerable decline since the figure of 500 given by the Spanish for Sooke Harbour in 1790. Population lists for 1841 and 1848, covering the area from "East Point of San Juan to the Songes territory", show just 100 people.

According to the Muir family, who settled in Sooke in 1850, in about 1848 the T'Sou-ke were "nearly annihilated" by Cowichans, Clallams and Ditidahts. It may have been after a T'Sou-ke chief was killed leading an attack on the Cowichan (see page 38) that the T'Sou-ke were attacked on their own territory. T'Sou-ke elders told anthropologist Diamond Jenness in 1934 that their people had been continually raided by American First Nations and that small pox "carried most of them off" before the big raid in 1848 that devastated them.

The areas between Pedder Bay and Sooke Inlet appear to have been largely vacated after this population reduction and then reoccupied by mostly Clallam peoples. Censuses show that a large number of people immigrated to the area in the late 1840s to quadruple the population by the time of the 1850 treaties and the census of 1856.

Later the people of Sooke and Becher Bay lost many more men when the sealing schooner *Walter Earl* sank in 1895: six men from Becher Bay, one from Rocky Point and five from Sooke drowned when the schooner went down, along with twelve from Victoria who were likely relatives. The Department of Indian Affairs report for that year claims "only two able-bodied men were left" at Becher Bay. The women and children stayed on and managed to make a meagre living by selling fish in Victoria.

8
First Attempt to Remove the Songhees, 1858–59

On June 15, 1858, the United States and Britain began a dispute over possession of San Juan Island, and the following year, the Americans stationed troops there. Victoria newspapers called it the "San Juan Excitement", because the presence of American troops so near made the citizens of Victoria nervous. Even more unsettling were fears of an "Indian War" as violence continued between southern and northern First Nations, mostly among the visitors.

Magistrate Joseph Pemberton took drastic measures in the summer of 1859, when he began what the *British Colonist* called "a novel method" of cropping the hair of those charged with "trivial" offences – "the Indians consider this a great outrage … and are ashamed to show themselves before their people until the hair grows out". On September 12, the police ordered First Nations camped at the north end of town to leave, but they refused to go. The *Colonist* complained about the government's lack of action, claiming that property in the area of the encampments was becoming "quite valueless".

In the spring of 1859, the problems brought on by the influx of northern visitors combined with the desires of land speculators and business promoters initiated the first attempts to remove the Songhees Reserve. Governor Douglas and a small group of supporters faced a strong group wanting to ignore aboriginal rights and forcibly move the Songhees off the reserve. The philosophies expressed by the opposing factions in the non-aboriginal community at this time set the stage for the events that were to affect the Songhees Reserve for the next 52 years.

In 1859, a small number of colonial landowners elected the first House of Assembly in Victoria. It became the only legal voice of opposition to the policies of Governor Douglas and his appointed Colonial Council. The first major issue debated in the House concerned the Songhees Reserve. Between January 15 and February 15, James Yates led the opposition voices calling for the removal of the Songhees from Victoria Harbour.

Yates asked if the colonial government had the power "to remove the Indians (by purchase) from that piece of land in Victoria Harbour". On February 8, the house speaker read out Governor Douglas's reply:

> Previously to the grant … to the Hudson's Bay Co. the whole island was vested in the Crown…. When the Settlement at Victoria was formed certain reservations were made in favour of the native Indian tribes. They were to be protected in their original right of fishing on the coasts and bays … and of hunting over all unoccupied Crown lands; and they were also to be secured in the enjoyment of their village sites and cultivated fields…. For that reason the Government will not cause them to be removed, because it is bound by the faith of a solemn engagement to protect them in the enjoyment of their Agrarian rights…. Further … the Title of those Lands is vested in the Crown, and that the Indians of themselves can convey no Title to any part of their Reserves either by sale or lease.
>
> The presence of the Indians so near the Town is a public inconvenience, but their violent removal would be neither just nor politic. I therefore propose … to enter into arrangements with their consent to subdivide the Reserve … [and to lease] to persons who will undertake to build and to make other improvements upon it, and to apply the whole proceeds … to the general benefit of the Indians … by providing them with a School House and Teacher,… and to endeavour thus to raise them morally and socially to a higher position…. By such means a great benefit … will be conferred upon the Indians themselves.

James Yates, who had become the main spokesman for those seeking removal of the reserve, responded with a simple plan: "the Indians ought and could be removed by purchase to another reserve and then the present reserve sold and the proceeds devoted to improvements in Victoria." He proposed that the reserve be divided into lots and "sold

This five-part panorama (frame 5 is on page 62), made in about November 1859, is the oldest photographic view showing the old Songhees Village in relation to the town of Victoria, across the harbour. On the far left in frame 1 is the second Johnson Street Bridge, which was torn down two years later to prevent the Songhees from having easy access to Victoria (it was not rebuilt until 1886). Among the old-style plank houses on the near shore is the peaked roof of a small European-style house (1, left) that was associated with a ship-building lease. Across the water, in frame 3, all the structures of Fort Victoria are still intact. The new James Bay Bridge and Legislative Buildings are in frames 4 and 5 (p. 62). BC Archives HP14365 F-09563, HP014366 F-09564, HP10606, HP014368 F-09566 and HP014369 F-09567.

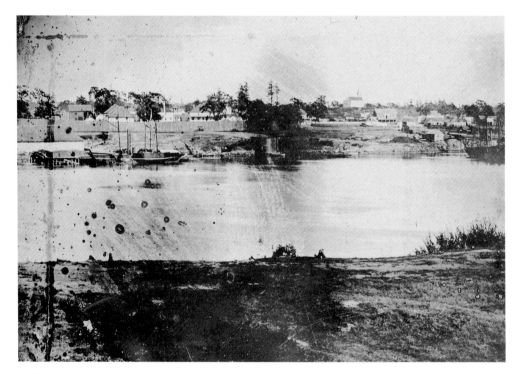

1

3

2

4

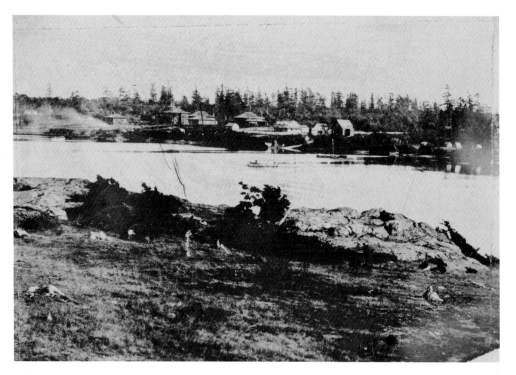

5

to the highest bidders without delay", and that the governor immediately remove the northerners from Victoria.

House member Joseph McKay defended Douglas's more humane approach, adding that he did not think "committing a robbery upon Indians the most praiseworthy method of making improvements."

On February 15, Yates revealed his true feeling about First Peoples when he declared them "a nuisance often insulting to the modesty of females or families". He called Douglas's proposition

> absurd, because whilst the Indians remained in a position where spirits could be so easily be had, nothing could be done in the way of civilising them; besides the income derived from the sale of part of the reserve … would bring in an enormous income, which would only be wasted … [and] the Indians would have such an idea of the value of land that hereafter their title could not be extinguished by this means.

More of Douglas's House of Assembly allies spoke up. Joseph Pemberton pointed out that it was: "only now that these lands had become valuable, that the Indians were found to be a nuisance; if bad spirits were the cause of preventing the improvement of Indians let the grog shops be removed." John Helmcken considered Yates motion "a gross insult and if agreed to would be a lasting disgrace to the House."

On February 24, 1859, a strong editorial in the *Victoria Gazette* titled "The Removal of the Indians" stated:

> No one can fail to see the policy of the Hudson's Bay Company heretofore in relation to the savages – however well suited it may have been to past circumstances, must be materially changed to meet existing and future contingencies…. The majority of the Indian women, who, in consequence of the vicinity of the Reserve, are daily seen in our streets…. This tribe should therefore be removed, and strict regulations adopted in regard to the visits of Northern Indians.

The newspapers published news of every incident involving aboriginal peoples. On March 3 they reported minor complaints about Haidas stealing turnips from Mrs MacKenzie's garden and chickens from Finlayson's farm, as well as the killing of an ox.

That same day, the House of Assembly, responding to an communication sent to Douglas on the subject of leasing the reserve and "allowing the Indians to continue upon the remainder", complained that Douglas's plan would lower the value of the land and result in cheap temporary housing on the reserve. Its members worried that when the Songhees "become extinct, which will probably be the case in a very few years", the reserve would become the property of the Crown instead of the Town of Victoria. It also suggested that the growth of the town around the reserve would prevent "civilising the Indians, it being a well-known fact that the presence of large numbers of white men among Indians has the effect of rendering the latter more vicious". And it expressed concern that the reserve would continue to attract large groups of neighbouring First Nations "prolonging the existence of the present Indian Village, which ought by every means to be avoided".

The House of Assembly proposed negotiations with the Songhees to move them "to some other suitable spot … Belle-Vue [San Juan] Island for instance." After the parties agreed to sell the reserve "with the exception of the water frontage and portions for public purposes", the proceeds would go to the colonial government, except for the building of a school and the cost of the survey. Interest on the money collected from property taxes for a period of 20 years would go to the Songhees, but the proceeds of the sale and rental of water frontage would be dedicated to harbour improvements, removing the Victoria Bridge and building a new bridge at Point Ellis.

If the government refused to adopt this plan, the House called for the removal of the Victoria Bridge to "thus at once isolate the Indians as well as lay open a portion of Victoria Harbour possessing every convenience for Shipping & having a frontage better adapted for wharves & of greater extent than those of the Indian Village."

Douglas's Policy and Reserve Rental

Governor Douglas successfully defended this attempt to move the reserve, and on March 14, 1859, outlined his policy for First Nations in a letter to the British Secretary of State. Douglas saw the settlement of aboriginal peoples on reserves as a way of protecting them from the "aggressions

of immigrants". He reiterated his belief that the proceeds from property rentals on the Songhees Reserve should be for the "exclusive benefit" of the Songhees. He indicated for the colony in general:

> I feel much confidence in the operation of this simple and practical scheme, and provided we succeed in devising means of rendering the Indian as comfortable and independent … there can be little doubt of the ultimate success of the experiment.
>
> The support of the Indians will thus, wherever land is valuable, be a matter of easy accomplishment, and in districts where the white population is small, and the land unproductive, the Indians may be left almost wholly … to pursue unmolested their favourite calling of fishermen and hunters.

Douglas wanted reserves to be entirely self-supporting. He strongly opposed the American system that kept First Nations

> in a state of pupillage, and not allowed to acquire property of their own, nor taught to think and act for themselves, [because their] feeling and pride of independence were effectually destroyed; and not having been trained to habits of self-government and self-reliance, they were found, when freed from control, altogether incapable of contributing to their own support.… I think it would be advisable … to cultivate the pride of independence, so ennobling in its effects.

Douglas proposed that each family be given their own portion of the reserve to cultivate "as their inheritance", but with no power "for the present" to sell or alienate the land. Families should be encouraged to buy more land off the reserve that would be left at their own disposal and "they should in all respects be treated as rational beings, capable of acting and thinking for themselves".

The plan began with the lease of Hope Point for a foundry and machine shop. According to Joseph Trutch of the Colonial Land Department, this lease was executed by Donald Fraser "entrusted by Governor Douglas with the management of this reserve, but without any formal commission". One of the first lists of renters, dated June 15, 1859, shows several three-year leases for $100 each.

The Royal Victoria Hospital

On February 19, 1859, Governor Douglas arranged with the Songhees to erect a general hospital on the reserve on the condition that it would serve both aboriginal and non-aboriginal patients. Its main purpose was to provide more efficient treatment of infectious diseases and help prevent their spread. Douglas set up a provisional Royal Victoria Hospital Committee of 14 persons, chaired by Alexander Dallas, a Company director, and including the surgeons, J.S. Helmcken, H. Piers (of HMS *Satellite*) and H.A. Tuzo. The hospital was to be paid for by public donations and the government would provide assistance in the "conduct of the institution".

Douglas appropriated $2000 for the construction, which began on March 26, just north of Songhees Point. The two-storey wooden building was to accommodate 20 patients. A house was later built for the resident doctor, and during the 1862 smallpox outbreak, two temporary buildings were built on the property behind.

The Royal Victoria Hospital operated on the reserve until 1869; in 1872 it was re-opened as an "Asylum for the insane" until 1878.

Burial Grounds at Halkett Island

Halkett Island, in Gorge Waters just south of Selkirk Trestle, is first mentioned in the 1850 treaties as "Island of the Dead", and marks the boundary between the Kosampson and Swengwhung areas. On early maps it is called Deadman's Island.

The *Victoria Gazette* described the Halkett Island burial site on October 5, 1858:

> The Songish tribe have another much larger repository for their dead, which is used at the present time. It is about three-fourths of mile [1.2 km] above the Victoria bridge, on a small island, and only accessible with canoes. Many rude carvings can also be seen there, as well as piles of canoes, fragments of boxes, blankets, and every … household article.… The corpse is packed in a box,… and covered down. The nearest friends then carry it to a canoe … which is prepared for the purpose.… Canoes proceed … to the appointed place, which is always a detached spot some distance from the village.

Special feeding-the-dead ceremonies took place on Halkett Island:

> Canoes have been observed to come frequently about twilight … where a fire of sticks is kindled, and occasionally gum-wood and other combustible material are thrown on to it so that it burns till after midnight, till which time the Indians keep up an incessant [sound], that can be distinctly heard for a mile.

In 1867, Edgar Fawcett and three other boys swam to Halkett Island to play there. They lit a fire with broken coffin pieces and accidentally set the island on fire. Two of the youths were charged and heavily fined. Later, in his reminiscences, Fawcett described the island as covered in trees and shrubs, and in the trees were corpses "fastened up in trunks and cracker boxes … the bodies being doubled up to make them fit in the trunk". Some were also buried in the shallow soil and surrounded by fences, and "boxes of corpses were piled one on top of the other."

The island has caught fire many times since then, most recently in 1993, the year it was restored to the Songhees after being removed as a reserve in 1924 by the Federal Indian Reserve Commission.

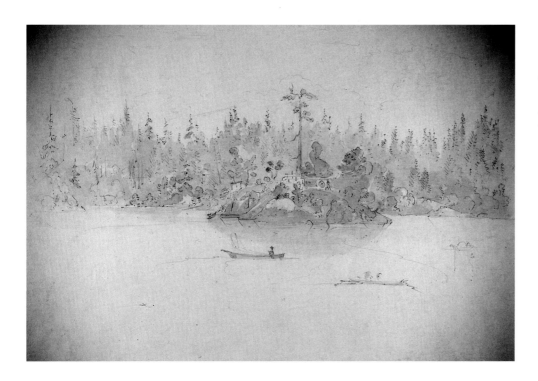

This watercolour by James Alden, June 26, 1857, shows burial houses and carved wooden figures on Halkett Island. Washington State Historical Society.

9
Trouble in the Camps, 1860–61

On January 17, 1860, Songhees Chief Freezy (Chee-ah-thluc) invited Bishop George Hills, Bishop Edgar Cridge and Magistrate Joseph Pemberton into his house. Bishop Hills describes the Songhees village as having about 20 wooden plank houses, each about 50 square feet (4.6 square metres), with leaky roofs. Freezy's dwelling "was partitioned off, the front open to the inside. On three sides were recesses, under a sub-roofing … in which were layers of matting for beds. In the centre was a small wood fire, at which were two women and a little boy.… Three friends, the councillors, came in, wrapped in their blankets."

Pemberton interpreted in Chinook Jargon – a trade language composed of words from several aboriginal languages, English and French. The visitors noted that the women of the house were making a rope. In other houses, women "were making mats, weaving rushes and grass". Hills was impressed with their "industrious character". One woman, he noticed, had bracelets, and many finger rings. The bishop reported that the Songhees

were glad anyone would be their friend & do them good & they would like to be educated & have better houses. They heard it said they were going to be removed. This grieved them much. What could they do if sent away? Now they could get work & dollars & food, but if sent away they must starve. They also were constantly in fear of … the Hydas who were allowed to be near them. They wished these to be removed away.

In the Camps of the Northerners

So the 1860s began peacefully enough, despite the growing violence of the last two years. But this was just an illusion, for two more years of turmoil descended from the north upon the First Peoples and colonists of southern Vancouver Island. The colonists' concern was expressed most strongly in a *Daily British Colonist* editorial of April 18, 1861:

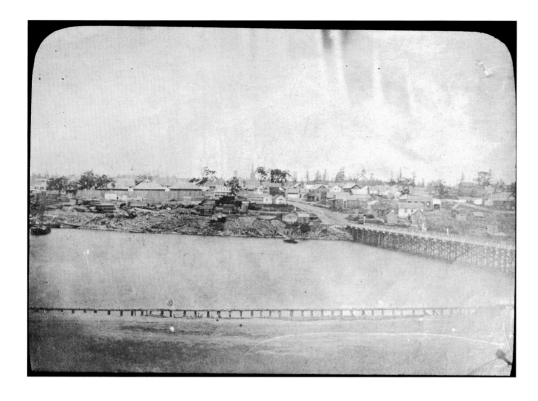

View of the town of Victoria and south side of Fort Victoria photographed by Captain Richard Roche in about January 1860. This is the fourth of a five-part panorama that Roche made from the top of the old Legislative Buildings, looking north across the recently built James Bay Bridge. Lantern slide, RBCM PNX529.

Panorama of 1860-61: this lithograph was made from four photographs by George Fardon. The house on Songhees Point (facing page, foreground) is a recent design based on the European style, but made of woven rush mats and wooden planks. The original colour lithograph appeared in *The Illustrated London News*, January 18, 1863. Grant Keddie collection.

The Victoria "Indian Mission School"

In 1860, James Douglas asked missionary William Duncan to come to Victoria to help control the annual migration of northerners and the resulting violence among First Nations camped in and around Victoria. He invited the local religious leaders to a meeting on July 10 to organize the building of a Mission School. The *Colonist* reported that meeting was for the purpose of "ameliorating the condition of the Indians, who are living in the vicinity of this town. ... and call forth their good qualities, and to impart into them that Gospel of which we are the favoured possessors."

The group invited donations from the local community for an "Indian Improvement Account" – Governor Douglas and Captain James Prevost contributed large personal donations.

Reverend Duncan oversaw the construction of the school and church, and Reverend Alexander Garrett applied to Douglas for 15 acres (6 hectares) on the Songhees Reserve for Church purposes. Colonial Secretary William Young indicated the Crown had no objection to building the school and residence, but it must not be "construed into a pledge on behalf of the government with respect to any further disposition of the land question" (that is, it would remain reserve land).

The Mission opened its doors on August 10, 1860, and mainly Tsimshian people attended the first services. On August 19, Bishop Hills wrote:

> The Songhees are jealous of the special attention ... paid recently to the Tsimshian. There were two Songhees present today.... They said those Tsimshian would go away & not understand what they had heard, but that if the Songhees were instructed they would understand all that was said.... So we are to have a gathering of that tribe the next time. There is some truth in what they said, as no doubt the Songhees do understand the Chinook better than the Tsimshian.

On August 26, the "two chiefs Freesy & Jim [Sqwameyuqs] & adults", came to the church, with about 35 children.

Reverend Garrett managed the Mission School for about eight years with the assistance of two European teachers and a First Nations policeman.

The Mission School is on the hill in the clearing above the reserve village.
Close-up from *Bird's Eye View of Victoria* (p. 106).

Invasion of the Northern Indians

… Every year since 1858, the town and country around Victoria has been overrun by Russian, Queen Charlotte Is., Fort Rupert, Fort Simpson, and Northwest Coast Indians. On their passage down and up they have been a perpetual source of terror to the settlers on Salt Spring Island and Nanaimo.

The events of the next two years had a serious impact on the Songhees and contributed greatly to the colonists' view of First Peoples in general, which would last for many years afterward. The following chronology is a sample of reports on the conflicts among the many First Nations gathered on and around the Songhees Reserve. Most are from Victoria newspapers (mainly the *Victoria Gazette*), as are the unattributable quotations.

February 28, 1860: About 500 Bella Bella (Heiltsuk) arrive and set up camp near Laurel Point. Many people go to the camp to buy their hand-made articles.

On March 8: A *Colonist* reporter, writing on the liquor trade, visits the Haida encampment "about half a mile across the Esquimalt Bridge" and recommends that the police disarm these people. Two days later, the police go there to arrest a Haida couple but are chased away.

March 24: About 500 Fort Rupert Kwakiutl arrive.

March 30: A Haida chief named Geesh is killed by two Cowichans or Songhees. In revenge, the Haida kill a Songhees woman and Chief Freezy promises vengeance. Days later, an older Songhees man, whose daughter was married to a Haida chief, walks over to the Rock Bay camp to attempt to bring about peace. The Haida invite him into a lodge where one of Geesh's relatives stabs him. "He died instantly, and a rope having been placed around his neck, the body was drawn to the water and thrown in. It floated down to the Songish encampment". The Songhees and Haida fire on each other all through the night. A Cowichan woman captured in town is "brutally murdered with a knife in the hands of a brother of 'Geesh' in the presence of a large number of Indian spectators". Expecting the imminent arrival of a large number of their friends, the Haida threaten to exterminate the Songhees.

April 3: Sixty-five canoes arrive from Fort Simpson bringing 600 Tsimshian men and women who camp on the reserve at Hope Point. They have been travelling for ten weeks "laden with valuable furs". By now, the Haida have avenged the murder of their chief by killing a Songhees "chief". But "a great fight" is anticipated, with large reinforcements of Haida and Cowichan arriving in town.

April 4: A Songhees kills a Haida in his house. Fifty-four canoes of Haida and Stikine enter the harbour.

April 30: A Haida named Taw-an is sentenced to three months at hard labour for having his people beat up the police officers who tried to arrest him for stealing clothes.

May 18: A Bella-Bella woman is stabbed. The *Gazette* describes the Bella Bella as the most peaceful and "well conducted" of all the visiting tribes; their camp represents "an agreeable contrast to those" of the Haida and Tsimshian.

May 26: Kawdede, a 23-year-old chief of the Tongass Tlingit, cuts the dog of a Haida named Captain John. John orders "his Cowichan slave to shoot the Tongass", seriously wounding him. Kawdede is the "son of the most powerful Chief on the Northern coast".

May 27: A Stikine boy is found with his throat slit. Fighting breaks out and continues into the night.

May 30: Kawdede remains in the Royal Victoria Hospital in serious condition. Believing war would ensue if he dies, the Haida offer his friends "12 slaves and plenty of blankets", but Chief Kawdede's friends refuse them.

May 31: Kawdede dies and is buried. His family releases his Haida slave girl as an insult to his enemies.

June 7: A ten-year-old Songhees boy is found dead, believed killed to avenge the death of the Stikine boy. The Stikine chase a Songhees man away from a watering spring and fighting breaks out, with the two groups "burning powder and wasting ball … at a great rate". Seventeen canoes of 200 Tsimshian arrive from Fort Rupert and camp at Hope Point near their "friends", the Songhees.

June 11: Many more Haida arrive in the harbour and the fearful editor of the *Colonist* warns readers that "over one thousand warriors are on their way down.… The jail will certainly have to be enlarged … as these Hyders are the worst vagabonds on the coast, and are always up to mischief."

June 20: A Haida is shot at the Rock Bay camp, renewing

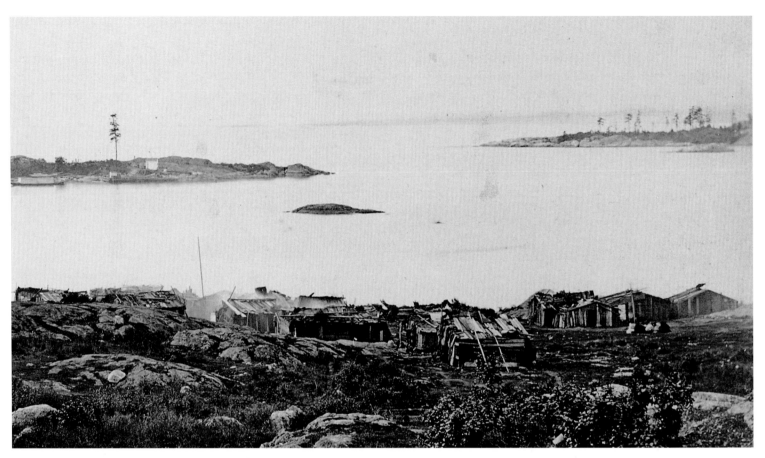

Haida encampment on the Songhees Reserve southwest of Mission Hill (now near the intersection of Kimta and Songhees roads). Most Haida continued to camp at Rock Bay until 1860, when they were moved here. This camp was burned down during the smallpox epidemic of 1862, but rebuilt, as shown here, in 1864. Arthur Vipond photograph, BC Archives HP97976, H-1497.

hostilities with the Stikine and Tongass Tlingit. A Haida then shoots a Tsimshian, and Captain John prepares for a siege by "throwing up earth-works" and "building barricades". Over the next week more people are killed on both sides.

June 22: Governor James Douglas assembles about 60 First Nations leaders at the government buildings. With Reverend William Duncan as interpreter, Douglas tells them he does not approve of their behaviour and will tolerate no more violence. The *Colonist* later reports:

> They were then told that a change would be made in their situations here; that places would be allotted for their residences; the tribes would be kept apart; a poll tax levied on each person of so much a month to support a police; and that they must erect suitable houses on the reservations [sic], under the instructions of an Indian Agent.

At this meeting, the Tongass complain about the murder of Kawdede by Captain John and his brother. Douglas orders the arrest of the Haida men.

June 24: Police search the Songhees camp for the murderer of a Fort Rupert Kwakiutl chief. The Songhees give the Kwakiutl 20 blankets and $10 in compensation for the murder, but this is not enough and the Kwakiutl throw the blankets into the water.

June 26: The papers announce that the Haida, Tsimshian and Stikine Tlingit "will be removed … to a point more remote from town. The Colonial surveyor was busy yesterday selecting plots of ground on which to locate the three tribes."

June 27: The Haida move "to a point back of the Royal Hospital" (west of Songhees Point where some Haida are already located). The Tsimshians "will be placed further up the arm of the bay, at about half-a-mile beyond their present encampment" (the north end of the reserve in Selkirk Waters).

June 30: After some Haida fire on a passing schooner, marines and police enter the Haida camp and publicly lash the offenders.

July 3: Police return to the Haida camp to arrest Captain John and his brother for the murder of the Tongass chief, Kawdede. The two Haida fight with the police and both are killed; Haida witnesses confirm that Captain John provoked the fight. But fearing an

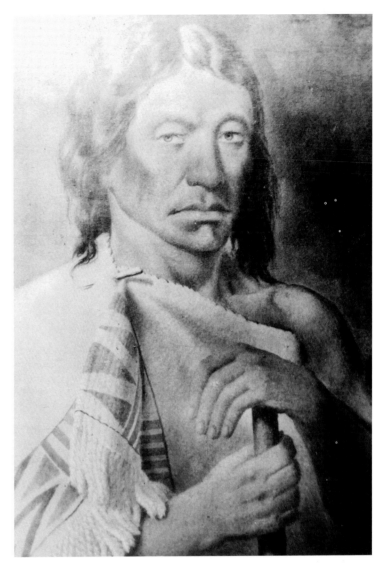

"Che-a-Clack", Chief of the Sangeys – oil on canvas by Paul Kane, 1847. Chee-ah-thluc was a prominent member of the Chekonein family of Songhees from Cadboro Bay, who signed a treaty with James Douglas in 1850. He was chief of the Songhees from the 1840s until 1864. Chee-al-thluc adopted the popular name "Freezy", in reference to what Roderick Finlayson called his mop of frizzled hair that he inherited from his Hawaiian father. (See page 93 for more on King Freezy.) Reproduced as a lantern slide, from private collection, for Charles Newcombe; RBCM PN9604.

This six-part panorama features views of the southwest bastion and the interior of Fort Victoria between April and November 1860. On the far left (in frame 1) is the corner of Wharf and Yates streets. The tall brick building (frame 2, left background) still stands today at 536 Yates Street. The Methodist Church spire (frame 2, right background) marks the southwest corner of Pandora and Broad streets. At Bastion Square (frame 3), two groups of First Peoples sit outside the court house, the brick building with turrets; First Peoples, mostly from the north, often gathered in the square during the sentencing or imprisonment of relatives. The open gate in the wall of the fort (frame 6) is now the location of Fort Street. (Despite the credit appearing on frame 1 (bottom left), this panorama was not made by Richard Maynard, who did not begin photography in B.C. until 1864. The real photographer is unknown; later, the Maynards sold these images from their Victoria studio.)
BC Archives A-4656 HP12178, A-3461 HP9495, A-2640 HP7873, F6691 HP7813, A-4099 HP10602 and A-9088 HP10604.

1

4

2

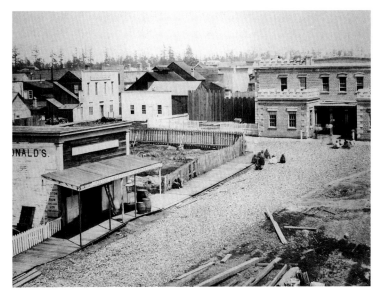

3

5

6

uprising, Police Commissioner Joseph Pemberton calls for volunteers to patrol the town, and deputizes members of the local fire brigades. Soon after, Governor Douglas informs other high-ranking Haida that all canoes entering the harbour will be stopped and searched, and that all arms found will be confiscated and kept safe for the owners until they leave.

July 3: The papers report that the Fort Rupert Kwakiutl, having left Victoria after the murder of their chief by a Songhees (June 24), "have murdered or taken captive every Cowichan Indian they came across" while on their way home. They apparently killed two Cowichan on Salt Spring Island and four more on the coast who were digging for clams. A few days later, the Cowichan surprise some Kitamat near Salt Spring Island, killing eight men, wounding the chief and capturing two women. Because one of the women is the daughter of a "great cannibal chief, and ranks very high in their estimation, a large potlatch will be offered for her, about a hundred blankets is said to be her ransom".

July 6: A brother of Chief Freezy, referred to as Cow-quail on the prisoner list and "Dick a Songhee" by the local newspapers, is sentenced to death for murdering the Fort Rupert chief. He was arrested a few days earlier "at a lodge near Mr Yates farm".

July 10: The papers express fear "that an Indian war is imminent". The *Gazette* reports that the northerners gave up their guns "quite willingly" to authorities when they obtained a receipt for their return.

July 20: Governor Douglas summons the northern chiefs and proposes giving each a paper empowering them to arrest and bring to the jail all First Nations who commit offences in the camps. They agree and are commissioned to act as special policemen. The reserve already has a lone "Indian Constable" named Le-qui-tush (John Clark), who is paid $5 a month. His appointment likely resulted from the Songhees complaining of "bad white men" living on the reserve.

July 26 and 30: The *Colonist* praises the First Nations police, especially for arresting a "notorious whiskey seller". The reports mention officers "Edensah", "Canary", "Sir Robert Peel" and "Winnets".

August 2 to 4: Thirty canoes of Haida enter the harbour and sixty leave; authorities return muskets to those departing. A thousand northerners are camped at Nanaimo on their way to or from Victoria.

August 23: Haida from Gold Harbour who began camping in "the vicinity of Major Bay [Fisherman's Wharf] and Laurel Point" are asked to move across to their allotted area on the reserve.

August 26: After "Indian Fighting" at the Haida camp and on Waddington Alley, the *Colonist* reports the failure of the First Nations police force. "All but old Edensah have thrown up their commissions and become as great rowdies as the common folk of the tribes."

September 1: The northerners are "leaving in large numbers for their homes.... The chief of the Hydahs, blind Paul Jones, is down again, and will remain, with a considerable number of his tribe, all winter."

September 5: A posse of police demolish about 40 lodges at the Stikine and Gold Harbour Haida encampments. The report notes that quite a number of those ordered away held jobs as household servants in town.

October 4 and 11: On visiting the northerner's encampments, Bishop George Hills is "struck with the large number suffering from disease"; then he observes a "sad amount of drunkenness in the camp" and a "melancholy case" where Haida Chief Edenshaw brought a "very powerful man down here, whom he had taken captive" and whose men later killed him with alcohol.

December 20: The *Colonist* reports the arrest of "Hydah Joe and friend Charley" for stealing from a store under the headline: "A Notorious Indian Rascal Again Caged". The newspapers often used exaggerated titles in reporting the arrests of aboriginal people.

February 21 and 26, 1861: The *Colonist* runs a sensational story about a Haida boy captured by a Stikine "Indian doctor" named Sah-hun, who told him he was to be "burned, and his ashes used in the preparation of a cordial" to cure Sah-hun's son. The paper, playing on the Christian fears of the time, follows up with an article titled, "Have We a Wizard Among Us". The article states that Sah-hun "tried to exorcise evil spirits, which he supposed had taken possession of the body of a Hydah boy". It says that Sah-hun's son was sick and dying, that he had given him

a piece of meat which deceased ate; that after giving the meal the Stickeen procured a canoe and paddled

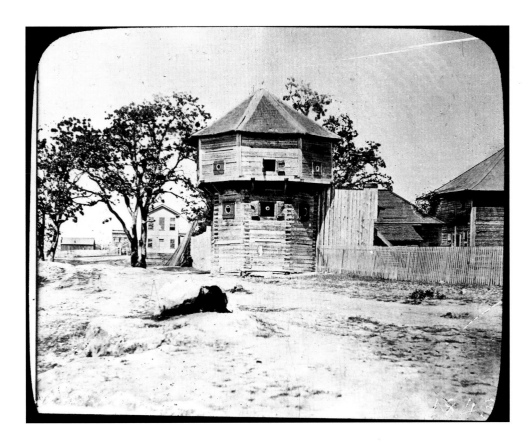

The southeast bastion of Fort Victoria, 1860.
Contact print, RBCM PN22700b.

off to a rock in the harbour where the body of a chief is buried, and tearing open the coffin … deposited on the breast of the corpse another piece of meat. The spirit of Satan then entered the breast of the Stickeen; he returned to the camp, and bewitched Sah-hun's boy who lingered and died.

The article appears to be describing a traditional ceremony where a man appeals to his ancestors to give him a special spirit power to help cure a sick relative.

March 7: "Another Horrible Murder of an Indian Woman" – a Haida, found dead on Esquimalt Road. Police Sergeant Blake goes to the Ditidaht camp near the Johnson Street Bridge to arrest Clack-eu-zet, who had arrived just three days ago. When Blake attempts to arrest him,

> several Nettinat [Ditidaht] Indians who were encamped by the Songhish village, cocked their rifles and presented them at the officer. Others drew their knives and surrounded Clack-eu-zet to prevent his

being taken. Blood should probably have been shed had not the Songhish chief come down and persuaded them to deliver him up.

The accused murderer turned out "to be a Cowichan Indian from near San Juan harbour", who had been told by the Songhees "that a Macaw [Makah] or Cape Flattery Indian is the guilty party."

March 9: The Haida murder a Songhees in revenge.

April 6: Haida Chief Edenshaw is convicted on a charge of attempting to murder Police Sergeant Blake and ordered to pay a fine of 40 pounds. The *Colonist* shows its attitude toward Edenshaw when it describes him as "rather a mild, inoffensive looking specimen of a native, but under his calm exterior is said to effectually conceal his real disposition, which is that of a perfect fiend."

April 15: More Fort Rupert Kwakiutl have arrived in 29 canoes and

> have taken up their summer residence just beyond Hospital [Songhees] Point, in close proximity to the

Hospital itself. Their presence there will no doubt be voted an intolerable nuisance by the Board of Management. The warriors brought with them a large number of fine furs and some articles of Indian manufacture. They were visited by a large number of curious white persons.

April 18: The *Colonist* publishes a litany of the problems caused by the northerners and pleads with the authorities to stop them. It announces that 400 more northerners have just arrived, with "thousands more" on their way.

April 24: The headline, "Anticipated Indian War", expresses fear of a potential clash between the Cowichans and the Port Townsend Clallams after the deaths of five Cowichans.

May 12: The newspapers report that the Haida "held a grand Potlatch. A chief of the tribe had died and left a large quantity of iktas [goods].… So his brother, also a chief, assembled his friends, to the number of 200, and … gave away whole piles of blankets and clothing." The Haida fired a schooners swivel-gun "in honour of the potlatch feast", which concerned the local authorities; so the police seized the gun and took it to their barracks.

May 18: More than 300 more Haida arrive in 23 canoes "for the purpose of disposing of their large collection of furs". They hold a funeral and distribute boxes of biscuits and large amounts of bread, cloth and blankets.

May 21: Under the headlines, "Great Fight with Indians" and "The Gunboat *Forward* Bombards an Indian Encampment", the newspapers report on a battle at Cape Mudge, near Campbell River, between the naval vessel *Forward* and about 400 Haida. The Haida were heading home after stealing goods from Victoria and Salt Spring Island. The *Forward*'s guns killed and wounded many, then returned to Esquimalt with five Haida, including two chiefs, under arrest.

July 2: The Rifle Volunteers are sworn in by Chief Justice David Cameron. This "all white" group was formed in response to the general fear of an "Indian Outbreak" and the American military presence in the Gulf of Georgia: "When General Harney startled the weak nerves of our folks by his descent on San Juan Island."

This turmoil, mostly caused by the presence of the northerners, continued until the spring of 1862, when a smaller, more deadly invader arrived in Victoria Harbour.

10
The Victoria Smallpox Crisis of 1862

One of the great tragedies in the history of British Columbia is the smallpox epidemic of 1862–63, which killed thousands of aboriginal people. Previous epidemics in the 1770s and 1830s were likely devastating in particular regions. But the 1862 epidemic spread much more widely and delivered a crushing blow to most First Nations on the coast as it moved from Victoria up the coast and throughout the mainland.

In early 1853, a smallpox epidemic spread from the Columbia River to Neah Bay, on the west coast of the Olympic Peninsula, causing a heavy death toll. On May 16, Governor James Douglas wrote to Hudson's Bay Company Secretary Archibald Barclay: "The small-pox is said to be raging among the Indian tribes on the American side, about Cape Flattery, but it has not made its appearance in this part of the country: and as a precaution against the ravages of that fatal disease, the Indians residing with the Colony, have been generally vaccinated." (Smallpox vaccine was available at Fort Langley as early as 1850, when it was taken north to vaccinate the Tlingit.)

American Indian Agent George Gibbs said, in 1854, that the Makah of the Cape Flattery region were reduced from 550 to only 150 people. The traders in Fort Victoria felt the impact of the disease when fewer and fewer Makah came to Victoria to sell their sea-otter skins.

On March 1, 1860, chief Tshama of the "Mytholomo" people (Ditidaht) of the upper Nitinat River reported that his people were dying of smallpox. He said they "would shortly go to fight the Clallams with a view of dying gloriously". This outbreak stayed confined to parts of the west coast of Vancouver Island.

Then, in 1862, the smallpox virus arrived in Victoria, carried by a man on a steamer from San Francisco. Because the Songhees had been immunized, they did not suffer greatly. Instead, the disease preyed on the First Peoples visiting from the north coast.

The *Colonist* reported on March 27: "about 30 Indians,

amongst whom were King Freezy, his queen, and the young princess, and all the Indian doctors, were brought to Dr John Helmcken's office and there underwent the ceremony of being vaccinated". Some northerners were vaccinated, but there was not enough vaccine for all of them, and some likely refused vaccinations. For the visitors with no protection, the result was devastating. Victoria became the staging ground for the disease as it spread northward. Visitors returning home took the disease with them, along the coast and up the rivers to the interior, causing annihilation in village after village.

Here is a chronological summary of the events in and around Victoria.

March 18: The *Daily British Colonist* reports that "several of the worst types" of smallpox are being treated in town, and recommends that people on their way to the gold fields "proceed at once to a physician and undergo vaccination".

March 22: As a precaution the police move some of the northerners in temporary camps on the Songhees Reserve to "camps up the Gorge & in the Esquimalt area", then burn the vacated buildings.

April 25: Reverend Alexander Garrett and Bishop George Hills visit the Tsimshian camp at Rock Bay. Hills reports that he "found the poor people in a great panic. The smallpox was raging with virulence: twenty had already died.... The patients were mostly removed [by their own families] to little tents or huts by themselves, and shut in as if left to die."

April 26: About 300 Tsimshian have smallpox. They ask if the disease was sent to wipe them out to get their land.

April 28: Several deaths have occurred, but Dr Helmcken has vaccinated more than 500 aboriginal people. Reverend Garrett is building a smallpox hospital west of the Royal Hospital. The Songhees are leaving for Discovery and San Juan islands to avoid the disease.

Police Commissioner Joseph Pemberton orders the immediate removal of all aboriginal people in Victoria, except for those "employed by whites". He gives the Tsimshian one day to leave and arranges for a naval gunboat to "take up a position opposite the camp to expedite their departure".

April 29–30: Police order the Tsimshian out of town with their sick and then burn part of camp. One more death has occurred. The *Victoria Press* reports "While small-pox in the unprotected is fatal in at least one-fourth the cases, it is so modified after vaccination as to cause death in only one case out of fifty, or perhaps a hundred." Several patients are now in the smallpox hospital and the police remind all First Nations living in town to move across the harbour to the reserve or their huts "will be pulled down about their ears". More of the Tsimshian camp is set on fire.

May 1: In the morning, the Tsimshian burn their own houses and blankets "without any compulsion from the police" and leave, probably for San Juan Island. Only three Tsimshian huts remain standing, for people staying behind to nurse the sick in the hospital. The police tear down several huts in the Johnson Street ravine and on Humboldt Street. Many of the Stikine and Haida have left, and others moved their huts away from the Tsimshian camp, where the disease seems to be confined.

May 4–9: The *Colonist* declares that the disease "is making frightful inroads" and makes a plea to the authorities to send the First Nations away. There are now ten cases at the hospital, as well as seven among the Haida and twelve among the Stikine who are camped at Ross Bay. Two Tsimshian and three Fort Rupert people have died.

May 11: The remaining Stikine have burned their homes and left. The Haida have been "slightly visited" by the epidemic and are burning their lodges. They all intend to depart tomorrow.

May 12: The police remove the Haida and Fort Rupert Kwakiutl. The Tsimshian and Stikine, with their sick, are encamped "on small islands in the Canal de Haro". The Songhees on Discovery Island have not encountered the sickness.

May 13: The police order all remaining northern peoples to leave the reserve, and they destroy about 100 lodges that are not part of the Songhees village. About 200 Haida sit by the shore with their goods but without any canoes. The next day about 100 Haida move to Cadboro Bay, where they are visited by a detachment of police who compel them to continue their journey.

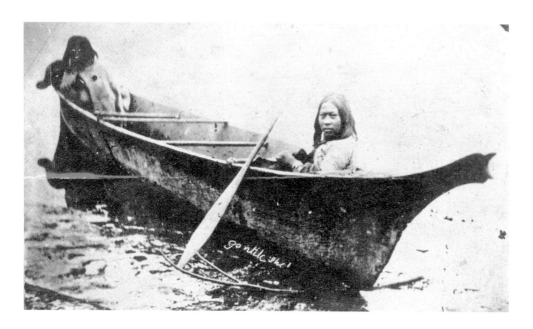

Lucy of the Esquimalt Reserve, 1862. Lucy worked in the home of a European colonist, Caroline Fellows, commuting by canoe. Carlo Gentile photograph, RBCM PN4732.

Location of an 1851 village in unnamed bay south of Camel Point, the far shore. It was here that Haida visitors camped temporarily during the epidemic. A pre-19th-century defensive site at Camel Point lies adjacent to a larger archaeological site extending along Dallas Road to St Lawrence Street. BC Archives HP66879, F-6188.

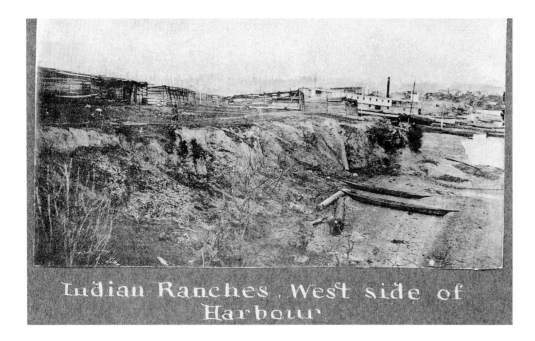

Indian Ranches, West side of Harbour

The front of the Songhees Reserve village in 1863–64.
RBCM PN6806.

May 18–19: The *Victoria Press* complains that the lack of First Nations labourers is forcing the lumber yards "to hire white men" at $2.50 a day to unload a cargo of lumber, instead of the $2 a day they paid to aboriginal workers. There are now two smallpox hospitals on the reserve, one for the seven patients who are sick and the other for four who are recovering.

May 22–27: Rev. Garrett and the police visit the Haida camped in the bay just north of Ogden Point and report that 30 out of 70 have the disease. Town officials estimate that "at least one third of all the northern Indians who were until lately encamped on the reserve or resided with townspeople as servants have already died". A number of Haida are still camped at Cadboro Bay, where several deaths occur daily. The *Colonist* reports that these "Cadboro Bay Indians" are "throwing their dead into the sea."

May 28–30: The smallpox hospital is now treating 18 patients, and 17 more cases are reported near Ogden Point. Employers of "Indian servants, can obtain a certificate granting them permission to stay", but all others have to leave.

June 2–5: First Peoples at Nanaimo are now dying of smallpox. Only about 15 of the Haida near Ogden Point remain alive. They have left their possessions and moved on, and the police are burning the huts and covering the bodies with lime. Smallpox is affecting the "Kanakas [Hawaiians] and Whites" on Quadra Street. The hospital now has 27 patients, and 3 who have just died. The police remove aboriginal people from the Johnson Street ravine.

June 6–9: Only a few of the Tsimshian "sent to the Island near Cadboro Bay are left" and smallpox has broken out again in the Johnson Street ravine. The hospital receives about 6 new patients every day, and the town's mortician is kept busy making coffins.

June 13–14: Reports from the north say that hundreds of aboriginal people are dying from smallpox at Fort Simpson and Fort Rupert.

June 16–17: Fear and discrimination are revealed in a newspaper report of a smallpox death in a shanty near Johnson Street:

Immediately round the same dwelling are about a dozen small tenants, several occupied by white families, some by degraded whitemen co-habiting with squaws and the remainder dens of Indian prostitution…. For four years Victoria has suffered to an extent unknown in any civilised town … from the

residence of an Indian population … cheap labour at the expense of a white immigrant population.

June 18–19: The *Victoria Press* sounds the alarm: "the disease which has been decimating the Indian population, has begun to take hold on the white."

June 22–27: The disease strikes a policeman who helped bury bodies at Ogden Point and Cadboro Bay. An aboriginal family in Waddington Alley has smallpox, and an American and young Canadian die from it. The smallpox hospital now treats only two patients. Up north the disease is ravaging the aboriginal population around Fort Rupert, who are being vaccinated by the surgeon of HMS *Hecate*.

June 30 – July 11: The Lekwiltok of Cape Mudge, near Campbell River, are dying in scores after killing a Haida man who had smallpox and taking his blankets. A hundred bodies are reported along the coast north of Nanaimo. Thirty aboriginal people arrive and set up camp at Hospital Point in Esquimalt, "the naval officers accordingly scramble for the safety of their men".

July 14 – August 9: In Duncan, smallpox causes the dispersal of people to local islands. The disease kills "Charlicum, the big chief", in Sooke.

August 26 – October 9: The disease wanes in Victoria, killing only about ten aboriginal people and a few others. But in the north, smallpox continues its devastation, spreading through the Bella Coola (Nuxalk), to the interior among the Chilcotin (Tsilhqot'in) and Carrier (Dakelh).

October 20: The epidemic has run its course in Victoria and fear of smallpox has gone with it. The *Colonist* reports that the Songhees have returned to their village to spend the winter, observing "canoes coming and going continually, and the work of rebuilding the lodges destroyed by the late fire progressing rapidly. The proximity of this tribe is not necessarily the cause of so much demoralisation to the white population, and injury to the labour market, as resulted from the presence of the large number of Northern Indians."

Most First Nations throughout the region were devastated by smallpox, but the Songhees and Esquimalt nations survived largely unscathed. Although many Victorians were glad to see the northerners leave, most recognized that the local economy suffered greatly in their absence. Eventually, smaller numbers of northerners returned, but the extent of their influence was never the same.

Colville Island was also used as a burial ground in the late 19th century. This 1869 painting by Thomas Somerscales shows a single burial house on the island. Buttons and parts of coffin handles have been found in the shallow soil. Victoria's outer harbour is beyond Shoal Point (centre), and one of the Coffin Islands is on the right.
BC Archives PDP00077.

Burial Grounds at Coffin Islands and Colville Island

Three islands to the west of the foot of Robert Street in Victoria West were used as burial grounds in the mid to late 19th century. Frederick Dally describes the second Coffin Island in 1867, while visiting the grave of King Freezy, who died in 1864:

> After Tyee Freezie had been dead about three years I visited his grave to see how he looked, it was an elegant structure according to the Indian notion and was built ... of cedar wood and was covered with a red blanket beginning to fade. Seeing a small square window I went to look in, and to my surprise a pair of eyes met mine and a human face. I stood back for a second or two to consider the point, and on closely examining it,

I found it to be a cheap piece of looking glass, I retired greatly amused.

> The mausoleum is situated on Dead Man's Island at the entrance to Victoria Harbour. There were numerous bodies in square boxes of many shapes lying round about and to make the bodies go in they press the lids down by standing on them, and tie them round with cord, but many of the boxes were partially open.

Johan Jacobsen, a visiting amateur anthropologist, observed this place on September 8, 1881:

> The bodies were wrapped in blankets and were in various stages of decay, and I found clay pipes on a few graves as offerings to the dead.

At one place a small wooden house with a pointed roof had been built and inside the tiny structure was just enough room for three grave boxes containing the bodies of a chief and his wife and daughter.

These islands have often been mistaken as the location of the 1867 burial-island fire (it was Halkett Island; see p. 65). Over the years looters and natural erosion have turned up human bones; many of these were turned over to the Royal BC Museum in the 1960s and have now all been reburied in the modern Songhees cemetery. Cement foundations for a footbridge were put on the first Coffin Island in 1986, but construction stopped due to the protests of both the local public and the Songhees to protect the islands.

The Coffin Islands, 1857
– watercolour by James Alden.
Washington State Historical Society.

11
The Early Minority Years, 1862–74

Aboriginal Labour and Trade

While the Songhees and colonial population of Victoria escaped the smallpox epidemic relatively unscathed, the loss of the large trading population of northerners had an enormous impact on the local economy, especially because it followed the decline of the gold rush. The import figures show a drastic decline from one year to the next: blanket imports dropped from 47,068 in 1862 to just 2,732 in 1863; gunpowder declined 83 per cent; cheaper brands of alcohol fell by 75 per cent; clothing, dry goods, hardware, tin, crockery, flour, grain and coffee dropped by 33 to 50 per cent.

In this time of economic depression, some Victorians complained about the idleness of aboriginal people, yet became more angry when they took jobs in colonial enterprises. On September 24, 1862, as smallpox waned in Victoria, the *Colonist* printed a letter on the topic of "Indian vs White Labour":

> At the present time there are hundreds of our country-
> men unemployed in this town; and I was much surprised
> … to find that one of our leading men … employ
> Indian men to do not only common labourer's work,
> but tradesmen's work, such as painters and carpenters….
> He is morally bound to use his utmost endeavours to
> help his countrymen.

Songhees men often earned good wages on construction projects. Some worked in the manufacture of roof shingles and some found employment related to shipping. First Nations women gained employment as housekeepers and many sold food products. On October 21, 1862, the *Colonist* alerted its readers to the First Nations monopoly of the oyster trade in Victoria: aboriginal women were collecting from the Gorge Waterway and from the tidal waters of Sooke and Cowichan, and selling them in town, making $4 to $5 a day. Since "there is money to be made at it", the *Colonist* urged unemployed men in town to go out and compete with them.

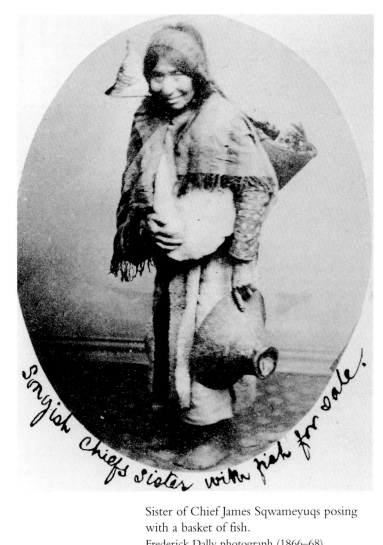

Sister of Chief James Sqwameyuqs posing with a basket of fish.
Frederick Dally photograph (1866–68),
BC Archives HP94498 F-08291.

First Nations mail carriers in front of the New Westminster office of George Dietz and Hugh Nelson, 1864. The six people behind the Salish-style canoe were employed to take the express mail to and from Victoria.
Francis George Claudet photograph, BC Archives HP087822, E-07739.

Aboriginal herring fishing and processing station at Constance Cove, Esquimalt Harbour, 1864. The shelter is a summer lodge made with tule mats. The canoe in front is north-coast style and the two behind it are traditional Songhees. Long herring rakes lean on the bank behind the lodge and gutted herring are drying on wooden pole racks on the left.
Frederick Dally photograph; RBCM PN905.

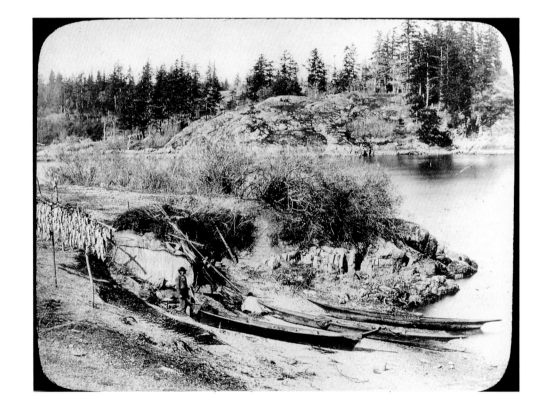

During the next ten years, northern First Nations returned to Victoria in greater and greater numbers, once again forming an important part of the economy. Yet, as more aboriginal people congregated around the city, the colonists' fear of violence rose once again. On April 23, 1873, the *Colonist* printed an alarmist headline: "Is an Indian War Impending?". The report discussed the possibility of the Songhees and other groups from the east coast of Vancouver Island forming an alliance to confront the colonial government about unsettled land claims. But any suggestion of removing First Nations visitors from Victoria provoked newspapers to issue dire warnings that this action would deprive the town of "one of its largest mediums of circulating money.... Such a measure will be the cause of the closing of all business north of Yates Street.... The Superintendent of Indian Affairs will find himself far from popular with business men if he resorts to such measures."

Management and Rental of Reserve Property

After 1860, colonial businessmen rented portions of the Songhees Reserve for many purposes: Robert Burnaby leased part of the waterfront for a black-lead and graphite store, ship builder James Trahey gained a ten-year lease near the Johnson Street Bridge, and others rented land for a stove yard, wharf and storage, a wood lot and a market garden. On August 13, 1862, the government appointed Edward Alston, Dr Augustus Pemberton and Joseph Pemberton to manage the Reserve with the power to grant leases. In 1863, they granted a 14-year lease to Peter Jewell for a chamois and buckskin-dressing business; Jewell employed many aboriginal people to collect Western Hemlock bark for the tanning process.

One of the more surprising leases was granted to Patrick Everett in 1862 for a tavern and liquor store on the reserve, which defied all the rules and public opinion of the time. He successfully fought a forced closure in 1876, brought on by the new Indian Act, and acquired a lease renewal in 1879.

The same year Everett got his original lease, the newspapers were filled with reports of alcohol-related crimes by First Peoples, mostly by northerners and non-aboriginal men living with aboriginal women. It was this kind of publicity that led to some heavy punishments for selling liquor to First Peoples – on December 15, 1863, a non-aboriginal

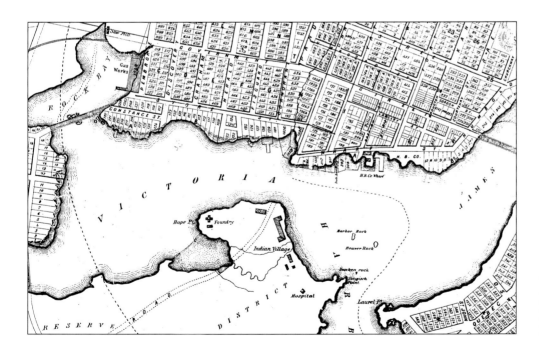

Victoria Harbour 1863, with the Songhees Reserve in the centre.
From Alfred Waddington, City of Victoria Map, BC Archives CM B272.

This four-part panorama attributed to Arthur Vipond shows part of the reserve and the city of Victoria in 1864. On the far left (frame 1) is the Rock Bay bridge and the old camping area of First Nations visitors (now the area along Store Street between Pembroke and Discovery streets). Hope Point (frame 2) juts into the Gorge Waterway – the buildings on the point are rental properties of non-Songhees people, such as the Foundry of McDougall and Geddie. The little bay and marshy lowland (frames 2 and 3) are now filled in; the dirt road and boardwalk leading to the Johnson Street Bridge extended from the end of what is now Wilson Street. To the right of the road the plank houses of the Songhees are spread along the shore (frames 3 and 4); and on the other side of the harbour sits the growing city of Victoria, with James Bay trestle in the background (frame 4, centre) and the old Legislative Buildings on the cleared land.

BC Archives Vipond file 98005-2:
B1, B2 (RBCM PN8956),
A2 and A1 (RBCM PN8954).

1

3

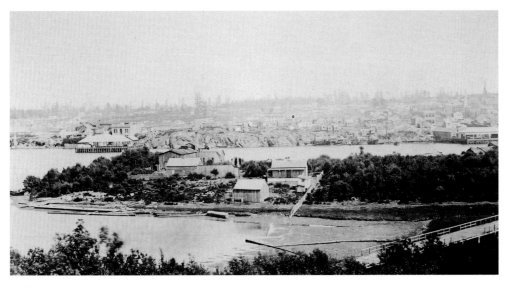

2

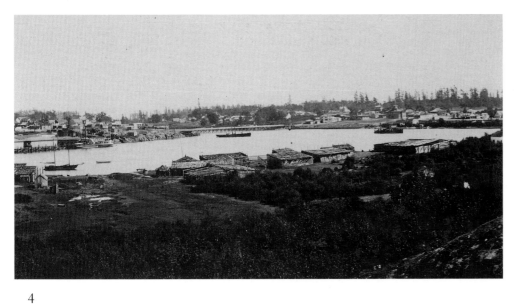

4

man was sentenced to a year at hard labour. Yet many people thought that the authorities needed to impose stronger punishments to prevent the sale of liquor to First Nations. After some urging from church leaders and chiefs, Governor Arthur Kennedy pointed out the ineffective law in the legislature on November 28, 1865: "This iniquitous traffic is carried on by a worthless and degraded class of men, the cost of whose maintenance in prison and repeated convictions arising from inadequate punishment, fall heavily upon the public funds."

Despite this outcry, Patrick Everett was allowed to continue running a saloon on the Songhees Reserve.

Aboriginal Policy and More Attempts to Move the Reserve

On January 21, 1864, Governor James Douglas addressed the First Session of the Legislative Council of British Columbia (the mainland colony) in reference to reserves in both Vancouver Island and the mainland:

The Native Indian Tribes are quiet and well disposed; the plan of forming Reserves of Land embracing the Village Sites, cultivated fields, and favourite places of resort of the several tribes, and thus securing them against the encroachment of Settlers, and for ever removing the fertile cause of agrarian disturbance, has been productive of the happiest effects on the minds of the Natives. The areas thus partially defined and set apart, in no case exceed the proportion of ten acres for each family concerned, and are to be held as the joint and common property of the several tribes, being intended for their exclusive use and benefit, and especially as a provision for the aged, the helpless, and the infirm.

The Indians themselves have no power to sell or alienate these lands, as the Title will continue in the Crown, and be hereafter conveyed to Trustees, and by that means secured to the several Tribes as a perpetual possession.

That measure is not however intended to interfere with the private rights of individuals of the Native Tribes, or to incapacitate them, as such, from holding land; on the contrary, they have precisely the same rights of acquiring and possessing land in their individual capacity, either by purchase or by occupation under the Pre-emption Law, as other classes of Her Majesty's subjects; provided they in all respects comply with the

This Frederick Dally photograph, made in 1864, shows the Songhees village from Songhees Point in the foreground to the area near the present Johnson Street Bridge on the right background.
RBCM PN903
(BC Archives HP34387 and HP15719).

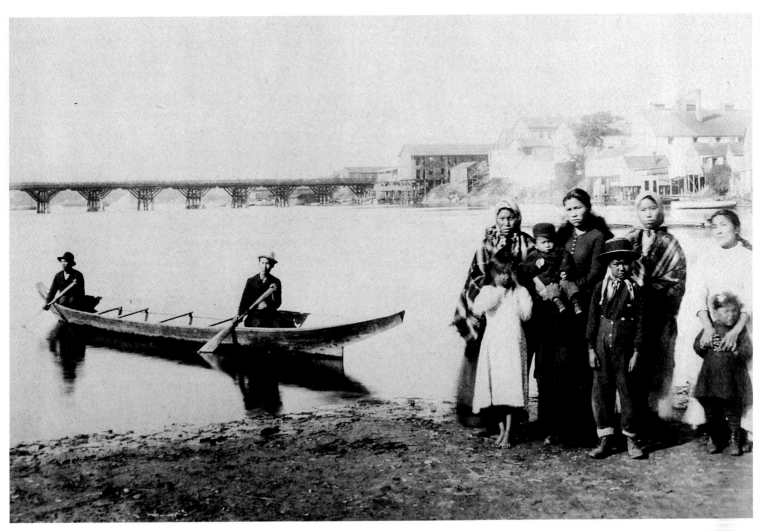

A group of Songhees at the head of James Bay in 1875 with a northern-style canoe. This location is now just east of the Crystal Gardens. Behind is the second James Bay Bridge.
BC Archives I-30804.

legal conditions of tenure by which land is held in this Colony.

I have been influenced in taking these steps by the desire of averting evils pregnant with danger to the peace and safety of the Colony, and of confirming by those acts of justice and humanity, the fidelity and attachment of the Native Tribes to Her Majesty's rule.

Soon after issuing this statement, Douglas stepped down as governor of both colonies. Arthur Kennedy became governor of Vancouver Island on March 26, 1864. Kennedy hosted a grand feast for the Songhees and discussed their moving the reserve. The minutes of the Executive Council of Vancouver Island for September 22 stated that Governor Kennedy "proposed to remove the Indians to Discovery Island compensating them for the removal." On May 29, 1865, the Legislative Assembly of the mainland colony asked their governor, Frederick Seymour, to suspend the Land Proclamation protecting First Nations reserves and opening them to settlement.

In 1866, the colonies of Vancouver Island and British Columbia united and on May 24, 1868, Victoria became the new capital. For a while, these political events overshadowed the Victoria colonists' desire to remove the Songhees Reserve.

On September 11, 1868, the Haida camp west of Songhees Point burned down. Visiting First Nations began to camp in any vacant spot in the city. The following June, the city passed bylaws preventing aboriginal visitors from pitching tents "at will"; the laws restricted them to the reserve where houses would be erected for them to the west of the hospital.

On December 30, 1869, the British government fired the three commissioners who had been running the finances of the reserve. The management was to be turned over to Joseph Trutch, who was not as sympathetic to First Nations as Douglas had been. Trutch stated that "it was not competent" for former Governor Douglas to delegate management of the reserve to appointed commissioners. He indicated that leaseholders had been paying their rents regularly until the arrival of Governor Kennedy in 1864, who had instructed the Reserve Commissioners not to lease any more land. In Trutch's words, Kennedy "thought that the leases were not binding on the Crown". The leaseholders now refused to pay rent; and some wanted their past rents reimbursed because of the government agent's failure to follow through on "alleged assurances" that the Songhees would be removed and lease money "expended in improving the property".

In 1871, British Columbia joined the Canadian Confederation as a province, and transferred control of "Indian Affairs" to the federal government. The following year, Israel Powell became the first Indian Superintendent in Victoria, representing the Indian Branch of the Department of the Secretary of State. In 1873, the Indian Branch instructed Powell to submit a scheme to move the Songhees Reserve from Victoria. Powell, himself, saw the reserve as a detriment to Victoria, mainly because of the activities of a small number of northern visitors living there who were engaged in prostitution. On October 5, he hired three aboriginal policemen to patrol the reserve in uniform, but with no authority to arrest.

At this time, Powell estimated the Songhees population at "about 120 – 45 men, 45 women and 30 children". He recommended on the August, 24, 1874, that Sidney Island – the home territory of Chief James Sqwameyuqs – should be purchased for the new Songhees reserve, but the Songhees refused to surrender and nothing further was done.

12
Potlatches and Winter Dances, 1863–74

The Grand Marriage Potlatch of 1863

On September 25, 1863, about 20 canoes from Washington arrived for a five-day Grand Potlatch at the Songhees Reserve. The *British Colonist* described the arrival:

> A landing party of braves armed to the teeth dashed up to the shore, where they were met and repulsed by the members of the Songish tribe.... After several assaults, they made good their landing, and were received with a hearty welcome. During the progress of the mimic warfare, the opposing tribes levelled their muskets at each other and then discharged them in the air, giving ... much the appearance of a genuine affray.
>
> The visiting tribes ... bring presents ... in return for the hospitality extended to them by King Freezy about two years ago. The canoes ... were loaded with blankets and other presents; and ... the visitors also bring large amounts of money for distribution. Jim [Sqwameyuqs], the sub-chief of the Songish, will also give presents. We are informed by Freezy that all of the numerous Flathead tribes living upon Puget Sound will be represented at the gathering.

The next day, 30 to 40 Ditidaht canoes arrived and performed a similar ceremony on the shore in front of the Songhees village. The *Colonist* noted· "The Braves, about two hundred in number, were arrayed in all the glories of paint and feathers." James Sqwameyuqs addressed the visitors before they landed. A Ditidaht, through a Songhees interpreter, then addressed the Songhees and made formal proposals for a bride. After the speech, the Ditidaht presented five new canoes, loaded with blankets and dried halibut to the Songhees. Freezy then addressed his visitors welcoming them and inviting them to land for refreshments. The Ditidaht chief "reiterated assurance of good faith, strongly recommending that no whisky should be drank, lest the

This three-part panorama shows the Songhees Reserve in 1863. Most of the houses are the old horizontal plank style. The sternwheeler is at the area leased for boat building.
From the album of Lt Surgeon J.L. Eastcott of the Royal Navy, private collection.

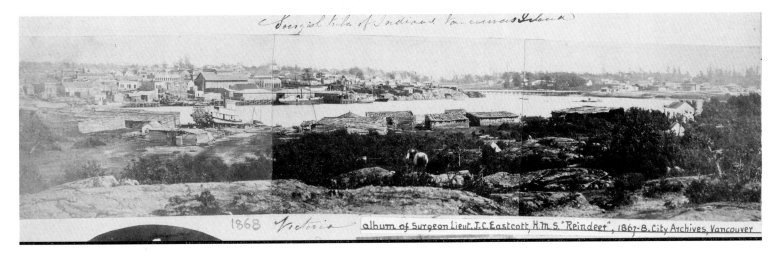

harmony of the occasion be disturbed." The male visitors then landed and proceeded to the residence of Freezy, where more ceremonies, dancing and feasting took place throughout the night.

The Songhees bride was not the daughter of Chief Freezy, but, as the *Colonist* reported, "a daughter of Kish [Chish, ca 1778–1876], a sub-chief of the Songish. The damsel occupied a place on the top of one of the rancheries [plank houses] … apparently witnessing with great delight the arrival of her future spouse and his courtiers."

On September 28, the Swinomish, from south of Bellingham, arrived. On the morning after, a "preliminary scramble" for several hundred dollars worth of blankets and muskets took place. The Grand Potlatch continued until about 10 p.m. the next day. The *British Colonist* announced that James Sqwameyuqs "whose wealth has raised him in an equal position with handsome King Freezy" would distribute 400 blankets, and chiefs were invited to attend the Mission School where Reverend Alexander Garrett will provide "a copious supply of rice and molasses".

When the festivities came to an end, the Songhees had renewed old alliances with relatives in Puget Sound and forged new ones with the Ditidaht.

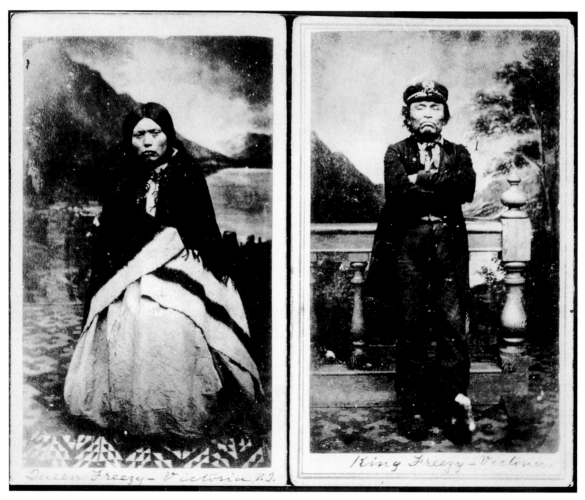

Winter Dance of 1868

On November 14, 1868, Chief Jim Sqwameyuqs invited Reverend H.B. Owen to a winter dance in his home. Owen observed at least 75 people around four large fires:

> Only intimate friends of the tribe are admitted.... The music was monotonous, but not unpleasing ... whilst nearly all lent the aid of their voices concluding each dance with a higher flourish & a general ugh! ugh!! wagh!!
>
> The dancers were variously clothed – some in blankets ... which ... they threw aside & stripped to their trousers, covered with perspiration with masked or painted faces & flourishing their knives.... Some of the masks were cleverly carved in wood & the expression singularly grotesque.... Following the dancing were speeches made by a few of the principal men – visitors & hosts. Beyond one or two blankets given by the chief Jim there were no presents.

After the feast, in which "food was piled up before each visitor who carried away his share for consumption in his own house", Owen was given "a pine wood torch" to find his way home. The winter-dance ceremonies continued for at least ten days afterward.

The Potlatch of 1869

On April 19, 1869, Reverend Owen, who spent time at Songhees village taking care of the sick, reported that about 1000 members of 15 different tribes had arrived there in recent days. A *Colonist* reporter met Owen at the village and noted that the Songhees "anticipate a visit from Governor [Frederick] Seymour upon the day of the potlatch."

Both Owen and the *Colonist* reporter noted ideological differences among the Songhees, between "about one-third ... [including the] chief of the upper half of the village [Jim

King Freezy (Chee-ah-thluc)

ROYAL CARTES DE VISITES – His Majesty King Freezy I, and his Royal spouse the Queen of the Songhishes, visited the city yesterday, and honoured Mr Gentile, Photographic artist of Fort Street, by sitting for their portraits. Their majesties appeared to be highly delighted ... although in neither case could the words of the poet be applied with justice. "Love and beauty still that visage grace." Before taking his departure the wily but uxorious old King requested the artist to potlatch his better half four bits, which was immediately done and the chickamen having been safely ensconced in the folds of the Royal robes (three-point blankets) their majesties stalked off with a dignity becoming their exalted station. – *Daily British Colonist*, February 2, 1864.

Chee-ah-thluc (facing page, right) was chief of the Songhees from the 1840s to 1864. He adopted the popular name "Freezy", which referred to his frizzled hair (see Paul Kane portrait on page 71). The "Queen of the Songhishes" shown here was the younger of King Freezy's two wives.

King Freezy posed for this portrait in his favourite clothing – a naval uniform. Edgar Fawcett, an early resident of Victoria, knew Freezy in his later years: "He might have been seen parading about town in a cast-off naval officer uniform with cap to match, and he was very proud, as befitted such an august personage. When asked his name, ('icta mica-name') he would reply 'Nica name King Freezy, nica hyas tyee.' ('My name is King Freezy, I am a great man.')."

Another Victorian, John Flewin, noted that Freezy purchased the uniform at a second-hand store and that "many of the lesser chiefs also dressed on festive occasions in cast-off military and naval uniforms".

King Freezy died just 10 months after posing for this portrait. On November 11, 1864, the *Colonist* reported, "DEATH IN A ROYAL (SIWASH) FAMILY – King Freezy is no more". The new chief, James Sqwameyuqs, informed the paper that Freezy and another man had been returning to Victoria in a canoe when it tipped and Freezy drowned. The other man survived but was arrested on suspicion of foul play. When the canoe was recovered, King Freezy's body was attached to it with a cord around his waist.

Two parts of a Frederick Dally panorama, made in 1866, showing the slowly expanding city of Victoria in relation to the reserve. On the far left (frame 1), the J.F. Dougall and Alex Geddis rental property on Hope Point has a new foundry building. Minor changes are apparent in the reserve village (frame 2): a few of the old plank houses have been torn down and others are missing roofs and walls.
BC Archives HP07926, A-02674; HP09457, A-03440.

1

Sqwameyuqs]" and the rest of the village. Chief Jim's group approved of the March 5 execution of "Harry a Fraser River Indian" for the murder of a Songhees man named Alpose. The lower village group thought the hanging was wrong. Because of this difference of opinion, "Jim's party had at first no share in the Potlatch beyond receiving as guests some of their visiting friends; they were, however, at length drawn in & also gave away some property."

Owen noted the potlatch "was given principally by Scultrnah (Mary [Saaptenar]) and Tschlekaik (Louis)". He estimated that she gave away nearly $1000 worth of goods, and "not long after, she had scarcely bread to eat", and that the total expenditure of the potlatch was about $6000 worth of goods and double that with the exchange of other money and property.

A year after her potlatch, Mary Saaptenar (ca 1834–1926) married Peter Pierre Friday (ca 1808–94), son of Hawaiian Joe Friday Polaie, whose name lives on as Friday Harbour on San Juan Island. The other principal potlatch giver was Louis Tschlekaik, who Reverend Owen called "a well-behaved, industrious & sober Indian, who though … to all appearances [is] impressed by what we say,… cannot … come out from his heathenism".

Religious leaders saw the practice of traditional medicine as a block to enculturalization and conversion to Christianity.

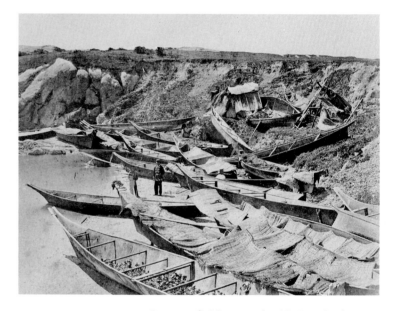

Canoes of visitors to the 1869 potlatch. Four Songhees-style canoes, with the straight, pointed bow, rest on the embankment; most of the others are west-coast-style. Woven tule mats make small, temporary shelters and prevent the canoes from drying out and splitting.
Frederick Dally photograph; RBCM PN06806.

2

Visitors await the throwing of blankets from the rooftop of a big house in the Songhees village.
Frederick Dally photograph;
BC Archives HP15872, A-6080.

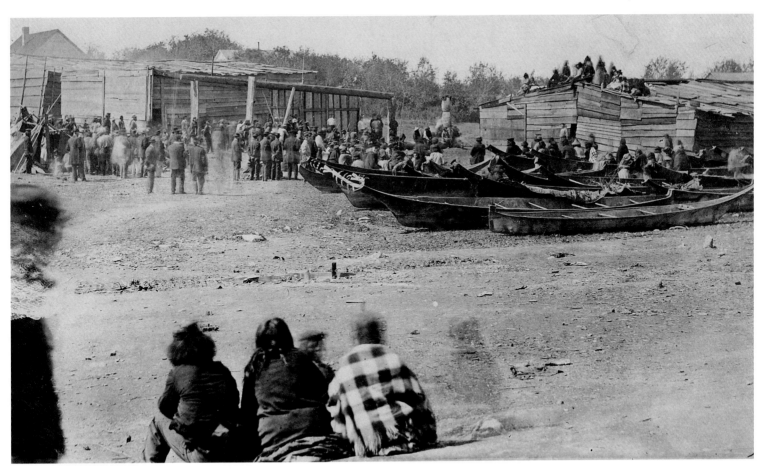

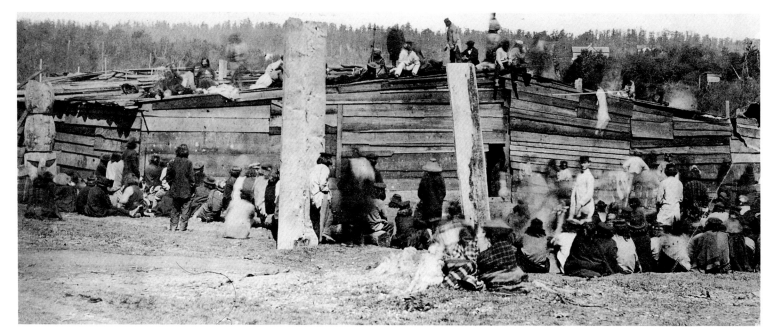

Potlatch guests gathered to receive gifts thrown from the roof of a big house. The posts in front of it are the remains another house.

Frederick Dally photograph; RBCM PN6805.

Frederick Dally Photographs of Songhees People

Frederick Dally made photographs of people in and outside his studio. He tried to represent the different "types" of people, and he usually named the groups they represented. He placed most of the Songhees photographs in his studio albums, which he invited customers to browse through. Some of these may have been taken by other photographers and sold by Dally.

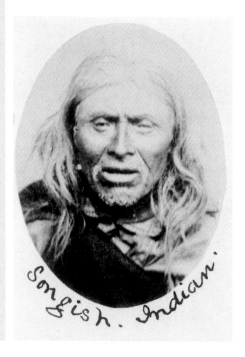

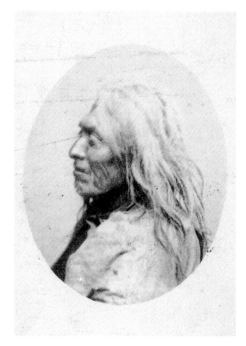

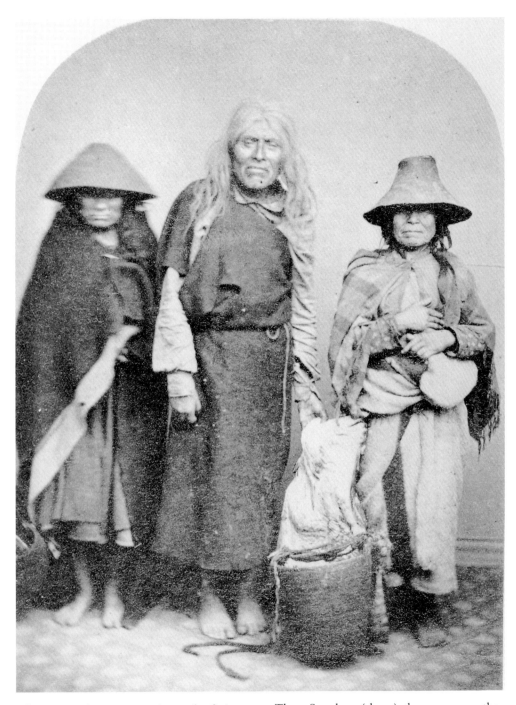

Songish Indians V.I.

Esquimalt Harbour

Songish Indian Woman

The man in the two portraits on the facing page is also shown above, centre. He is possibly Chief James Sqwameyuqs' brother, his wife's brother or a man named Sanett. RBCM PN05907 and PN05932.

Three Songhees (above): the woman on the right is Chief Sqwameyuqs' sister and the woman on the left is unknown. BC Archives HP94486 F-08294.

Dally made these portraits between 1866 and 1868. BC Archives HP094468, F-08311; F-08323.

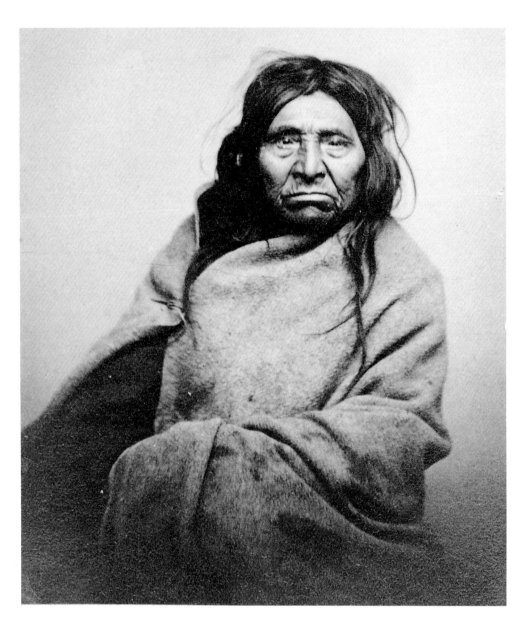

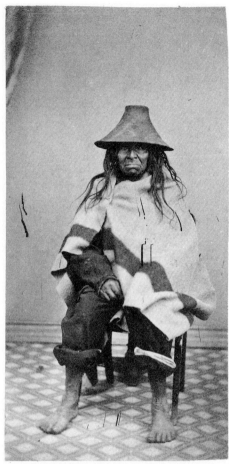

This Songhees man, identified as "Sapalell Bummer", posed for these portraits in the Dally studio between 1867 and 1869.
Carte de visites, RBCM PN7567 and PN5933.

James Sqwameyuqs,
Songhees Chief from 1864 to 1892

James Sqwameyuqs or Chief Jim was born about 1797 and became chief of the Songhees on November 12, 1864, succeeding Chee-ah-thluc (King Freezy). His name, which in the Lekwungen language means Grand Fir Tree, is spelled several ways in English documents and reports about him, including Scomiak, Skomiax, Kumayaks, Skwamayuks and Comey-uks (on the South Saanich Treaty of 1852).

Sometime before 1860, Chief Freezy invited James Sqwameyuqs and his people of Sidney Island to move to Victoria. In an attempt to move the Songhees Reserve in 1874, Chief Jim's old territory on Sidney Island was suggested as a possible destination.

Chief Jim died of consumption on September 12, 1892. The *Colonist* announced:

> SCOMIAK IS NO MORE –
> The veteran chief of the Songhees ... proved himself a capable leader.... On the reserve flags are flying half-mast, the canoes are drawn up on the muddy beach, and the tribesmen ... with their sympathising friends of the Cowichan, Saanichs and Beechy Bays, are telling the history of men, women and children remaining to claim the name of Songhees. The death of the Chief again directs attention to the little kingdom over which he reigned ... and from which he declared, less than a year ago, he would never be carried alive.

Regarding Sqwameyuqs position on the removal of the reserve, the *Colonist* added:

> the old chief refused to see the question in the light the city people wanted him to, and the tribesmen stood by their ruler.... He has listened to the voice of his council; he has encouraged industry, morality and temperance, and discouraged too much intercourse with the whites.... Scomiak succeeded Frazier [Freezy] in the chieftainship, not by right of descent, but by appointment of Sir James Douglas ... who recognised in the young Indian the qualities of honesty, sobriety and self-reliance.

The Songhees held a potlatch to mourn Sqwameyuqs' death, distributing 150 pairs of blankets. (At his memorial potlatch a year later, they gave away 3000 more blankets and a considerable sum of money.) The funeral procession went from his home, to St Andrew's Roman Catholic cathedral. He was buried in Ross Bay Cemetery, where his wife Mary (1836–1904) and his nephew Alex Peter (Songhees chief from 1935 to 1942) were later buried next to him.

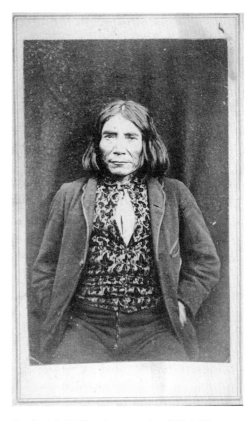

Frederick Dally photograph of Chief James Sqwameyuqs, 1866–68.
Carte de visite; RBCM PN04816.

The Great Potlatch of 1874

Chief Sqwameyuqs and his people held a potlatch for more than 2000 people from April 21 to 27, 1874. An observer, J.D. Edgar, noted that most visitors came from the east coast of Vancouver Island and from Puget Sound. They arrived in several hundred canoes, and "ordinary residents number only about 300".

Edgar observed First Peoples playing *Slahalam*, a game using 10 flat, circular pieces of wood, each five centimetres in diameter – three are marked and seven blank. Two players sat "opposite each other upon neat mats pinned to the ground, often with silver skewers". They shake the wooden pieces under a mass of cedar bark fibre and then divide the bark into two parts with five pieces concealed in each. The players pass the fibre bundles from hand to hand and guess which one has the more of the marked pieces.

Sqwameyuqs people tossed gift blankets into the canoes and flung fowling pieces and rifles into the sea enticing guests to dive for them. In all, Sqwameyuqs distributed 12 bales of blankets worth $90 a bale.

The potlatch ended on April 27 after the distribution of 4000 blankets, two crates of crockery, 100 suits, calico shirts, pieces of calico, beadwork, 100 boxes of biscuits, barrels of molasses and a washtub full of 50-cent pieces. The *Sxwayxwey* (Bird Dance) began at 9 a.m. on the final day and at 1 p.m. the visitors packed their canoes and began to depart – "by night-fall only the Nanaimo delegation remained in the village".

Two-part panorama of the 1874 potlatch: the roofs of the big houses are lined with piles of blankets and other goods about to be given away, and Chief Sqwameyuqs is about to give a canoe to each of the visiting chiefs; the mat-covered structure against one of the houses (frame 1, centre) conceals dancers until they are ready to perform. Visitors' canoes line the shore and some visitors are camping on the beach (frame 2); moored on the Victoria side of the harbour is the steamboat *Maude*.
Attributed to Albert Maynard, RBCM PN6810; Brian Cunningham private collection.

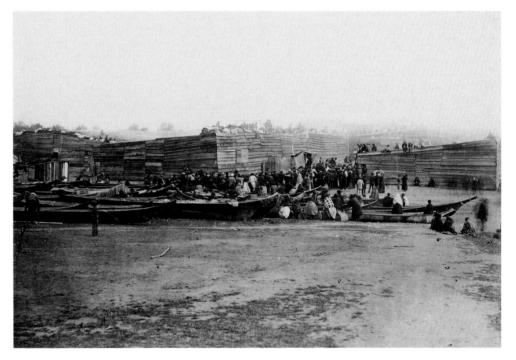

1

A view of the 1874 potlatch from the south end of the village. More goods are being distributed in front of the two European-style houses in the background.
Richard Maynard stereograph (one side); RBCM PN6807.

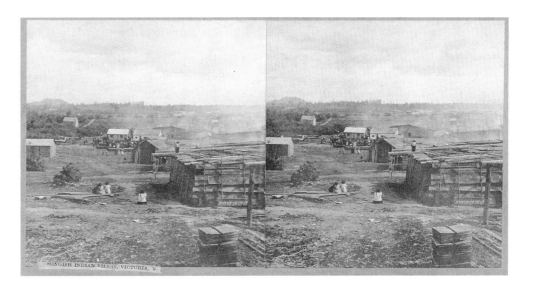

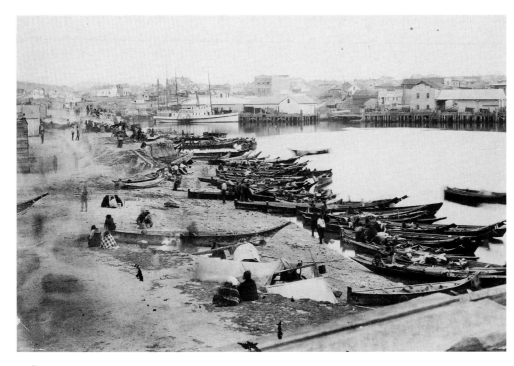

2

Chief Sqwameyuqs' House Posts

These house posts ("Ka-kin") once faced each other supporting roof beams in the house of Chief James Sqwameyuqs. He inherited the right to use the figures through his Quamichan mother, who had the same figures in her house at Quamichan (near Duncan). While attending Chief Sqwameyuqs potlatch in 1874, J.D. Edgar noticed the house posts:

> In the lodge of the Chief ... there are a few curious carvings.... Tall wooden figures, ten feet [3 metres] in height, are found there with huge heads of superhuman aspect – the hair painted blue, the flesh red, and eyes white. In the arms of one monster, and crawling up his body, are huge black lizards.... Jim delights to parade [the carvings] on rare and momentous occasions.... The first time I saw [them] he had veiled the faces with pieces of calico.... We were lifting up the curtains ... when a gentleman ... asked an Indian, in Chinook, why they covered up the figures. He answered with a laugh, "Hy-as ty-ee (great chief) putten-on-airs."

Ethnologist Franz Boas drew the posts in 1889. He described them as being "carved and painted.... Such posts do not belong to the Lukwungen [Songhees] proper, but were introduced into one family after intermarriage with the Cowichan." Boas was told that the animals represent minks (not lizards) and the human figures represent the spirits "whom the owner saw when cleaning himself in the woods before becoming a member of the secret society *Tcyiyi'wan*". He was also told that the faces of these figures are kept covered except during festivals.

In 1900, Stewart Culin and Charles Newcombe saw the posts lying on the ground at the reserve, when many of the old style houses were being torn down. They purchased the posts from Chief Michael Cooper for museums in New York and Chicago. They describe the post in the middle as a man with a male lizard and the one on the left a man with four female lizards, or powerful four-legged serpent-like creatures that often gave power to shamans.

Stereograph; BC Archives HP18267, G-6931 and H-5004 (RBCM PN6829 and PNX158).

13
The Politics of a New Era, 1876–1907

In 1876, the provincial and federal governments established a Joint Commission on Indian Land in British Columbia to allot reserves according to local conditions. The governments agreed on a figure of 20 acres of land to each head of family of five west of the Cascade Mountains. The Reserve Commissioners were Alexander Anderson for the Dominion of Canada, Archibald McKinlay for British Columbia and Gilbert Sproat, representing both governments. (Sproat became the sole Commissioner, from 1878 to 1880. Peter O'Reilly succeeded him (1880 to 1898), and lived across from the reserve at what is now historic Point Ellis House.)

On August 16, 1876, Canada's Governor General, Lord Dufferin, visited Victoria and participated in a regatta on the Gorge Waterway, with boat races by Songhees and other First Nations. Dufferin gave a speech emphasizing that, since James Douglas's time as governor, the government has "failed to acknowledge that the original title to the land existed in the Indian tribes". Local First Nations regarded his speech as clear support for the protection of their rights.

In 1882, Indian Agent William Lomas presented a depressing view of the Songhees Reserve: it is "one of the most degraded on the coast, and I have little hope of it ever improving until these Indians are removed from the neighbourhood of temptations which it seems impossible for them to resist...."

From 1883 to 1894 a First Nations Special Constable resided on the reserve. The constable's job was to prevent saloon keepers from selling liquor to the Songhees and their visitors. In an 1886 report to the federal Department of Indian Affairs, Superintendent Israel Powell stated that the Songhees themselves requested the constable's appointment "as Northern and West Coast Indians were in the habit of camping on the Songhees Reserve during their trading visits to Victoria and their drunken orgies were often laid to the credit of the Victoria Indians". Lomas reported that the constable's presence "has to a great extent prevented the scenes of riot and drunkenness which were common."

The first census of the main Songhees Reserve in 1876–77 listed 187 people: 54 men, 63 women, 18 youths and 52 children. Most of the men in this census still used their Songhees names. The census-takers put remarks after some of the names:

Hay.ip.kay.num
Su.lh.kwitch.tun
Sui.ah.lah.gou
Ith.lay.use
Pul.whey.mit
Nucks.suahk.um ("hf Skatchets" [half Skagit])
Kway.mitch.ten
Swal.la.pal.lah.nuck
Un.haim
Sim.ma.lah.nook
Say.thlay.ah ("died")
Quet.Kuhg
Kale
Huck.pay.mult
Sil.low.itch.chen
Quit.tay.silluck
Qual.lay.mult
Sal.la.que.lah.nuck
Kul.chay.mult
Kweet.sah.las
Se.e.pock ("dead")
Shal.lohk
Ski.ax ("Jim chief")
Sclum.mook ("Bahk.sit")
Tsim.may.luck ("Penalacut" [Cowichan]) ("Sit.say.may-luck")
Sah.quitch.ton

Lall.leech.ton
Tee.tsay.it.ton
Kul.Kway.lum
Tsee.Tsee.wun
Whey.ook
Tsah.ney.muck
Chish
Yot.ahcum
Haw.quilluck
Pahl.sit
Quay.silluck
Ku–aw.Kwil.ton
Clui.kway.mitch.ton
Kway.mul.ton
Hul.hahl.is.ton
(S)Hut.ty.ilth
Qut.tagh
Tuck.stah.lum
Yellalth
Chit.chait.len
Chaeth.lum
Schwep.culth
Sah.pal.luck
Hah.mitch.ten
Sock
Tchai.lum
Hack.qualth.sook ("Joseph")
Shappu.kway.see.oukw

This three-part panorama by Richard Maynard shows the reserve in 1877. In the of frame 1 is Cook's Shipyard (now Point Hope Shipyard). Behind it, across the water, is Dickson and Campbell Co. (now Capital Iron) and to the left the wharf and boats of Joseph Spratt. Frame 2 shows the old road and wooden bridge (the inlet it crossed is now filled in) that led to Limit Point (now the west side of the Johnson Street Bridge). The Songhees Village, in frame 3, is still mostly old-style plank houses, but not as many as there were a decade before. The large building on the right is the Marine Hospital, built in 1874.
BC Archives HP79716, F-6749; HP93790, F-6748; and HP93789, F-06747.

1

3

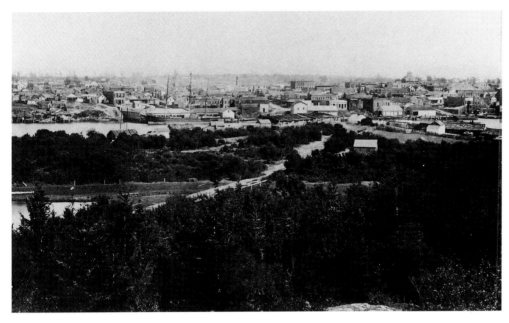

2

The steamer *Leonora* transported Reserve Commissioners to the reserve in 1877. In the background is the Limit Point area of the reserve (now the west end of the Johnson Street Bridge), where three of the original large 1840s plank houses still stood in the late 1870s. During the 24 years when there was no bridge across the harbour, people boarded a small ferry at the boat-house on the left.
BC Archives HP51976, F-04584.

Bird's Eye View of Victoria shows the key features of the city in 1878, including the southeastern part of the Songhees Reserve. BC Archives PDP002625.

Songhees' or visitors' canoes at the wharf just north of Johnson Street in the early 1880s. The ferry boathouse is across the water below Limit Point. Several of the large old-style plank houses on the reserve have been replaced with European-style houses. Those above the boathouse were moved in 1887 to make room for the railroad right-of-way and a new Johnson Street Bridge.
Richard Maynard lantern slide; RBCM, X191.

People gather to welcome the first E&N Railway train to cross the new Johnson Street Bridge on March 28, 1888. Across the bridge is the central portion of the Songhees Reserve, from Limit Point to Hope Point. The bridge was completed in 1886, giving the Songhees a direct walking path to town.
Lantern Slide, RBCM, X553.

The Railway Dispute

In 1881, Indian Affairs Superintendent Israel Powell reported that a majority of the Songhees (25 men) signed an agreement to move to Cadboro Bay, "their ancient camping grounds, provided suitable lands could be secured". The Hudson's Bay Company agreed to sell their property of 1,125 acres (455 ha) in Cadboro Bay for $56,250. Powell recommended acceptance, but the Department of Indian Affairs rejected the deal.

In 1883, Canada's Minister of Justice, Sir Alexander Campbell, visited Victoria and signed a preliminary contract with industrialists Robert and James Dunsmuir to construct a railway on Vancouver Island as part of the Trans-Canada Railway concession. The Dunsmuirs wanted land in both the Esquimalt and Songhees reserves included in the concession. The next year, Indian Affairs instructed Powell and Reserve Commissioner Peter O'Reilly to work together to find a "satisfactory location" to replace both reserves. The new site had to be "from 500 to 1000 acres" (about 200 to 400 ha) and to be within 20 miles (32 km) of Victoria.

Robert Dunsmuir, president of the newly formed Esquimalt & Nanaimo Railway Company wanted the Esquimalt Reserve as the site for the railway's southern terminus. Powell reported to Indian Affairs "that the terminal buildings would be extensive and he [Dunsmuir] would insist upon getting the whole reserve". He acknowledged that the Esquimalt people were "very anxious" about the E&N Railway's intentions and stressed that the matter had to be resolved before any construction began. He had hoped to remove the Esquimalt and Songhees from their reserves quickly, but found the 20-mile limit an unreasonable restriction. Later in the year, Ottawa instructed Powell to "induce the Indians to remove to some suitable place and at as great a distance from the town as they will agree to."

On December 29, 1885, growing impatient with Powell's unsuccessful attempts to relocate the Songhees, the E&N notified him that it would take possession of a rail-line right of way through the Songhees Reserve "as they were allowed" according to the Consolidated Railway Act of 1879. Following negotiations with the Songhees and monetary compensation for people who had to move from the

right of way, grading operations for the railway began in 1887. A year later, the railroad officially opened for traffic through the reserve.

Meanwhile, Powell and O'Reilly recommended the purchase of 1635 acres (662 ha) in Metchosin at Weir Beach for a new reserve, conditional upon the consent of the Songhees and Esquimalt people for the sale of the two reserves. Robert Dunsmuir offered the Songhees $60,000 for their reserve, but they rejected it. On March 19, 1890, in a letter to the Victoria Indian Office, Dunsmuir stated that his company considered the Weir Beach site "totally unfit" for a reserve, as the Songhees informed him: "it is both bleak and cold and in the winter season impossible in a south east wind to land from a canoe".

In 1891, the federal government received an offer from the Vancouver Island Land Investment Company to purchase the Songhees Reserve for $350,000, with a deed of 15 acres (6 ha) to the E&N Railway Co. But the Songhees refused this offer as well.

The Songhees Express Their Terms

On December 3, 1893, Chief Charley Freezie (son of King Freezy) and 68 other Songhees men and women signed a letter expressing their willingness to dispose of the reserve "under arrangements beneficial to them". But, competition between the provincial, federal and civic governments prolonged the move.

The impetus for moving the Songhees Reserve was largely based on the European perspective that any land not fully exploited for profit is not being properly used. Many government officials and local citizens wanted the land to be managed by people who could best develop it for its monetary value – and in their view, these people did not include the Songhees. The newspapers published several opinions on why the Songhees should be removed from the Inner Harbour: some blamed them for creating a negative impact on the city; some claimed that city life had a demoralizing effect on First Peoples; and others simply saw the Reserve as a "great eye-sore to Victorians".

On January 29, 1896, the *Colonist* called moving the reserve a matter of the "utmost importance to the citizens of Victoria". That the occupation of this "very valuable

piece of land" by a people "who will not use it as it ought to be used" will continue to be "a great drawback to the city". They claimed that it was in the interest of all concerned, "including the Indians themselves", that they be removed with the "least possible delay". The Songhees would then be "comfortably settled in a place where they could live happier and better lives" and the "now useless" land on the Inner Harbour would "contribute to the progress of the city and would add to its beauty".

Over the next five years, the provincial and federal governments haggled over the expenses of moving the Songhees and who would own the reserve land. This was complicated by the presence of the E&N rail line and the company's legal battle with the province over the value of the land it occupied and payments due. Meanwhile, the city was growing around the reserve, and the municipality applied for rights of way through the reserve to connect streets on either side and to a bridge.

On November 5, 1897, the *Colonist* offered a solution for the Dominion's position:

> The Indians are the wards of Canada, and all their reserves are held in trust, with a reversion to the province after the death of the last Indian.… [The province argues that] the provision in the Indian Act, whereby the reduction of reservations is authorised in case the number of Indians is greatly decreased, applies to the Songhees reserve, and that the Dominion government can therefore with perfect equity recast the reserve … so as to make it more appropriate to the present condition of the Indians. As yet the Dominion authorities have not seen their way to assent to this view.

A March 1898 editorial in the *Colonist* argues that as "the Indians are gradually decreasing", they will soon "become extinct, or lose their tribal distinctions". Since "they occupy some of the best lands" the province should not "barter away any constitutional rights as a matter of temporary convenience".

On January 1, 1901, a petition circulated throughout Victoria urging the province to settle the removal of the Songhees before the end of the year. It stated that the removal would be of "advantage and benefit to the Indians … and besides, it would tend greatly to increase the material welfare and prosperity of the city of Victoria." It also argued for the need of a public park in that part of the city.

In February 1901, James Dunsmuir, now Premier of British Columbia, proposed that the Dominion surrender to the province two portions of the reserve, totalling 42 acres (17 ha), sell the remainder and give any post-move surplus to the province. The Dominion agreed, but could not find an appropriate site for a new reserve.

In 1904, the Dominion made another proposal, but the Songhees rejected it. On March 7, 1905, Premier Richard McBride acknowledged a major failing in the negotiations so far:

> It was clear that the Indians must retain possession of the Reserve until they were made party to an arrangement satisfactory to them. The Indians had been taught to believe that it would be foolish for them to yield their tenure without a considerable indemnity and generous terms. They could not be removed by force. The first essential was to get the Indians to acquiesce in an agreement.

On September 28, 1906, McBride sent a letter to the Dominion saying that the province was now "agreeable to the detraction from their reversionary claim to the moneys to be netted from the sale of the reserve", and with the "total expenditure to be made on account of the Indians and the surrender of their present title."

Frank Pedley, Deputy Superintendent General of Indian Affairs, came to Victoria to try to reach a settlement. He declared that the city "had no legal status in the affair", that the only hope of reaching a settlement was by direct negotiations with the Songhees. But all his attempts failed due to the problem of finding a site for the new reserve. The Songhees agreed to move, but would accept "no reserve other than their old camping ground on the Hudson's Bay property at Cadboro Bay".

Again, the negotiations fizzled out, and in June the following year, the province reverted to its old position when Premier McBride "declared publicly that he believed the reversionary interest, and therefore right of settlement" in reserve lands rests with the province.

First Nations camp, possibly Songhees, on the shore of James Bay west of Menzies Street, about 1899.
Richard Maynard cabinet card; RBCM PN8751.

Tsimshian visitors on the beach just north of the Johnson Street Bridge, ca 1902. Cabinet card; RBCM PN06104.

First Peoples landing canoes at Cattle Point about 1900. This was the landing place for Songhees living on Discovery Island.
A.G. Franklin photograph;
BC Archives HP098838, H-02401.

Saanich people camping at the old public market near Store and Chatham streets in Victoria, September 23, 1904, after their return from picking hops in Washington. RBCM PN1433.

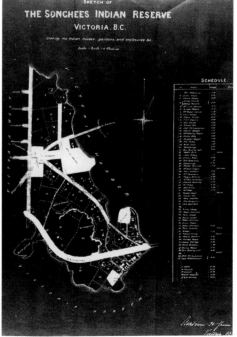

This map by Ashdown Green was part of a formal survey of the reserve in February 1906. It shows property owned by Songhees individuals, common lands and rental properties.
National Archives of Canada NMC12392.

14
Employment, Recreation and School, 1880–1900

Census of the Songhees Reserve, August 26, 1886, taken by Indian Agent William Lomas: 81 adults, 12 youths, 41 children; total, 134 people. (This census did not include the Esquimalt or Discovery Island reserves, nor people from other First Nations, who camped on the reserve seasonally, especially in the fall when they came to purchase supplies.)

Victoria resident Edgar Fawcett observed commercial ventures on the Songhees Reserve in the 1870s and 1880s:

Groups of men may have been seen carving miniature canoes with carved Indians … while three or four Indians would be at work shaping a full grown canoe…. The women … made fancy articles out of tanned deer hide embroidered with pearl buttons and beads, moccasins mostly, … worn for slippers. I have bought many pairs at fifty cents a pair. The blankets they wore were decorated with rows of pearl beads down the front, red blankets being the favourite…. All these articles, as well as … game, fish and potatoes and fruits, were brought to our doors[:] … grouse 35c. to 50c. a pair, wild ducks the same, venison from 5c. to 8c. a pound … potatoes about 1-1/4c. lb., salmon 10c. each, wild strawberries at about 5c. lb. Even gumstick for lighting fires was brought to the door at 10c. a bundle. Oysters and clams for 25 cents … a bucketful…. All these cheap foods were a Godsend to early residents, and at the same time were fresh and wholesome.

City merchants welcomed visitors from Clayoquot Sound on June 14, 1881. The *Colonist* reported the arrival of four large canoes of Nuu-chah-nulth families who brought seal skins and other items to trade and "are said to possess a good deal of money which they are not at all backward in spending". Johan Jacobsen, a visiting amateur anthropologist, observed on September 3 that "the streets of this town swarmed with Indians of all kinds, for Victoria is the Indian centre of the coast…. Indians come here each year to trade

their furs, others came to seek employment, and fishermen came for commissions from canneries".

On September 3, 1893, the *Colonist* reported that First Peoples had returned from their jobs at the canneries and were holding potlatches on the reserve. The workers, "well provided with chickimin [money,] are giving the police plenty of business". Two days later, most of them were on their way to work in the hop fields of Washington.

But seasonal work was not always dependable, and sometimes work was very difficult to come by. The minutes of a Songhees band meeting on March 20, 1897, contains the resolution:

As very few of us have been able to obtain any work during the past winter we are compelled to ask the Department to allow each head of a family the sum of five dollars … to purchase seed, fishing gear and provisions … to be taken from the funds to the credit of our Band held for us by the Department. The number of heads of families is at present thirty four.

They also requested two debts to be paid for out of the trust held by Indian Affairs: $20 for a plough purchased by the late Chief Charley Freezie and $30 for a funeral. Indian Agent William Lomas forwarded their requests to Indian Superintendent A. W. Vowell, urging him to accept them:

At the present time most of the Indians of the agency are in a poorer condition than I have ever known them to be, but this is more particularly the case with the Songhees – formerly most of the men obtained employment on the wharves and in city, now this labour is done by white men…. The closed season for salmon on the coast has affected them very much, particularly the old men, as formerly they earned a good living by trolling in the bays near Victoria and Esquimalt.

Vowell authorized Lomas allot the cash to band members and to pay the balance owing on the plough, but he said that the funeral expenses were "too great an outlay for such a purpose" and consented to a lesser "reasonable amount".

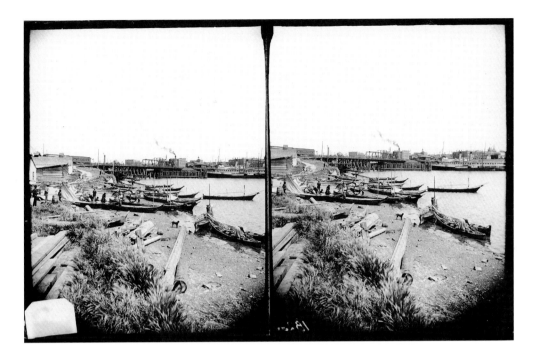

Canoes drawn up on the reserve beach south of the Johnson Street Bridge (in background), ca 1891. They likely belong to First Peoples returning from summer employment in fish canneries. The last of the old-style plank houses is visible on the left.

Stereograph attributed to Richard Maynard; BC Archives HP18265, H-5002.

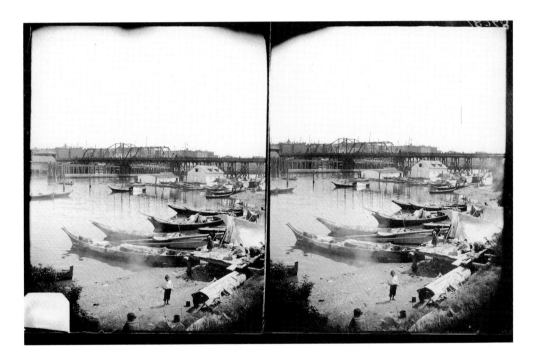

Visitors camped on the beach north of the Johnson Street Bridge (in background) between Hope and Limit points, likely also cannery workers.

Contact print stereograph, BC Archives HP18268, H-5005.

A family prepares to leave the reserve. Cabinet card print attributed to Richard Maynard; RBCM PN06839.

On May 13, 1897, the *Daily Colonist*, unaware of the economic condition of the Songhees, suggested that reserve changes were undertaken to increase land values for the sale of the reserve:

> Throughout the Songhees reservation [sic] new fences, fresh paint and substantial additions are the order of the day, the native residents either having become suddenly imbued with the desire to improve their homes and their surroundings, or else are filled with the idea that when values are set upon the reservation property these little things will all be taken into consideration to the advantage of those who look ahead. The number of gardens under cultivation is also greatly increased this year, and the Songhees on the whole have apparently awakened to an understanding of the advantages of civilisation.

On December 20, 1898, a *Colonist* editorial comments on the economic conditions of the Songhees:

> HAVE THREE RESERVES – Songhees Indians Better Off in the Way of Homes Than Most People
> Besides what is known as the Victoria [Songhees] Reserve there is one at Esquimalt and another on Discovery Island. According to the registry at the Indian office 116 of these Indians have their homes on the Victoria reserve, 36 on Discovery Island, and 20 at Esquimalt.... At the present time with very few exceptions they are all on the Victoria Reserve, while during the summer the majority will be found on the other reserves.... All of the Indians are practically self-sustaining, what they do receive from the Dominion government coming out of funds that belong to them. A few years ago most of the men … found employment in the sawmills, on steamers and along the wharves, but the Chinese sawmill hands and the white longshoremen have taken their places. Now they make a livelihood by fishing and doing odd jobs.

The Sealing Industry

Sealing was a major industry in Victoria during the latter decades of the 1800s, employing many First Peoples. In the early 1890s, the sealing industry directly employed about 8500 people and brought an average of $750,000 annually

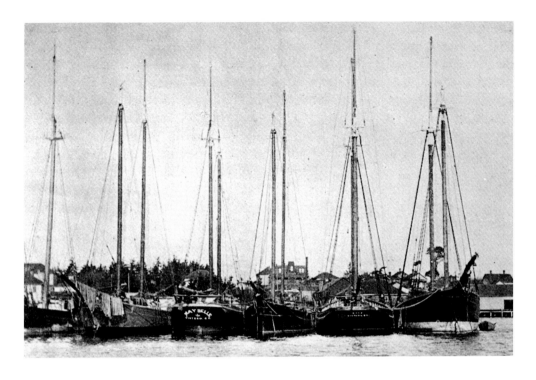

Sealing boats at the docks of the Victoria Sealing Company in the harbour, early 1890s. The *May Belle*, fourth from the right, sank in 1896, losing all on board, including almost all the men of the Becher Bay Reserve.
BC Archives HP045724, C-00461.

Sealing boats moored in the Gorge Waterway. The Rock Bay Bridge is in the background and on the left is the reserve's Point Ellis Shipyard.
BC Archives HP00383, A-0183.

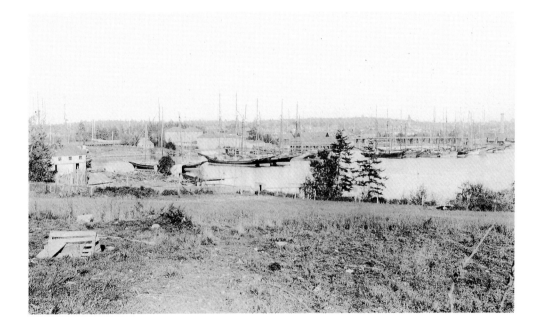

into Victoria's economy. In 1894, 59 schooners operated out of Victoria, employing 518 aboriginal and 818 non-aboriginal people; that year they brought in a 94,474 seal skins.

The schooners transported hunters and canoes to the sealing areas. A hunter worked in tandem with a paddler, whose job was to get him close enough to harpoon or shoot a seal (hunters almost always used harpoons). The owner of the schooner provided all supplies and ammunition. Hunters were paid $2.50 to $3.25 for each skin. Canoe paddlers (sometimes women) received a monthly wage plus a small amount for each skin. On shorter trips off the west coast, the aboriginal crews kept the bodies of the seals and dried the meat for food.

First Nations crew made a lot of money when hunts were successful, but two voyages in the mid 1890s resulted in tragedies that devastated many families. On April 14, 1895, the schooner *Walter A. Earle* capsized in a violent storm on off Cape St Elias, Alaska, killing all aboard, including 12 aboriginal men from Victoria and 14 from Metchosin and Sooke. Then, in January 1896, the schooner *May Belle* sank off Cape Cook, Brooks Peninsula, drowning 22 men, which included practically the entire adult male population of Becher Bay.

The sealing industry began to decline around the turn of the century. The Victoria Sealing Company sent out 36 schooners in 1901 and only 5 in 1907.

Limit Point area of Reserve, 1898–1901. None of the old-style plank houses remain and a new boathouse has been built on the beach. The large dark-coloured building above the boathouse is the home of Chief Michael Cooper. The high area in the background is now the area of condominium developments above Tyee Road. RBCM History Collection #972.280.2 (PN13060).

The Changing Face of the Reserve

Anthropologist Franz Boas visited the Songhees Reserve on September 19, 1886, and wrote: "Only a few of the old houses are still inhabited. The Indians have built themselves others according to the European plan."

On July 25, 1899, the *Colonist* reported on the fate of some of the remaining older-style houses:

> The old Indian shacks across the bay near the marine hospital … are being torn down and more modern structures will soon occupy their places. The old shacks were all built of man-made boards…. Many relic-hunters have been going there during the past few days, carrying away sticks and pieces of boards…. The houses were built … over 60 years ago, and the largest of the three has been the scene of many potlatches.

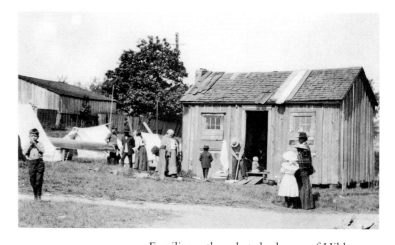

Families gathered at the home of Hibbens Joseph, south of the Marine Hospital, possibly getting ready for canoe races in the early 1900s. The woman at the left corner of the house may be Mary Rice from Kuper Island. RBCM PN8831.

First Nations Canoe Racing and Celebrations

Boat regattas on the Gorge Waterway began during the gold rush of 1858, started by American visitors celebrating their Independence Day on July 4. But the local British forbid the event on July 4 and encouraged moving it to May 24 in celebration of Queen Victoria's birthday.

In the 1870s First Nations canoe racing became a part of the larger Gorge Regatta, in which thousands of people brought boats up the waterway for the festivities. Just below the Gorge Falls, the navy strung colourful banners across the waters. Teams raced against each other in various kinds of boats; there were events for navy personnel, local clubs, the Chinese community and First Nations, with local dignitaries handing out prizes to the winners.

In the earlier regattas, the First Nations canoe races were divided into "Southern Indians" and "Northern Indians", but by the 1890s, mostly southern groups took part. The canoe entries for 1895 included the Songhees, Saanich, nine bands from the Cowichan and Chemainus areas, the Ditidaht from the west coast, and the Snohomish and Lummi from Washington. There were several kinds of canoe races for men and women, but the most exciting was between the 40-foot (12-metre) war canoes. The war canoes started at a barge near the Gorge Falls and raced eastward to Halkett Island and back. In 1876, a Songhees canoe won the 3.2 km race in 15 minutes.

After 1900, canoe races were sometimes started in the Inner Harbour and rowers used specially designed racing canoes. In the 1920s and 1930s local First Nations organized most of their own races at other locations, but continued to be part of the Gorge Regatta. After the start of World War II, the Gorge races became less regular. They stopped in about 1948, and were then held on the Gorge Waterway only on special occasions. Canoe races remain as a popular sport on Vancouver Island reserves to this day.

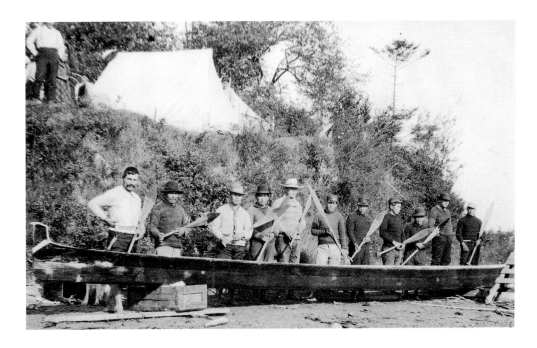

Ready for the races: a visiting team from the Cowichan Westholme Reserve prepares to launch their canoe from the eastern shore of Hope Point in the early 1900s. Left to right: Big Joe, Jack Norris, Ed Norris, Louie Norris, Sta-tsun, unknown, Freddie Joe, Moses Seymour, Johnny Norris, Big Brown and David Jack.
RBCM PN8911.

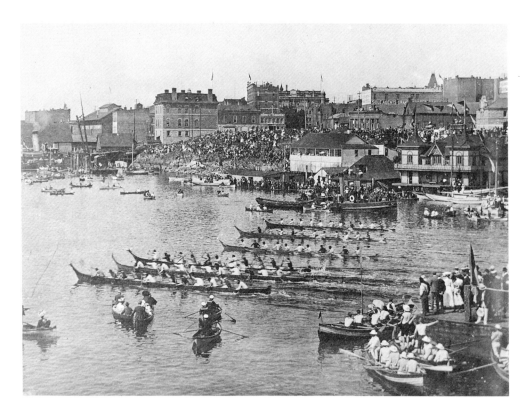

Canoe races on Victoria Day, May 24, 1904, starting in Victoria's Inner Harbour.
BC Archives HP20270.

First Nations canoe races on the Gorge Waterway in 1900. The closest team is Cowichan, paddling a modern-style racing canoe.
A.G. Franklin photograph; BC Archives HP098854 H-02417.

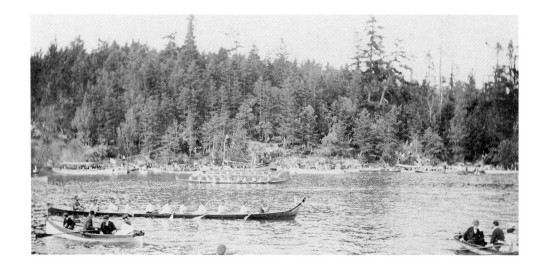

The Songhees Reserve School

In January 1887, the Songhees requested that the Department of Indian Affairs build a school on the reserve for 40 children, but Indian Superintendent Israel Powell felt that the funds would not be approved due to the uncertain future of the reserve location. Finally, in 1891, the department built the school and opened it on June 8: 22 children attended, aged 4 to 17.

The school's first teacher, John Raynes, reported to Powell on January 17, 1893:

> Since July 1, 1891, the school has been attended ... irregularly. Five children have left to live at another reserve.... Six children have died. Last year (1892) there was a visitation of the small pox, and after it had died out and I reopened the school, the attendance was extremely small owing to the fact that a large number of the Indians had left the reserve and were afraid to return for some months. Five children between 10 and 13 years of age left about September last to go to the Roman Catholic college.... In June of 1891, seven or eight young fellows of 16 to 25 years of age ... only attended the school for that month in order to have a little instruction before they went on their annual fishing expedition.

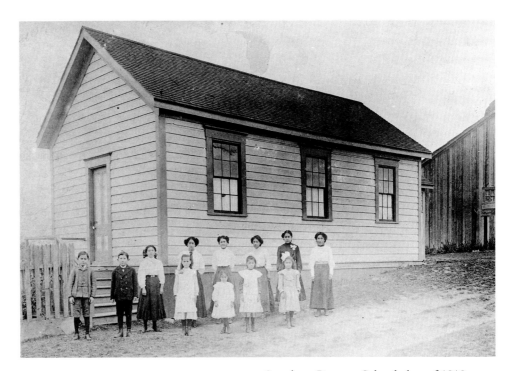

Songhees Reserve School class of 1910. Built on the north side of the Johnson Street Bridge behind the home of Chief Michael Cooper. The second boy from the left is the chief's son, George Cooper, and the girl beside him is Ellen Albany.
BC Archives HP021832, A-07690.

15
The Ches-lum George Potlatch of 1895

On January 1, 1885, an amendment to the Indian Act banned potlatches and a dancing ceremony called the *Tamanawas* (Blackface Dance). Many non-aboriginal citizens considered the law unnecessary, and although a few officials tried to enforce the ban, most ignored it in Victoria.

The biggest potlatch of the 1890s was a memorial held by Ches-lum George (ca 1855–1903), the great grandfather of Norman George, who was Songhees chief from 1991 to 1997. Ches-lum held the potlatch in 1895 to honour his late wife and two daughters. The following accounts of outsiders contain obvious biases and misinterpretations, but they give us a flavour of the events.

On May 23, the *Daily Colonist* reported on the activities of the previous day:

> Indians … have been arriving at the Songhees reserve, and now the whole place is dotted with tents and presents a most animated appearance. There are … many British Columbia tribes, and several canoe loads from [Washington].… Yesterday morning at sunrise the

Indians went to their graveyard on the point [Lime Point] and gathered in a large circle around the … departed.… Relatives and friends then recited in glowing terms and with dramatic emphasis the virtues and prowess of the dead and occasionally one would break into a … song, full of plaintive melody.

Then a series of small potlatches took place. The Cowichan hosted the first, starting at 8 a.m. at the back of a house where blankets were piled on a scaffolding. Dancers hid below the stacks of blankets in an area curtained off by hanging blankets.

There was a chorus of twenty-five men and women with blackened faces, and in the front row were four braves having the heads of birds and animals. Before the play commenced several old men took their place before the curtain and proceeded to deliver short and eloquent orations descriptive of the great deeds of the Cowichans.… [At the sound of a rattle the curtain went down] and the chorus began to sing, while the strange

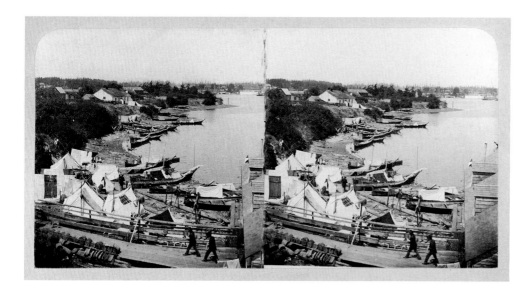

Visitors camped on the stretch of beach from Limit Point to Hope Point in the mid 1890s. They may be visitors attending the Ches-lum George potlatch, or possibly an earlier potlatch reported by the *Colonist* on September 3, 1893, after they returned from working in fish canneries. All the canoes are rigged with sails.

Richard Maynard stereograph; RBCM PN6834.

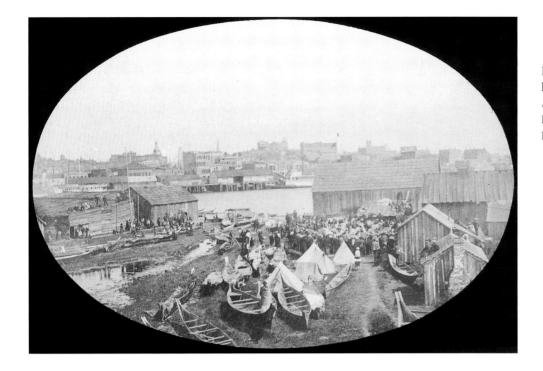

People gathering outside Ches-lum George's house for the distribution of blankets and *Sxwayxwey* dances.
Richard Maynard lantern slide;
RBCM PNX120.

birds opened their mouths and flapped their wings, keeping in time to the music with a swaying of the body. This was repeated four times.

The event concluded with two men throwing blankets from the platform to the large crowd gathered below. People grabbed the blankets and some offered the others five or ten cents each to let go.

In the afternoon, Mary Tate held a memorial potlatch for women only, to honour her brothers, Henry and Joe George, who had drowned on the sealing vessel *Walter Earl* just a month before. The *Colonist* reported that Tate gave her guests blankets and "trinkets", then they all sang mourning chants.

> Late in the afternoon the men gathered in one of the large houses and the storytellers … entertained them with tales of valour and of love. The legends … were recited, and also of the days when war raged and the tribe went forth in all its power to crush its rivals.…

> The great event … will be the potlatch to be given by George, a well-known Songhees. Elaborate preparation is being made.… The dances, potlatches and other ceremonies … now being presented … certainly have never

before been presented within sight or sound of city civilisation. They are full of peculiar interest to the student as well as the sightseer.

On May 23, people held more potlatches to pay off debts. An old man called a "lawyer" stood beside a wagon heaped with blankets – he called out the names of creditors and each one came forward to receive a blanket. All day inside and outside the big houses, people "scrabbled" for blankets and other goods thrown from elevated platforms and rooftops. The following day, First Nations participated in the Gorge Regatta, as part of Queen Victoria's birthday celebrations.

The Ches-lum George potlatch took place on May 27. Reporter David Lewis covered the event for the *Colonist*. In his article, titled "A Potlatch Dance", he described part of the elaborate *Sxwayxwey* dances, seen for the first time by many Europeans. Today, these dances are performed indoors and viewed by invitation.

> At 10 a.m. … many Victorians and their American cousins might have been seen wending their way across the railway bridge … where all was bustle and preparation, a dressing room … having been improvised by

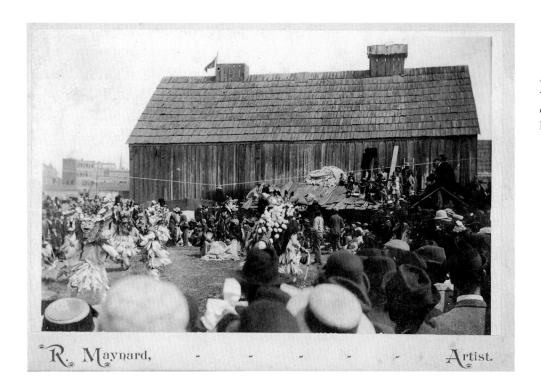

R. Maynard, - - - - - Artist.

Above the *Sxwayxwey* dancers is a rope from which a container of money is suspended, as described in David Lewis's account.
Richard Maynard cabinet card; RBCM PN6884.

stringing red bunting around poles planted in the ground at the corner of a large dwelling house.... After mature deliberation and frequent consultations, a ring was formed by planting poles in the ground about twenty feet apart, and to these were attached native blankets, so as to form a barricade about four feet in height. These blankets, woven from the hair of the mountain goat ... and in some cases are dyed in the most artistic fashion. Then a rope was attached to one of the adjacent buildings, carried across the circle and made fast to one of the poles. To this rope ... was tied a string which hung down about two feet, so that it was just within reach when standing on tiptoe. What purpose this was to serve was a mystery and gave rise to many surmises among the spectators.... To intensify our curiosity they kept fooling around with that bit of string like boys around a wasps' nest. First an Indian held the pendant loop in his forefinger, and in that position delivered quite an oration in silvery sonorous Songhee, then the string, slipping off his finger, would be jerked up with the rebound of the rope.... A small box was brought, in which was ... placed a considerable amount of money,

and the lid ... securely tied down, it was attached to the loop of string. Then the shouts and singing, a canoe was carried in, and piles upon piles of blankets heaped over it.

In place of the blanket barricade about thirty [women] ... seated themselves around the enclosure: each one was provided with two cedar sticks about eighteen inches long [50 cm].... Our notice was attracted to a large dwelling-house near by, from the door of which a procession of three men and three women was moving in our direction, the women carrying three effigies representing a woman and two children. They were most fantastically attired in goat's hair robes, with ermine skins sewn on, and head-dresses of down and feathers, the latter being flexibly attached so that they swayed about in startling fashion with each movement of the wearer.... In their hands they carried rattles made by stringing the bills of gulls upon small wooden hoops, which produced a dry, harsh noise when shaken. As they advanced within the circle, the row of [women] started up a weird chant, keeping time by beating with the cedar sticks upon boards placed in front of them. These effigies, which we discovered were intended to represent the dead wife and

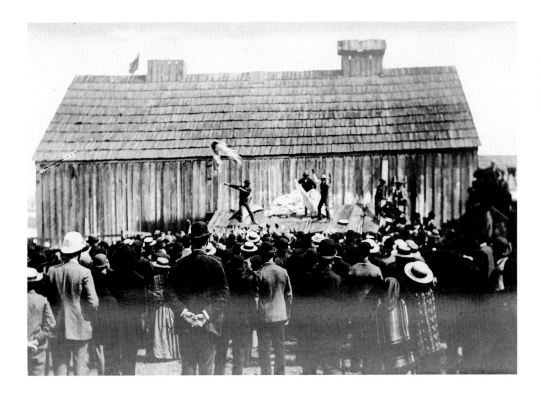

Men throwing blankets from a platform attached to Ches-lum George's house.
Attributed to Richard Maynard; RBCM PN6808.

More *Sxwayxwey* dances. In the lower right corner, standing next to the woman wearing a white woollen blanket, are two women and a cloth model representing George's deceased wife and daughters. In the lower left, people are rapping sticks on a wooden beam to accompany the music.
Edward James Eyres photograph; RBCM PN6492-B.

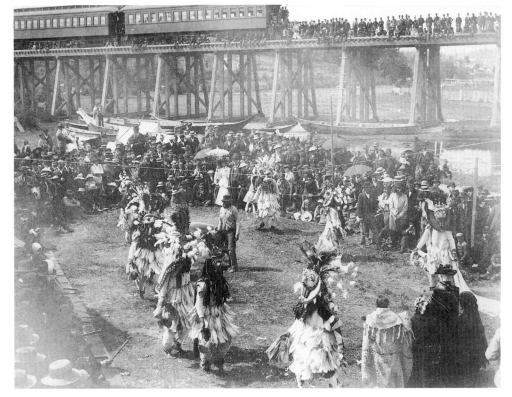

children of Chief George, and in whose honour this potlatch was given, were placed most reverentially in the canoe. Where upon some of the sage counsellors and orators of the tribe came forward, and in an amazing flood of eloquence … extolled the character and good deeds of the departed wife, and recommended their listeners to emulate her exemplary career…. After the speeches, native blankets were taken out and cut into strips, and … distributed … the remaining blankets placed upon the roof of a small shed … which was to serve as a further distributing point at the conclusion of the dance.

At the side of the open space were placed chairs upon which two aged crones seated themselves, and supporting between them the effigy of the late lamented Mrs George. One of them held a framed representation in her Sunday best upon her knee. Then at a given signal began again that … chant…. The dancers now emerged from their dressing-room, one by one, and at intervals, until there were ten whirling … figures tripping about in time with the chant…. The feet were bare but ermine leggings, trimmed with ever-clashing puffin beaks, encased the legs from the ankle upwards, while the body was concealed by a robe made of gull and eagle feathers, these turning and twisting with every motion of the wearer…. Wooden masks covered the face, while over the back of the masks and hanging down the back were shawls trimmed with ermine. To the top and sides of the masks were attached fringes of hair made from cedar bark, dried and beaten into threads, while feathers and down stood erect upon the forehead. In the right hand was a hoop, upon which was strung … large pecten shells…. The slightest movement of the wrist … caused them to clash and jangle together. Some of the masks displayed great artistic taste and skill in their construction. A specimen of the cunning manner in which a representation of a … distorted human face is combined with a bird's head…. The bill of the bird is retained in position by stings manipulated by the wearer, and the transfiguration is quite startling to behold. This occurs as some critical time in the description of exploits and legends, as chanted by the chorus of women. In some masks the eyes and mouth are so contrived that they roll about in most alarming fashion. Loops and thongs bind the mask to the head, and sight holes are pierced either in the nostrils or eyes of the mask, apertures being also cut for breathing through. It would seem that to even bear the weight alone of these masks for any length of time would be extremely fatiguing, [but they danced …] for fully forty minutes. At certain periods the time of the chant would be changed by striking the cedar boards with the sticks held in each hand, alternately; then it would stop unexpectedly, with some word … to burst out again after an interval of a few seconds….

At the conclusion of the dance, the assembled Indians gathered around the suspended wooden box containing the money, the rope,… being so lifted by a pole that the wished-for prize was far beyond reach…. Now the box is allowed to drop among the expectant swarm, but being securely tied with string, it is by no means an easy matter even then to obtain the much coveted money, and the scene that followed simply baffles description…. Like a pack of hungry wolves quarrelling over some desired morsel, those on the outskirts climb over the men in front of them,… when they disappeared as if down the vortex of a maelstrom. It was one surging, writhing, revolving, struggling mass of humanity for fully fifteen minutes, when, with a shout, the lucky man emerged from the confusion minus half his shirt,… dishevelled, but bearing aloft in his clenched fist the source of the excitement…. Two men commenced throwing the blankets among the crowd when a similar scene was presented, with the exception that a man was entitled to as much of the blanket as he might hold in his hands or under his arms; those not interested in that particular blanket, cutting it into pieces with their knives,… these … are torn to pieces and again woven into blankets…. Now, a potlatch dance is generally preceded by a feast, but in this instance the order was reversed, the feast taking place in the evening.

Lewis did not attend the feast, but did describe the eating of *soopolallie* (whipped soap berries, also called "Indian ice-cream"). On May 30, the *Colonist* reported that the large crowds of visitors "had greatly diminished" and the potlatch had ended.

Mud Bay

Beginning in the 1870s, visitors from the west coast of Vancouver Island camped on the shores of Mud Bay in the southwest corner of the Songhees Reserve. A narrow peninsula called Lime Point separated Mud Bay from Lime Bay, to the west. There was once a trench across the peninsula that was part of a fortified village on Lime Point about 1200 to 600 years ago. In the mid 19th century the point was a burial ground. Half of Lime Bay is now located at the foot of Catherine Street. The other half was filled in by industrial development in the 1930s, as was all of Mud Bay; later, condominiums were built on the landfill.

In the time of the old Songhees Reserve, several band members had properties in this area. By the early 1900s, European-style buildings overlooked Mud Bay, occupied by Songhees and their west-coast relatives. Visitors from the west coast camped here on their way to and from the fish canneries on the Fraser River. Mud Bay had a broad beach when exposed at low tide, ideal for landing canoes.

The many photographs from this area show the build-up of houses and the coming of the railway. The railway extended from Russel Station near the corner of Esquimalt Road and Bay Street, down to and along the back of the northeastern corner of Mud Bay and then northeast. to the Johnson Street Bridge.

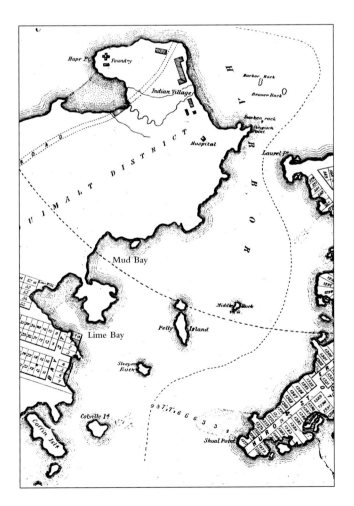

The Inner Harbour in 1863, showing Mud Bay and Lime Bay.
BC Archives Alfred Waddington, City of Victoria, CM B272.

Two-part panorama looking north at camps in Mud Bay and Hattie Dick's property, 1901–3. The Columbia River fishing boats indicate that the visitors have returned from working in the Fraser River canneries all summer.
RBCM PN6815 and PN6817.

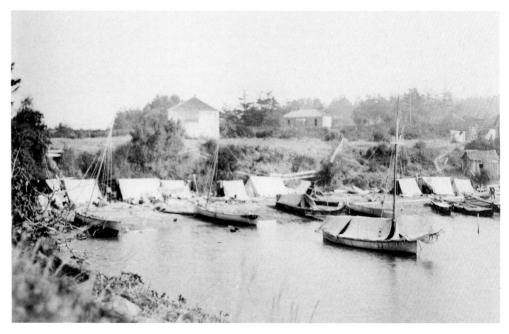

1

Two-part panorama of Mud Bay, 1909, showing canoes ready to be finished (left) as well as a "Kwakuitl style" pole in front of the house.
Harlan I. Smith lantern slide; RBCM PNX125.
William Taylor photograph; RBCM PN6872.

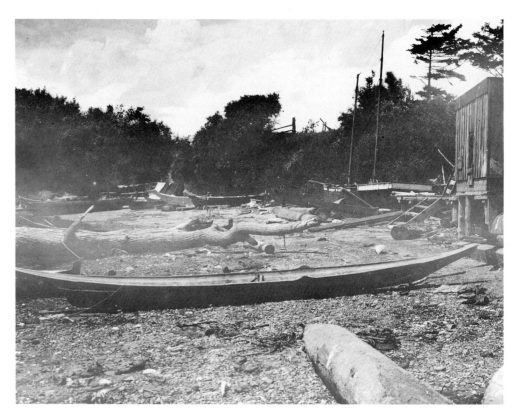

1

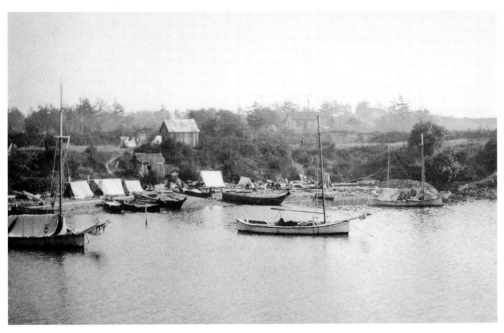

2

2

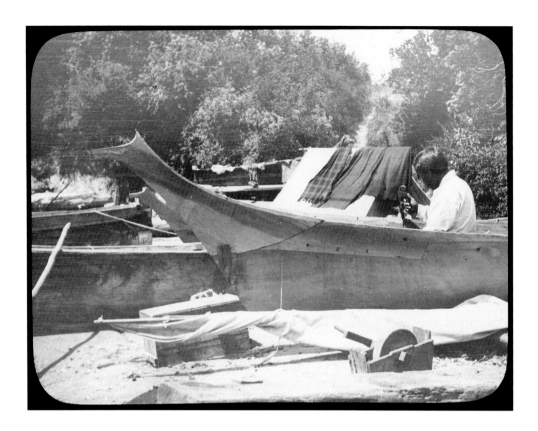

Nuu-chah-nulth man at Mud Bay carving the inside of a canoe with a D-adze.
Harlan I. Smith lantern slide; RBCM PN26009.

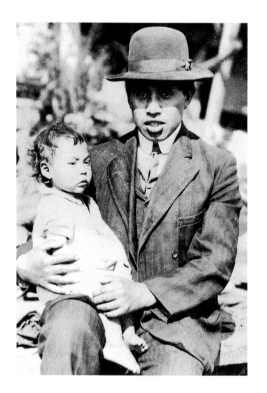

Songhees band member Robbie Semalano (also known as Robert Davis) holding a baby. Robbie married Martha (T'chin-tz) of Elwha, Washington.
RBCM PN8836.

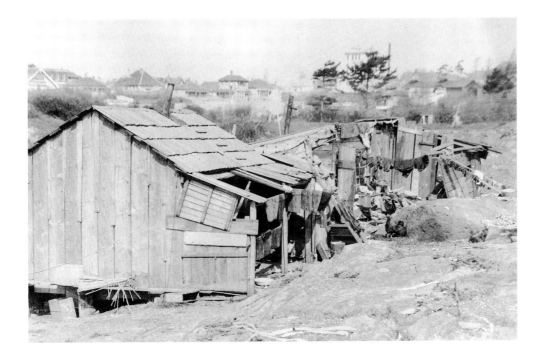

The backs of houses on the east side of Mud Bay, ca 1910.
RBCM PN8830.

Nuu-chah-nulth man carving a northern-style pole on the porch of a house, ca 1910.
RBCM PN8858.

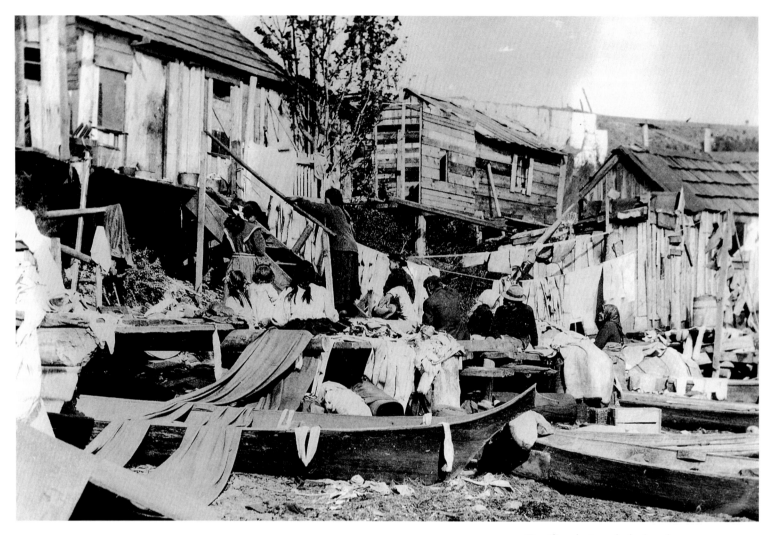

Families drying cloth that they appear to
have dyed, 1910–12.
RBCM PN8880.

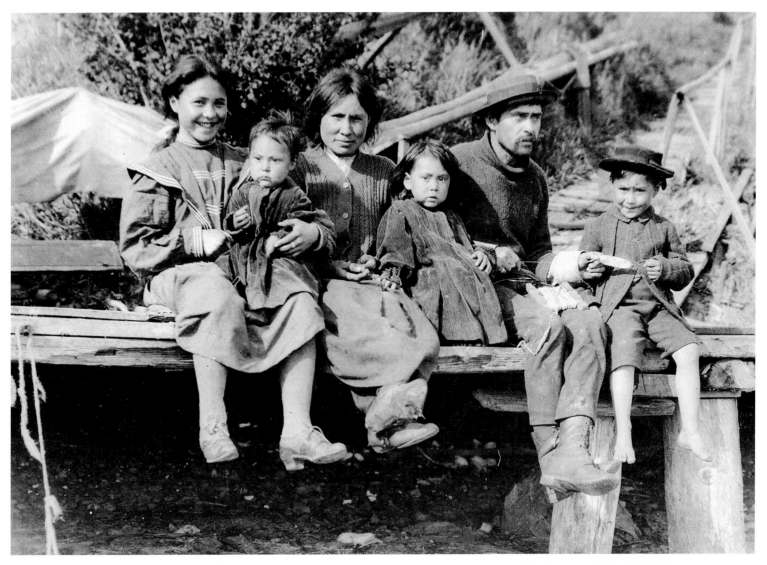

Family at Mud Bay, 1910–12.
RBCM HP8883.

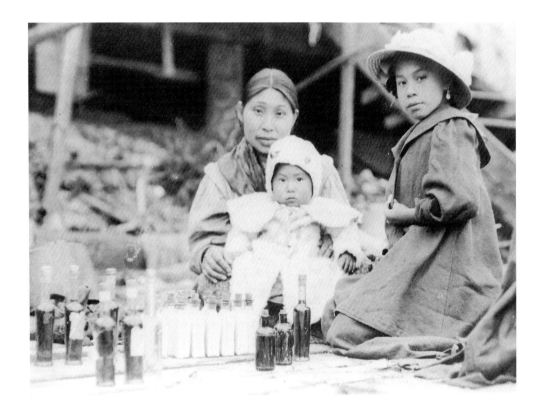

A woman and her daughters selling milk and other liquids, 1910–12.
RBCM PN8834.

Man and boy at Mud Bay, 1910–12.
RBCM PN8848.

Boy wearing the latest style striped shirt,
1910–12.
RBCM PN8806.

Man with load of blankets, 1910–12,
probably taking them to be given away
at a potlatch.
RBCM PN8859.

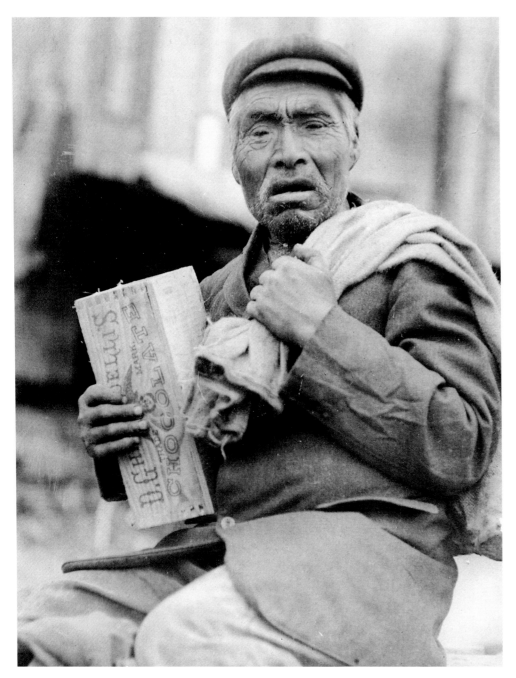

Small boy at Mud Bay, 1910–12.
RBCM PN8885.

A man with a chocolate box and sack,
1910–12.
RBCM PN6887.

A Songhees Christian cemetery on Lime Point. The two-storey house in the background is at 211 Mary Street. The house on the far right is now an open space just south of Spinnakers Brewpub and Guest House on Catherine Street.
Howard Chapman photograph (dry plate); BC Archives HP99388, H-3206.

16
The Last Big Potlatches, 1900–1908

Between 1901 and 1904, an unknown photographer took several photographs of boats arriving at the Songhees Reserve. They may have been returning at the end of the fishing season or bringing visitors to a potlatch, possibly Tommy George's in 1901. Many are the new Columbia River fishing boats.
RBCM PN6841.

Willie Jack's Potlatch

On May 21, 1900, Willie Jack, the son of King Freezy by his first wife, Tsullace, held a potlatch to pay back his debts. The *Colonist* reported that Jack's payment was considerable: "From the … owner of a buggy, a sailboat, a war canoe and many, many blankets, to say nothing of a long list of other valuable and desirable effects, which were the envy of his neighbours, Willie suddenly dropped to that of the average resident of the reservation. Affluence became sufficiency."

The report went on to describe the events:

In all over two hundred persons attended the potlatch … in the wee small hours…. The guests … congregated in front of the old square hut of roughly hewn slabs which fronts on the roadway to the Marine hospital at a distance of some fifty feet [15 m] from the Railway Bridge. A driftwood fire was built in the centre of the roadway, and the assembled guests sat in a circle around this…. The guests had hardly taken their seats when there was a demonic yell from the blackness beyond the light of the fire. Then came a hurrying patter of bare feet, and a dancer, with a gaudy headdress of red flannel and heavily rouged brows and cheeks, and wearing the customary coat of feathers, broke in to the circle. Then the dance began. One by one others took up the step, klootchmen [women] as well as men, and soon a number were jumping up and down … to the tune of a couple of tom-toms and … [the] chant of the onlookers. So the hours passed, with little intervals of feasting, until daylight – the hour of Willie's sacrifice of his property.

Then mounting on the roof of the square home of many families, Willie … told of how glad he was to pay

back his debts, of how great he was.... His speech finished, the blankets were brought to him, together with shot-guns, silver dollars, carved planks and many other things....

Jack threw out the blankets first, which his creditors grabbed and attempted to pull away from each other; if they could not pull them away whole, they cut the blankets into pieces. Then he threw out shot guns, carvings, decorated paddles and silver dollars. For the larger items, some creditors bought off the others struggling for possession.

Then came the potlatch of Willie's buggy.... It was yanked about and pulled up and down ... until, like the other potlatch articles, the one who tugged for it more than his fellows bought out the others. The same procedure was carried on in the potlatching of a war canoe, then of a sailboat.... Article after article went, until ... the greater portion of Willie's goods had been potlatched – his debt was paid.

This has been a week of celebration.... On Saturday a big dance was held.... A number of Indians took part, all wearing big wooden masks, many having beaks which opened and shut with the pulling of strings....

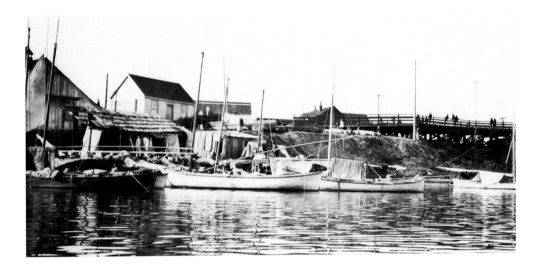

Boats moored in front of the reserve, where people are camped in beach sheds. RBCM PN6818.

A meeting in the harbour between a Columbia River fishing boat and a dugout canoe. The tall building in the background is on Wharf Street at the foot of Yates (still standing and now decorated with a giant mural of whales). RBCM PN6891.

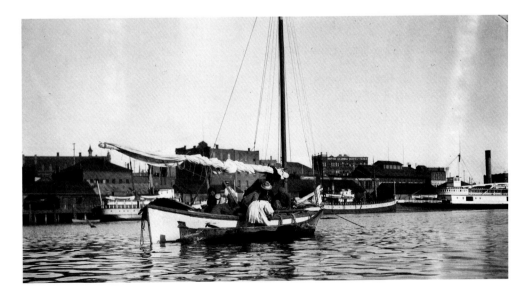

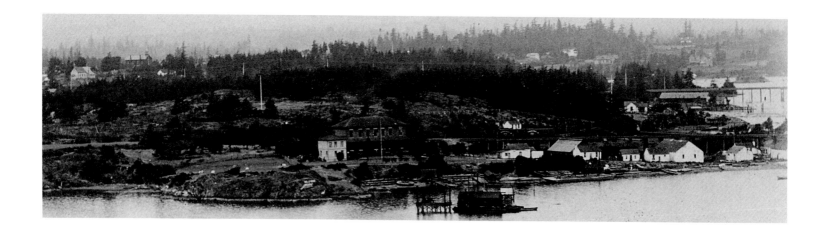

Thomas George's New Lodge, 1901

On January 18, 1901, three hundred people attended an early morning feast and "dancing séance" in celebration Thomas George's new lodge. Thomas George (ca 1879–1947) was the son of Ches-lum George (see Chapter 15). A *Colonist* reporter attended the event and printed the following description:

> When the last of the 'owls' were wending their homeward way, and men slept in the quiet city, there came a great noise from across the harbour.... This noise was the accompaniment to the dancers in the lodge of [Thomas] George.
>
> Ever since Willie [Jack] … gave his big potlatch of ten months ago, there has been desire in the heart of George to give a "doings" that would equal that of Willie and yesterday morning his feast surpassed Willie's potlatch … as the sun outshines the moon, even though the expense account will not be so great.
>
> Soon after midnight the canoes began to arrive above the Railway Bridge, and guests commenced to arrive by road, and by 2 o'clock yesterday morning there were nearly three hundred … seated around the sides of the big new hut. A low planked bench had been built around the hut, about four feet from the matting-covered walls, and behind this foot-high barrier, were seated three tiers of siwashes, arrayed in all their best gala dress.... In the centre of the mud floor, which was packed down hard by constant trampling, were two big

> log fires, from which flames leaped, and a shower of sparks rose and struggled for an outlet through the ventilators … at the top of the ridged roof.
>
> With their bedaubed faces shining in the reflection of the fires, were two dancers clad in skins of animals, with long hats bedecked with feathers, and with clusters of animals' claws, all a-rattle as they hopped about, and hysterically waved their arms; and behind them were three hundred yelling, shouting siwashes, all garbed most strangely, and all armed with short sticks, with which they beat the planking of the low benches in front in time with the movements of the dancers....
>
> The klootchmen sang their "sad songs", chants of the departed tribesmen and lost glories, and the Indian men sang dirges of sorrow and defiant songs of war, telling of fights long ago.

Over the next two days a feast was held, featuring dancers from Becher Bay, Cowichan and Saanich.

Just five days later, the *Colonist* reported:

> INDIANS MOURN – A sorrow dance was held last night in the big hut in which the recent feast of sub-chief [Thomas] George was held … to mourn the death of the Queen [Victoria]. A large number of Songhees Indians attended the mourning dances, and many sorrowful dirges were chanted.

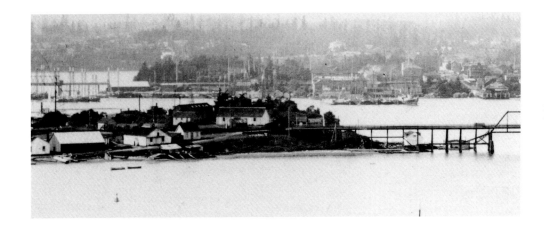

The reserve in about 1902. The second from the left of the larger buildings (on facing page) belongs to Thomas George.
BC Archives HP23887, A-08817;
HP23886, A-08816.

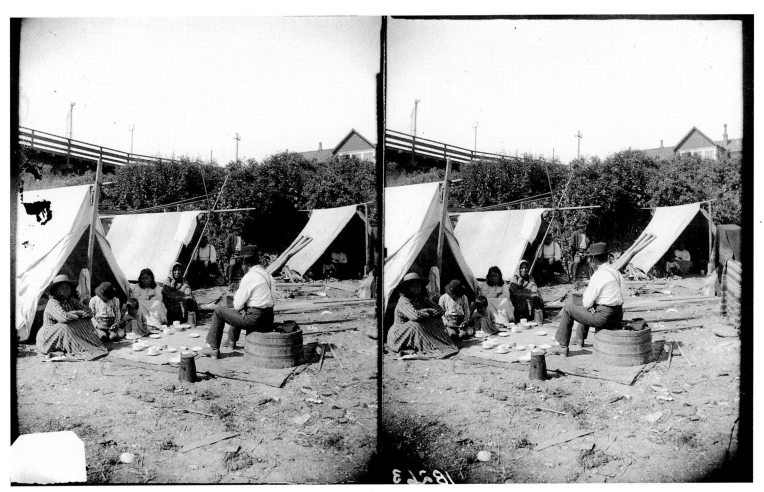

Visitors having morning tea below Limit Point, 1904–7.
Stereograph; BC Archives HP18263, G-6882.

A two-part panorama (left and below) showing the front of the reserve in 1907 or 1908, with visitors in fishing boats. In the background is Laurel Point and the newly constructed buildings of B.C. Soap Works and the British American Paint Company.
Post card and lantern slide
attributed to Richard Maynard;
RBCM PN6849, PNX520.

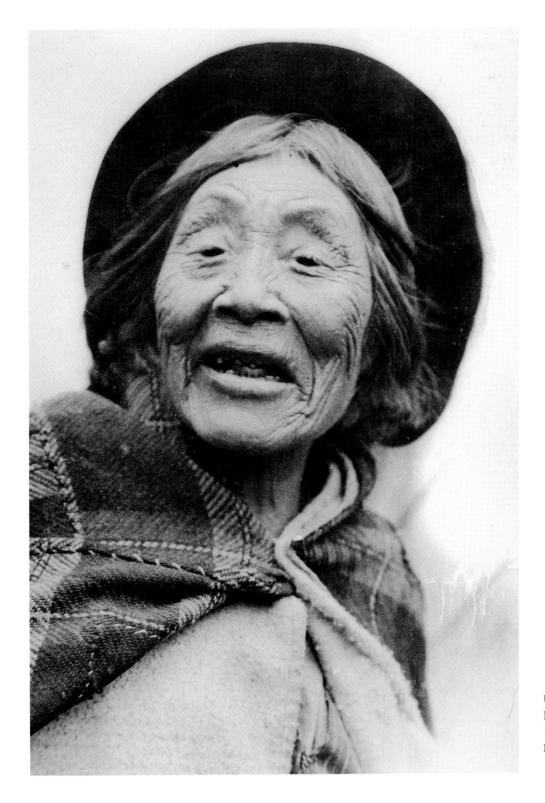

Unidentified woman on the Songhees
Reserve near the Johnson Street Bridge,
1904–8.
RBCM PN8860.

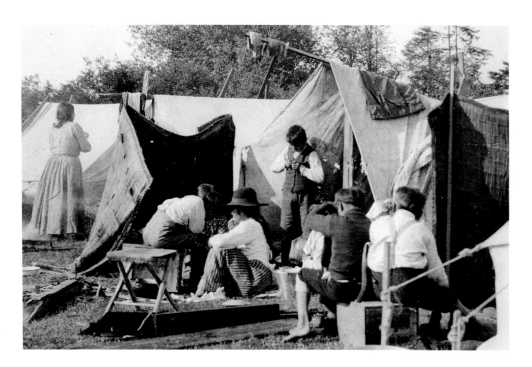

Left and below: Visitors camping at Hope Point, about 1907. First Nations camped on the reserve on their way to and from their work picking hops and working in the canning factories. They brought or made many artifacts to sell to curio buyers and artifact collectors.

Attributed to Richard Maynard; RBCM PN8823, PN6147, PN8567.

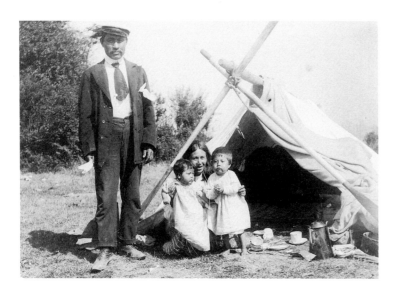

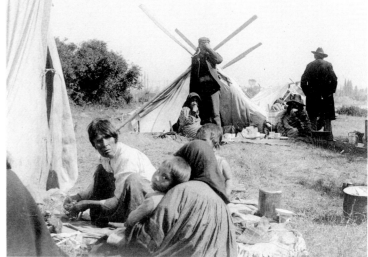

The Memorial Potlatch of Ida Jackson

A set of designs on the European-style house of Alec Kulqualum attracted much attention after 1908. They depicted a Thunderbird on a whale, four wolves, two killer whales and two human figures in circles, all painted in memory of 18-year-old Ida Jackson and her baby daughter, who both had drowned the previous year. Ida was the daughter of Jacob and Sarah Chipps of Clo-oose (on the west coast of Vancouver Island). The house painting was said to represent a dream of Jacob Chipps – the figures in the circles represented the deceased.

Jacob owned a Columbia River fishing boat and made many trips to mainland waters to catch fish for the Imperial Cannery, often taking the family with him to work on the boat. On July 11, 1907, while sailing between Steveston and Vancouver a sudden storm capsized the boat. Sarah Chipps and three other passengers clung to the overturned boat, but Ida and her nine-month-old baby were flung clear and the boat drifted away from them. Jacob swam out to save them. He reached them and tried for hours to swim to shore with Ida and his granddaughter clinging to his back. Weakened by the cold waters, eventually, Ida could no longer hold her baby and then could not hold on herself; they both slipped under and drowned. After nine hours in the water, Jacob barely made it to shore alive.

The family buried Ida and her baby in Ross Bay Cemetery. The newspaper printed a brief obituary saying that Ida was "a faithful and bright pupil of the school conducted under the auspices of the Methodist church".

The potlatch was attended by a large number of visitors and many citizens of Victoria gathered around the perimeter to watch.

The designs on the house of Alec Kulquulum.
Postcard; RBCM PN7598.

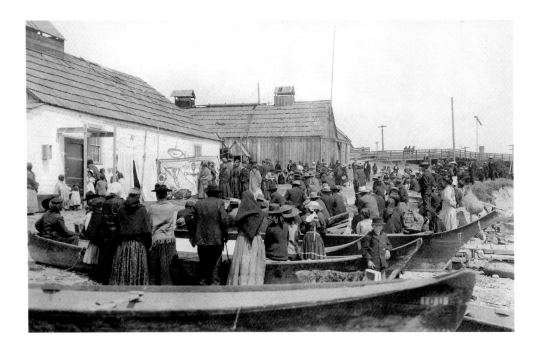

People gather for the Ida Jackson memorial potlatch. In front of the house is a screen painted with human-like figures. RBCM PN6886.

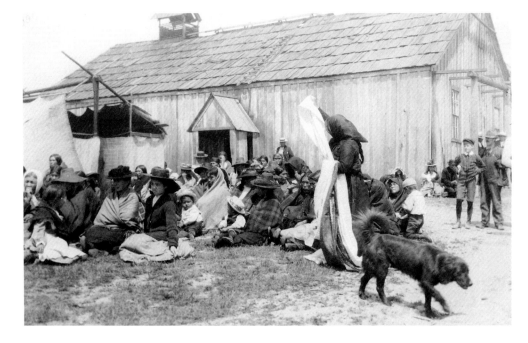

A woman giving out cloth at the Ida Jackson memorial potlatch. The temporary mat structure on left is to conceal dancers until they are ready to perform. The house belongs to Mary Hallates. RBCM PN8927.

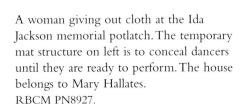

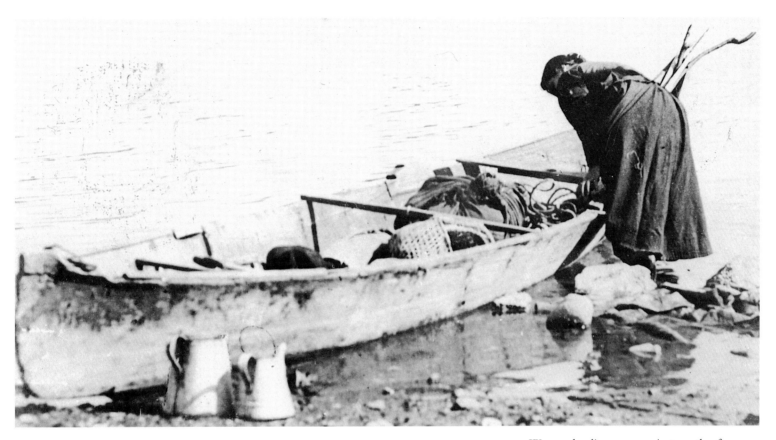

Woman loading a canoe just south of
Johnson Street Bridge, 1906–9.
RBCM PN6804.

17
The Final Move, 1910–12

In 1910 the Songhees signed agreements in principal with the federal and provincial governments to move to a new reserve. They made the final agreement in 1911, and legal challenges followed in 1912.

The discussions to move began with meetings between Songhees representatives, Chief Michael Cooper and Councillor William Robert, and their lawyer, Dallas Helmcken, who then negotiated with Price Ellison, the Provincial Chief Commissioner of Lands. On January 17, 1910, Helmcken sent a letter to Ellison labelled "Strictly Confidential" and in it stated, "the problem before us is how best to approach the Indians". He explained:

> There are two factions in the Songhees; the larger majority, the followers of Chief Michael Cooper who are not averse to moving … and the minority who are averse to moving, holding the position that the Reserve is absolutely their property.… I have had five interviews

with the chief alone.… Originally the Indians wanted to go back to Cadboro Bay, but … the piece of land they wanted is sold.… Everything must be patiently and thoroughly discussed and the Indians treated with every respect and consideration.

On May 16, Victoria Mayor A.J. Morley took some pressure off the negotiations by declaring that the city would "refrain from pressing claims". A little while later, after being informed that Prime Minister Wilfrid Laurier was planning to visit Victoria soon, Ellison said: "It is to my mind very important that we should have something definite done if possible before Sir Wilfred comes here, and I think every effort should be made to that end."

On October 26, the federal government presented a plan to move the reserve, and as the *Colonist* stated, the Songhees "all expressed their satisfaction [for] the first fair offer which has been made to them".

A WHOLE LOT OF TROUBLE OVER A "GIFT HORSE"

March 1910 census of the Songhees Reserve: 94 Songhees and 43 heads of families. Taken by an Indian Agent with data provided by Chief Michael Cooper.

This political cartoon in the *Victoria Daily Times* of July 23, 1912, was sparked by complaints of large amounts of money going to individuals involved in the reserve settlement. The cartoon shows Premier Richard McBride up against the Songhees Reserve represented as an elephant.

Chief Michael Cooper, 1864–1936

Michael Cooper was the chief of the Songhees for 41 years, from 1894 to 1935, which included the long period of negotiations to move the reserve and settle on the new property. He was born on October 4, 1864, on San Juan Island. His mother was Katy Skomtena (also known as Catherine Skuvanit and KwipKwop) and his father was Captain Henry Cooper, an American soldier (born in England), who died when Michael was young.

A Roman Catholic, Michael Cooper attended the St Louis College, Victoria. His opponents liked to point out that he was not related to any past Songhees chief, though a couple of oral histories recall that his mother's father was a high-ranking warrior named Skwalatlst. On December 4, 1894, Cooper married Sara (Peters) Albany (1856–1943), a niece of King Freezy.

Cooper was first elected chief in October 1894. Under the provisions of the Indian Act, a chief's term of office was three years. He won successive terms but resigned on June 12, 1902, after complaints from a group led by his main contender, Willie Jack. On June 3, 1903, Cooper won re-election, this time as "chief for life", after a vote of 12 to 5 against Willie Jack.

On November 20, 1935, the Times reported that Chief Cooper "feels he can no longer perform his duties", due to ill health. He retired the following day and died on January 10, 1936, at age 71.

BC Archives HP005318, G-08917.

On October 28, Chief Cooper and Songhees band councillors went with British Columbia Premier Richard McBride, Minister of Lands William Ross and other government officials to visit the proposed site of the new reserve at Esquimalt Harbour, a place called Maplebank, south and adjacent to the Esquimalt Reserve.

Shortly afterward, Chief Cooper and Songhees councillors William Robert, James Fraser, Tom George and Jimmy Johnnie worked with their representatives, Dallas Helmcken and J.S. Matson (editor of the *Colonist*), on the details of the proposed settlement. After this group went "over the lines of the proposed reserve" they "expressed complete satisfaction with the property and the arrangements". Subsequent meetings with the provincial government established the property lines defining the new reserve.

Sir Wilfrid Laurier confirmed the agreement by telegram:

> Have consulted with Minister of Interior and any arrangement satisfactory to Indians will be quite acceptable to us. Would only suggest that as we are the guardians of the Indians,... that department be party to arrangement and that same be made under Indian Act. We intend introducing legislation this session in connection with similar questions.

On October 30, the Premier McBride received a legal petition delivered by Barrister E.E. Wootton on behalf of ten Songhees women who protested "against the transaction for the obliteration of the old reserve proceeding further". Reporting on this action, the *Colonist* pointed out that under the Indian Act "the decision must rest with the majority of the male members of the band of the full age of 21 years" and called the petition an "ineffectual protest".

Then on November 6, the *Colonist* expressed almost giddy delight over the agreement to move the reserve:

> One of the most gratifying points about the [settlement] is the fact that the Songhees themselves are eminently satisfied.... The results show that they needed to be treated with consideration.... Nothing but praise of the men who brought about the settlement is to be heard from the Indians, who describe the arrangement as a "Delate cloosh hoy-hoy kina mox Boston-man pi Songhees" [Chinook Jargon meaning "very happy with the agreement".]

Visit to the site of the new reserve by Songhees band councillors and government representatives. Chief Cooper and Premier McBride are on the far right.
RBCM PN8817.

The Final Arrangements of 1911

On April 4, 1911, a formal ceremony on the heights of the old reserve marked the transfer of reserve lands. A week later, Sir Wilfrid Laurier introduced a bill in the House of Commons to ratify the Songhees Reserve Agreement – a bill was necessary because the move conflicted with the Indian Act. In his address to the house, the Prime Minister stated:

> Efforts have been made from time to time … to induce the Indians to release their hold on the land.… The provincial government [has] been able to effect … a settlement whereby in return for the payment of a large sum of money, the Indians … accept a reserve elsewhere in the vicinity of Esquimalt. An agreement to that effect has been reached between the Dominion government and the provincial government, and the object of this Bill is simply to give to that agreement.
>
> The money is to be paid by the provincial government [who …] shall deposit in the Canadian Bank of Commerce … the sum of $10,000 to the credit and in the name of each head of a family of the Songhees.…

There are some 43 or 44 of these heads of families. (The act recognized payments to the heads of families named in a band census made November 21–25, 1910.)

During the ceremony of April 4, Minister of Lands William Ross had assured the Songhees that the money promised to them was in the bank; he showed them the bank books and informed them that the money would be handed over after they moved. And on April 30, forty-one family heads collected the last of the money considered compensation for band improvements on the old reserve – $30 each for the value of the community water main, school and church. All that remained in the agreement was the transfer of human remains from the cemetery on Coffin island to a graveyard on the new reserve.

On May 19, the Senate and House of Commons approved as a Statute of Canada "An Act respecting the Songhees Indian Reserve" and confirmed the agreement for the sale of the reserve.

On December 19, 1911, an Order of the Privy Council #1142 (British Columbia) marked the official surrender of the old Songhees Reserve and the movement to the "New Songhees Reserve, No.1 A of 163 acres" (66 ha).

Songhees band councillors and government officials outside a house near the school where they signed the formal agreement to move the reserve.
RBCM PN8872
(BC Archives HP077582, E-00252).

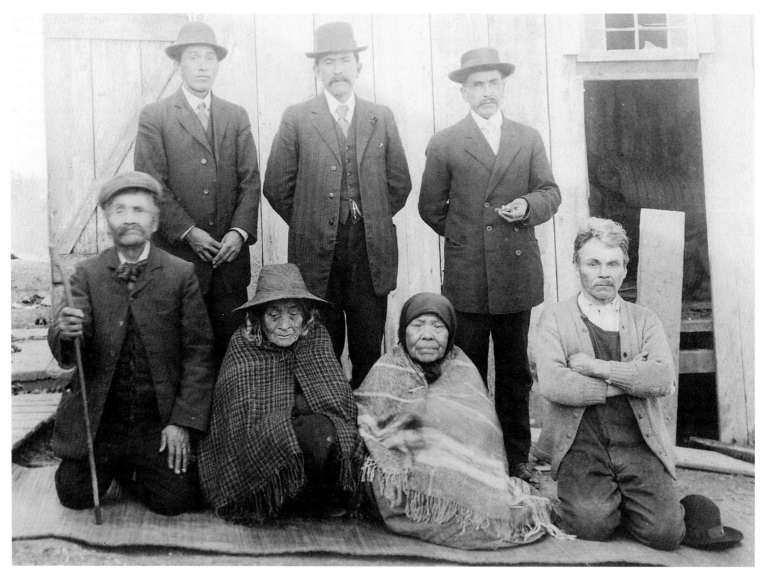

Songhees at the April 4 ceremonies. Front row, left to right: Sam Qullamult (ca 1835–1925), Mrs Pelkie, Mary Freezie (wife of the late Charley Freezie, mother of James Fraser) and an unnamed man. Back row, left to right: Councillor Thomas George, Chief Michael Cooper and Councillor William Robert. RBCM PN8814.

Five members of the Songhees council, left to right: Jimmy Johnny, Thomas George, Chief Michael Cooper, William Robert and James Fraser.
RBCM PN6878.

Songhees councillors and government officials at the April 4 ceremony (left to right): Councillor James Fraser, Price Ellison (B.C. Chief Commissioner of Lands), Councillor William Robert, J.S. Matson, Dallas Helmcken, Premier Richard McBride, William Ditchburn (Federal Reserve Iinspector), William R. Ross (B.C. Minister of Lands), Chief Michael Cooper, Councillor Thomas George and Councillor Jimmy Johnny.
BC Archives HP077579, E-00249.

Face to face: Chief Michael Cooper talking to Premier Richard McBride. RBCM PN6890A.

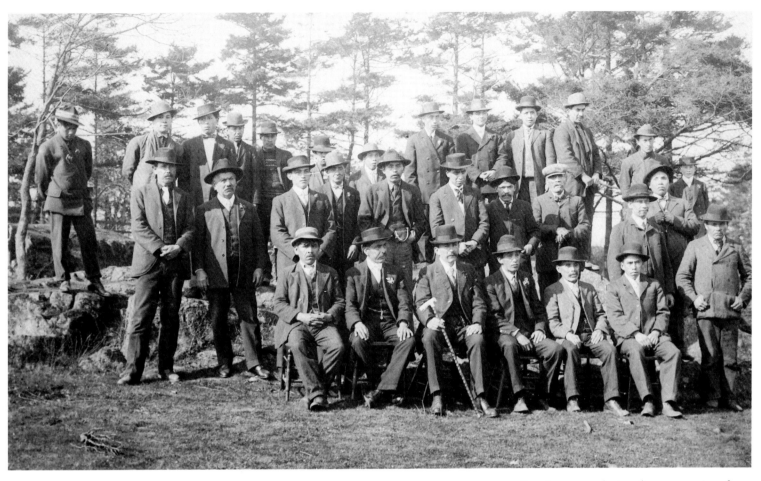

Songhees men during the ceremonies of
April 4, 1911. The boy on far right at the
back is George Cooper, the chief's son.
Private collection.

Aftermath, 1912

In January 1912, homeless people (aboriginal and non-aboriginal) began squatting in abandoned houses on the vacant reserve, but later that year demolition crews tore down all the houses, leaving a barren landscape on the west side of the harbour. The provincial government had plans for the old reserve lands, but first they had to work out an arrangement with the two railroad companies that occupied rights of way there.

In December, the province gave the Canadian Northern Pacific Railway 34 acres (14 ha) at the north end of the abandoned reserve, and the Island Division of the Canadian Pacific Railway (now operating the E&N Railway) 32 acres (13 ha) at the south end. It kept the rest of the land, along the waterfront, for industrial sites and docks.

Meanwhile, a controversy surrounding the legal status and rights of First Nations' women was coming to a boil. Mary Anne and Tom James had not received any reserve settlement money, because Tom's legal status was not Songhees. But the James's had many friends in the non-aboriginal community, among them Reverend Charles Tate, who often held services in the James's home, and Martha Douglas Harris, the daughter of James Douglas. On January 4, 1912, the *Colonist* reported on the proposed eviction of Thomas James from the reserve under the title, "An Indian Wife's Status":

> The case of Tom James offers some unique points of adjustment in federal law,… the squatter having married into the Songhees tribe, although he himself is a Cowichan. According to tribal law, his wife became with him a Cowichan Indian. It is maintained by Tom James, acting under legal advice, that he is entitled to a share in the partition of the Songhees reserve, and for this reason he has maintained his right by occupancy. The Indian department … hold that Tom James and his wife are now Cowichans, and therefore not entitled to any rights under the Songhees reserve distribution…. The matter of right will now be adjudicated by the courts of law. This is the last claim to be submitted in account of the settlement or the Songhees reservation [sic].

Martha Douglas Harris spoke in defence of the James family:

> There are many questions arising out of the government's settlement that cry but for satisfactory answer. If according to tribal law Mrs Tom James, who is a true Songhees woman, becomes a Cowichan on her marriage with Tom James, how is it that Chief Cooper, who was born on San Juan Island, and whose father was a soldier, does not become a white man? … Tom James came as a youth to the Songhees and married a Songhees maiden…. He has lived with, and as one of them for 34 years, and, with all the lavish dispensation of money elsewhere, is denied his distributive share of $10,000. Why?

Despite this support, Mary Anne James never received a portion of the Songhees settlement. She died on December 3, 1912, at her home on Fraser Street in Esquimalt. Tom James eventually received a partial settlement and continued to live on Fraser Street with his daughter and son-in-law, Willie Jack.

The Songhees people lived on the old reserve for 68 years. The reserve and its people played important roles in shaping the Victoria that we know today. Now the descendants of the 19th-century Songhees have been living on their reserve at Esquimalt Harbour for 92 years. The legal agreements made more than 150 years ago with the Songhees giving them the right to hunt, fish and gather food on their unoccupied lands are still in effect.

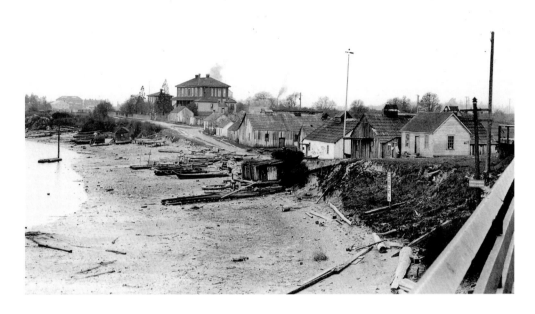

The deserted reserve looking south from the Johnson Street Bridge, May 1912.
Howard Chapman photograph;
BC Archives H-4673.

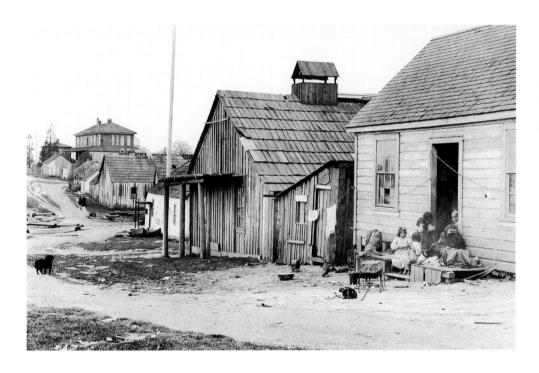

A homeless family sits on the porch of Andrew Tom's vacated house, May 1912.
Howard Chapman photograph;
BC Archives H-4675.

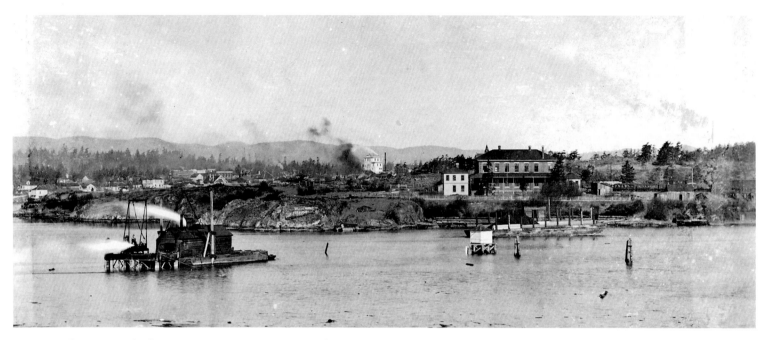

1 Above, across both pages:
Taken in May 1912, this two-part panorama
is the last photograph of the old Songhees
Reserve, from Songhees Point to the

Johnson Street Bridge. Soon afterwards,
these buildings were torn down.
Howard Chapman photograph;
BC Archives H-4683 and H-4684.

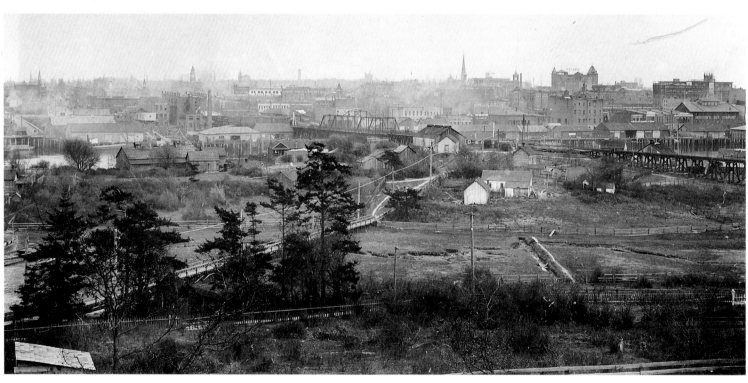

1

2

Below, across both pages:
Another two-part panorama of the old
reserve, looking southeast towards the city

from the high ground north of the current
intersection of Tyee and Esquimalt roads.
The long railway trestle is the approach to

the Johnson Street Bridge.
Howard Chapman photograph;
BC Archives H-4682 and H-4677.

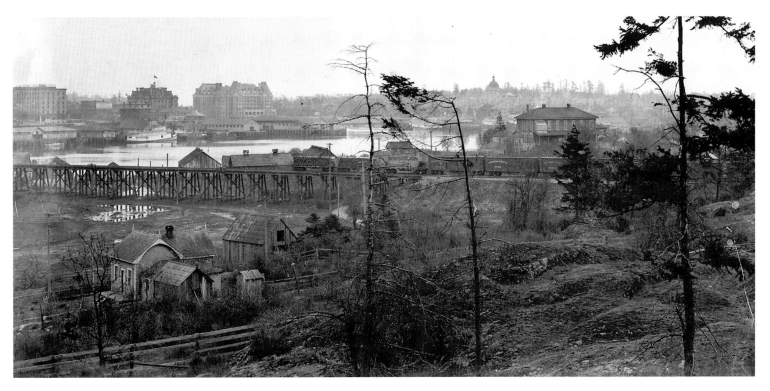

2

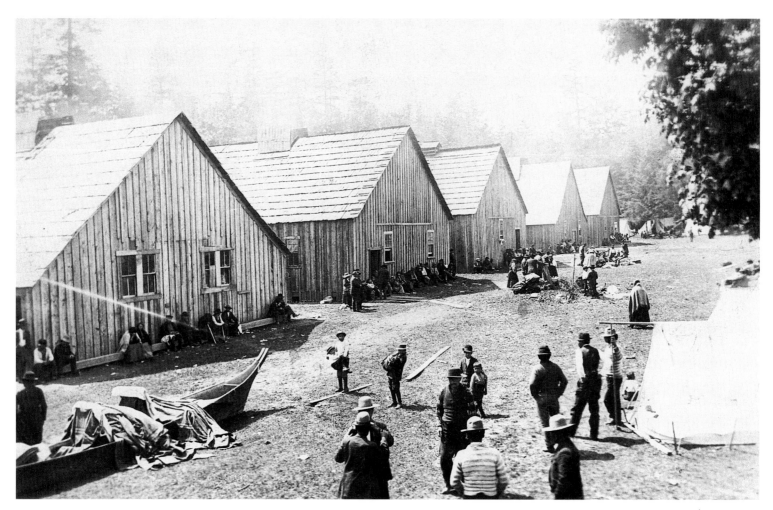

Chief Michael Cooper and others held this potlatch on the new Songhees Reserve in 1912 to celebrate the building of their new big houses.

The houses, left to right, belong to Chief Cooper, William Robert, James Fraser, Jimmy Johnny, and (co-owned by) Jack Dick and Alex Peter.
RBCM PN9468.

Appendix
Songhees Traditional World View

Traditional Songhees culture experienced a different reality in the natural world than Europeans did. Reality is not just what we see, but what we have learned to see. To the Songhees, the human and natural worlds are interwoven by threads of spiritual power. The natural and supernatural worlds are inseparable; each is intrinsically a part of the other. Natural events affecting peoples' lives were caused or influenced by human actions. It is important to behave correctly toward nature to prevent harmful consequences.

By undertaking gestures of respect, people would be given special powers to enhance their chances for success and survival, to assure good luck and good health.

The Songhees had the knowledge necessary to find what they needed to survive in their territory. They understood the cycles of time by observing the movement of the stars and planets and the patterns of wind, water and plant growth. They knew the resources that these cycles provided, and how to use them. They had a well-established social

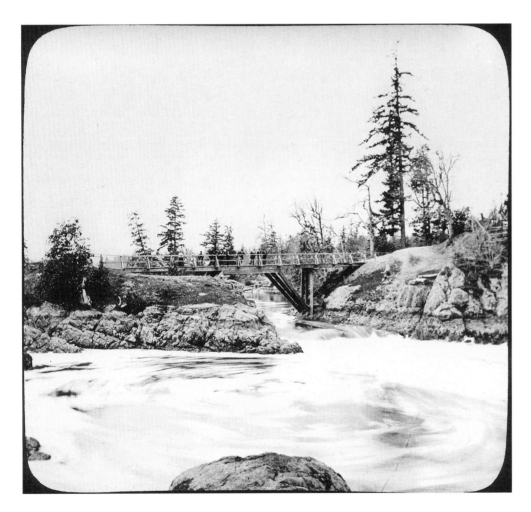

This photograph of the second Tillicum Bridge, made in the 1870s, shows the abode of Camossung, a young girl who was turned to stone by Hayls, the Transformer. Here at the Gorge Falls, one could see a stone representing Camossung underwater at low tide. Before some of the upper rocks were dynamited away, the falls created a large whirlpool. Ritually-prepared Songhees would dive into the whirlpool to gain special spirit power from Camossung. Lantern slide; RBCM PNX 298.

order, and each member of the group knew how to relate to others in order to survive. But, as important as practical knowledge can be, religious knowledge was considered the foundation of survival. Specialized skills were more an expression of spirituality than learning. An individual gained spiritual powers through being clean – through correct social behaviour and the proper undertaking of cleansing rituals that involved fasting and rigorous bathing. Being socially and physically clean gave a person the ability to receive the powers and knowledge of survival.

Songhees people regarded the sun, moon, stars and planets as animate beings with powers. A clean person could pray to the dawning sun for special powers and receive them. Songhees elder James Fraser, in 1950, said that the Sun watches you when you train to acquire power, and the Sun listens when you pray. When a baby is born, he said, you should hire a trained person to pray, "mark the baby's face like Sun" and pray until sunrise. Young boys would be sent out to run during lightning storms to acquire the power to make them great warriors. A person could call for power in a dream or sing for it. Fraser had a wolf spirit that helped him hunt deer. One time when he fell out of his boat, a rainbow saved him, because Fraser had learned to sing and bring out the Rainbow spirit.

After proper ritual cleansing a person could dive into the waters below the Gorge Falls in hope of being granted special powers, such as the ability to hunt seals. Powers would be granted by Camossung, the spirit being guarding the area, and they would form a special link between the hunter and the seals.

Supernatural Overseers

Traditional stories and ceremonies explain the origin, design and function of nature, and the proper human relationships to it.

The world's creation and its transfiguration to modern form took place in the distant past. Traditional stories and ceremonies explain the world's origin and evolution, beginning in a time when animals and other natural entities were human, living in an essentially human society. These stories show how natural entities are endowed with spirits and have spiritually based power. Humans and natural entities are involved in a constant spiritual interchange that profoundly affects human behaviour. Many natural entities acquired their physical, behavioural and spiritual characteristics through transformations in the distant past.

In traditional Songhees society there exists the concept of a supernatural entity referred to as the ruler of the animals or certain species of animals. James Fraser described the Sun as the "father of all the animals" and that the word for Sun and the headman of a village were the same. It is similar to the word for "one who speaks for you". Supernatural experiences as told in stories, often concentrated on animal personas or transformer beings. It was the Transformer *Hayls* who came from the north with his friends Raven and Mink to teach people how to live, speak a language, and make spears and nets.

People who knew the ritual language could perform special rituals to appeal to supernatural beings who provided good luck in fishing. A person who had gained the power to oversee the season's fishing was called *siem*, Chief of the Fish.

Cycles of Life

An important aspect of Songhees spiritual thinking encompassed the cycle of death and rebirth, and communication between the land of the living and the land of the dead. The soul was seen as a personal possession that defined a unique individual, a non-material component that was continually reborn. In the 1930s, Tom Paul, a Saanich man, said that inside a person is the soul of an animal that has visited him in a dream; this is the *saila*, and if you have the "big owl" saila inside, you will be a good deer hunter. James Fraser said that the saila goes away when you sleep, causing you to dream, and when it comes back you awaken.

A ghost was something different from the soul, having human form but not human substance. Tom Paul said that the shadow of a person becomes the small owl, *spalkwithe*. When this owl flies through the roof of a big house, it has come to talk to a *thetha*, a medicine-man.

In traditional society, the afterlife is a replica of life on Earth. Souls of the dead travel to a country similar to that of humans, and there they continue to be what they were on Earth. But they may live in special zones or habitats of animals and animal spirits, such as the sky, the woods, a lake or

Storyteller James Fraser, seated here at his sister's house in about 1904, provided much information on the history of the Songhees. He was born on the reserve about 1873 and died November 28, 1967, at the age of 94. His aboriginal names were Kin-kay-num, Unthame and Cheachlacht. His father was Louis "Unsame" Freezie (1841–91), brother of Songhees Chief Charley Freezie. The boy may be Fraser's nephew Samuel Joseph. RBCM PN8804.

the ocean. The souls of the dead may travel to the world of animals before coming back to the human world, but this could also be done by the souls of the living. During the spirit dances the life force of a human is reborn into the land of the dead or into an animal realm. Initiates in these performances are called babies to signify their rebirth.

The Songhees did not divide the afterlife into positive and negative realms, such as Heaven and Hell. People would be reborn in the normal world rather than permanently transcending it. They could ensure continuing survival by maintaining a balance between the physical and spiritual worlds.

The traditional oral history of the Songhees contains the ethical premise of equality between human consciousness and that of other animals. Humans had to demonstrate their respect for an animal's spirit. Hunters and fishers were expected to conduct themselves well, with the proper knowledge and ritual words, so that the animals whose lives they took for food would choose to be reborn so that humans could catch them for food year after year.

The goal of Songhees religion was to actively seek personal powers and use them to create a balance between the human and natural worlds, and so ensure lasting prosperity.

Imprints on the Landscape

Traditional Songhees oral history has strong links with the physical features of the landscape and the sky. History is written across the skies, in the moon, planets, stars and their names. The names of unusual rocks, water features and mountains are the keys that unlock the stories of the past and explain the origins of things.

Some parts of the environment possess a supernatural consciousness and spiritual powers. They would bestow certain favours only to those who were ritually prepared. Individuals or families protected their livelihood by holding certain skills and knowledge with an understanding of the supernatural.

Much of the traditional world view of the Songhees has eroded away. Today, links to the past have been maintained through the names passed on to each generation and through ceremonies and their teachings still practised in the big houses. A growing interest in Songhees tradition has inspired a re-discovery and re-integration of some of the old knowledge and a changing view of the world.

The story of Sahsima "harpoon" is stimulated by a large glacial erratic rock standing just offshore at Harling Point. In initiating the second phase of the world, Hayls the Transformer changed a man into stone while the man was harpooning seals. The large rock can appear like a seal or a person depending on the tide and the angle from which it is viewed.
Grant Keddie photograph, 1994.

Acknowledgements

I sincerely thank all the Songhees and Esquimalt people who, over the last 160 years, have provided historians and anthropologists – including me – with information about their history. They have contributed greatly to our knowledge and understanding of this region.

Many people contributed to the creation and production of this book. I extend special thanks to the following people for their support:

At the BC Archives: Kathryn Bridge, Manager of Access Services, for her advice and for making special arrangements for me to access the visual material; Records Curator Louise Bourassa for advice and help in finding material; Provincial Archivist Gary Mitchell for special approvals; archivists David Mattison, Michael Carter, Katy Hughes, and archives technicians Kelly Nolin, Brent McBride and Frank Veerkamp for answering my questions, solving problems and getting the items I needed.

Museum volunteers Sharon Ireland and Shelagh Graham for searching the often-difficult-to-read newspaper microfilm; they found lots of useful material, including many direct quotations that appear in the book.

Randy Bouchard, Dorothy Kennedy, Duncan Stacey, Sharon Keen, Norm Pearson, Chris Hanna, Richard Mackie and Cary George supplied specific sources of written data. And Tammy Hannibal of the Hudson Bay Company Archives helped me obtain several important images.

At the Royal BC Museum – Andrew Niemann, whose time I consumed too much of, showed me how to scan and store images, then smoothed out many of the imperfections and untangle some of the knots I'd created in organizing them – I owe Andy more than a pound of gratitude. Alan Hoover and Bob Griffin, Managers of Anthropology, protected my time so that I could get this project done. Gerry Truscott and Chris Tyrrell transformed a large and complex manuscript into a beautiful book.

And most importantly, special thanks to Dan Savard, manager of the Royal BC Museum's Anthropology Audio-Visual Collections. This book was to be our joint project, but the heavy demands of his regular duties did not allow Dan the time to continue as a co-author. He and I began together identifying, selecting and scanning photographs, and trying to unravel the conflicting and errant information that came with many of the data sources. Working with Dan gave me a better appreciation of the physical and social complexities associated with photographs and the role of visuals in telling a story.

References

About the Photographs (by Dan Savard)

Bant, M., and C. Hinsley. 1986. *From Site to Site*. Boston: President and Fellows of Harvard College.

Blackman, M. 1981-1982. "Copying People": Northwest Coast Native Response to Early Photography. *BC Studies* 52.

———. 1984. Tzum Seeowist ("Face Pictures") British Columbia Natives in Early Victoria Studios. A paper presented at the conference on "The Photograph and the American Indian", Princeton University, September 1985.

———. 1986. Studio Indians: Cartes de visite of Native People in British Columbia, 1862–1872. *Archivaria* 21:68-86.

Buckland, G. 1980. *First Photographs, People, Places & Phenomena As Captured For The First Time By The Camera*. New York: MacMillan.

Carline, R. 1971. *Pictures in the Post*. London: Gordon Fraser.

Clah, Arthur Wellington. 1890. Diaries. London: Wellcome Institute (WMS Amer. 140 (1–72). Microfilm copies in the National Archives of Canada: Reel A-1706, vol. 41: Nov. 19, 1889 – Apr. 21, 1890. (Thanks to Robert Galois for this reference. – D.S.)

Coe, B. 1978. *From Daguerreotypes to Instant Pictures*. Gothenburg: AB Nordbok.

Coe, B., and P. Gates. 1977. *The Snapshsot Photograph: The Rise of Popular Photography, 1888–1939*. London: Ash & Grant.

Coe, B., and M. Haworth-Booth, 1983. *A Guide To Early Photographic Processes*. London: V&A Publications.

Davison, R. 1981. Turning a Blind Eye: The Historian's Use of Photographs. *BC Studies* 52.

Gilbert, G. 1976. *Collecting Photographica, The Images and Equipment of the First Hundred years of Photography*. Vancouver: Clarke, Irwin & Co.

———. 1980. *Photography: The Early Years, A Historical Guide for Collectors*. New York: Harper & Row.

Gross, L., J.S. Katz and J. Ruby. 1988. "Introduction: A Moral Pause". In *Image Ethics: The Moral Rights of Subjects in Photographs, Film, and Television*. New York: Oxford University Press.

Haworth-Booth, M. 1997. *Photography: An Independent Art, Photographs from the Victoria and Albert Museum 1839–1996*. London: V&A Publications.

Holt, T., and V. Holt. 1971. *Picture Postcards of the Golden Age*. London: MacGibbon & Kee.

Johnson, T., ed. 1998. *Spirit Capture, Photographs from the National Museum of the American Indian*. Washington: Smithsonian Institution Press.

Kendall, L., B. Mathe and T.R. Miller. 1997. *Drawing Shadow To Stone*. New York: American Museum of Natural History.

Kreis, K.M. 1992. "Indians" On Old Picture Postcards. *European Review Of Native American Studies* 6:1:39–48.

Long, C. 2000. In The Round. *The Beaver* 80:2:28–33.

Marino, C. 1998. *The Remarkable Carlo Gentile: Pioneer Italian Photographer of the American Frontier*. Nevada City: Carl Mautz.

Mattison, D. 1980. Victoria Theatre Photographic Gallery (and the Gallery Next Door). *B.C. Historical News* 4:2.

———. 1985. *Cameral Workers, The British Columbia Photographers Directory 1858 - 1900*. Victoria: Camera Workers Press.

———. 1985. Richard Maynard: Photographer of Victoria, B.C. *History of Photography* 9:2.

Meehan, J. 1990. *Panoramic Photography*. New York: Amphoto.

Sandweiss, Martha A., ed. 1991. *Photography In 19th-century America*. Fort Worth: Amon Carter Museum.

Scherer, J. You Can't Believe Your Eyes: Inaccuracies in Photographs of North American Indians. Exposure 16:4.

Smith, H.I. 1910. A Visit to the Indian Tribes of the Northwest Coast. *American Museum Journal* 10:2.

Suttles, W. 1982. The Halkomelem Sxwayxwey. *American Indian Art Magazine* 8:1.

Thomas, A. 1978. *The Expanding Eye: Photography and the 19th-century Mind*. London: Croom Helm.

———. 1981. Photography of the Indian: Concept and Practice on the Northwest Coast. *BC Studies* 52.

van Hasbroeck, Paul-Henry. 1989. *150 Classic Cameras, from 1839 to the Present*. London: Philip Wilson Publishers.

Weissman Wilks, C. 1980. *The Magic Box, The Eccentric Genius of Hannah Maynard*. Toronto: Exile Editions.

Welling, W. 1976. *Collectors' Guide to 19th-century Photographs*. New York: Macmillan Publishing.

Williams, C. n.d. Encounters with Photograhy – Recording Cultural and Class Differences between Aboriginal and Non-Aboriginal Women in the North Pacific Coastal Region 1860–1890. Unpublished paper.

Wyatt, V. 1989. *Images from the Inside Passage: A Northern Portrait by Winter & Pond*. Vancouver: Douglas & McIntyre.

———. 1991. Interpreting the Balance of Power: A Case Study of Photographer and Subject in Images of Native Americans. Exposure 28:3.

Chapter 1: Songhees – the Place & the People

Anderson, James Robert. 1920s. Manuscript and notes of Alexander C. Anderson with additional material by his son James. Additional manuscript 1912, Vol.15.

Bancroft, Hubert H. 1887. *History of British Columbia, 1792-1887*, vol. 32: *The Works of Hubert Howe Bancroft*. San Francisco: The History Co. Pub.

Barnett, Homer G. 1938. The Coast Salish of Canada. *American Anthropologist* 40:118–41.

Boas, Franz. 1890. Second General Report on the Indians of British Columbia. *Report of the Meeting of the British Association for the Advancement of Science*, 1886–89, 1890, pp. 562–83. (Reprinted in *Northwest Anthropological Research Notes* 8:1\2.)

Duff, Wilson. 1969. The Fort Victoria Treaties. *B.C. Studies* 3:3–57.

Fort Langley Journal. 1830. Manuscript, BC Archives (A/B/20/L2/A2M).

Grant, Walter C. 1857. Description of Vancouver Island by its first colonist. *Journal of the Royal Geographical Society* 27.

Hill-Tout, Charles. 1907. Report on the ethnology of the southeastern tribes of Vancouver Island, British Columbia. *Journal of the Anthropological Institute of Great Britain and Ireland* 37:306–74.

McDonald, Archibald (compiler). ca 1826–27. Census of Indian Population, Fort Langley. In Report to the Governor and Council, Feb. 25, 1830. Hudson's Bay Co. Archives, Provincial Archives of Manitoba, Winnipeg, D.4/123.

Suttles, Wayne P. 1974. *Coast Salish and Western Washington Indians*, 1: *The Economic Life of the Coast Salish of Haro and Rosario Straits*. New York: Garland.

Teit, James A. 1910. Salish Tribal Names and Distribution. June 10. Manuscript. Files of Franz Boas, American Philosophical Library, Boas 372, Roll 15. (Copy: BC Archives Add Mss 1425, Reel A246.)

Tolmie, William. 1841. Vancouver Island Tribes. *Journal of the London Geological Society* 13 (BC Archives NW 910.6 R888). (And in *California Farmer and Journal of Useful Sciences* edited by Alexander Taylor. 1862. San Francisco.)

Wilson, Captain Charles. 1866. Report on the Indian Tribes Inhabiting the Country in the Vicinity of the Forty-Nineth Parallel of North Latitude. *Transactions of the Ethnological Society of London*, New Series 4:275–332.

Yale, James (compiler). 1838–39. Census of Indian Population crossing over to Vancouver's Island and coasting at about latitude 50° from there returning southward along the mainland and up Frasers River to Simpson Falls". Manuscript. Hudson's Bay Co. Archives (B223/Z/1, fos. 1–21).

Chapter 2: Before European Settlement

Curtis, Edward S. 1913. Salish Tribes of the Coast. *The North American Indian* 9:175.

Daily Colonist. 1893. Escaped From Slavery – Death of Kstephset an Aged Songhees Indian With a Strange History, May 24:6.

———. 1935. Centenarian Chief of Saanich Tribe Dances for Movies, September 4:2.

———. 1936. Chief David with woven costume and spear (photograph), May 3:1.

———. 1936. Chief David's Story. May 17:6.

Eliza, don Francisco de. 1791. An Extract from the log, surveys, and discoveries carried out under the orders of His Excellency the Count of Revilla Gigedo, Viceroy of New Spain. BC Archives A/A/10/M57t/v.3.

Green, Rev. Jonathon S. 1915. Journal of a Tour on the Northwest Coast of America in the Year 1829. Charles. Frederick Heartman, N.Y.

Jane, Cecil. 1930. *A Spanish Voyage to Vancouver and the Northwest Coast of America; Being the Narrative of the Voyage Made in the Year 1792 by the Schooners Sutil and Mexicana to Explore the Strait of Fuca.* London.

Jenness, Diamond. ca 1934–36. Coast Salish Field Notes. Ethnology Archives, Canadian Museum of Civilization. Ms #1103.6:161.

———. ca 1938. The Saanich Indians of Vancouver Island. Unpublished manuscript. Ethnology Archives, Canadian Museum of Civilization. Ms #1103.6:111, appendices.

Latasse, David. 1902. Letter to Department of Indian Affairs. BC Archives. Cowichan Agency, Incoming correspondence for 1902–1904, RG 10 Vol. 1343, Reel B1874.

Lugrin, Nancy de Bertrand. 1931. Soliloquies in Victoria's Suburbia. *Victoria Daily Colonist*, September 30.

———. 1932. The Last Great Battle. *Macleans*, December 15:22&28.

———. 1936. Chief David's Saga. *Daily Colonist*, May 17:6.

McKelvie, Bruce A. 1957. *Fort Langley: Outpost of Empire*. Toronto: Thomas Nelson and Sons.

Stuart, Charles Edward. 1855. Nanaimo Journal, Oct. 9 & 13. In Nanaimo Correspondence. BC Archives, Ms A/C/20.1/N15.

Tate, Rev. Charles M. 1872–1933). The Son of the Nanaimo Chief's Carried Away by the Laquiltoes. BC Archives, Tate Family, Ms 0303, Box 1, File 6:1–39.

Taylor, Herbert C., Jr, and Wilson Duff. 1956. A Post-Contact Southward Movement of the Kwakiutl. *Washington State College Research Studies*:24:1:55–56.

Victoria Daily Times. 1936. Chief David Dies at 109, May 2:1-2.

Viso, El Edicionces. 1986. To the Totem Shore. The Spanish Presence on the Northwest Coast. World Exposition, Pavilion of Spain, Vancouver.

Wagner, Henry Raup. 1933. *Spanish Explorations in the Strait of Juan de Fuca*. Santa Ana, California: Fine Arts Press.

Chapter 3: Settlement Among the Songhees

Bolduc, J.B. 1845. *Extrait d'une letter de M. Bolduc, Missionnaire apostalique, à M. Ceyenne. Cowlitz, le 15 février 1844.* In *Annales De La Propagation De La F01 Recueil Péreiodique* 17, A Lyon. BC Archives NW282A614V.17.

Bowsfield, Hartwell (ed.). 1979. *Fort Victoria Letters 1846–1851.* Winnipeg: Hudson's Bay Record Society.

Douglas, James. 1843. Diary of a Trip to Victoria, March 1-21, 1843. BC Archives, Ms A/B/40/D75.4.

———. 1843. Letter Feb. 5, 1843 to James Hargrave. BC Archives.

———. 1848–63. Report of July 12, 1842, on the Survey of Southern Vancouver Island. Enclosure in letter from Sir J.H. Pelly to Benjamin Hawes. In: Great Britain Colonial Office Vancouver's Island. Copies and extracts of despatches ... London 1849. In Great Britain Colonial Office Miscellanious Papers relating to Vancouver Island.

Finlayson, Roderick. 1891. Manuscript. Autobiography of Roderick Finlayson. (BC Archives NW 971.1vi F512.)

———. n.d. History of Vancouver Island and the Northwest Coast. Manuscript. (BC Archives A/B/30/F49.1.)

Fort Victoria Account Book. 1852. Fort Victoria Affairs, Oct. 1852 – Dec. 1859, pp. 91, 171, 352, Ms, BC Archives.

Hudson's Bay Company. 1845–74. Fort Victoria Journal. Hudson's Bay Company Archives Ms B226/a/1; Fort Victoria, Miscellaneous Items, 1845-74. B226/z/1-3; Fort Victoria District Statements, 1852-53, B226/1/1.

Landerholm, Carl (ed). 1956. *Notices & Voyages of the Famed Quebec Mission to the Pacific Northwest.* Pp. 189-99: Letter of M. Bolduc to M.C. Cowlitz, February 15, 1844. Oregon Historical Society.

Lamb, W. Kaye. 1943. The Founding of Fort Victoria. *British Columbia Historical Quarterly* 7:2:71–92.

———. 1943. Five Letters of Charles Ross, 1842–1844. *British Columbia Historical Quarterly* 6:103–18.

McLoughlin, John. 1943. Letter to George Simpson, March 20, 1840. In: *McLoughlin's Fort Vancouver Letters.* Second Series, 1839–44. London: Hudson's Bay Record Society.

Rich, E.E. 1956. *London Correspondence Inward From Eden Colvile, 1849–1852.* London: Hudson's Bay Record Society.

Victoria Gazette, 1860, May 30, p.2: Contributions for Future Historians. (McNeil and McLoughlin landings in harbour).

Chapter 4: Life in the 1840s

Anderson, Alexander C. ca 1920 In: James R. Anderson, Additional Manuscript 1912:171.

Duff, Wilson. 1969. The Fort Victoria Treaties, *BC Studies* 3:57.

Elmendorf, William W. 1993. *Twana Narrative: Native Historical Accounts of a Coast Salish Culture.* Seattle: University of Washington Press.

Finlayson, Roderick. 1844. Letter of June 28, to James Douglas. BC Archives, A/B/40/F49.

———. 1879. History of Vancouver Island and the Northwest Coast. P. 7: Letter to Bancroft, Oct. 18, 1879. BC Archives A/B/30/F49.1.

———. 1891. Biography of Roderick Finlayson, Manuscript, BC Archives, NW 971.1.vi F512 1891.

———. 1848. Victoria Post Journal. Hudson's Bay Company Archives, B 226/a/1.

Harper, Russell J. 1971. *Paul Kane's Frontier.* (Including: *Wanderings of an Artist Among the Indians of North America* by Paul Kane.) Toronto: University of Toronto Press.

Kane, Paul. 1859. *Wanderings of an Artist Among the Indians of North America. From Canada to Vancouver's Island and Oregon Through the Hudson's Bay Company's Territory and Back Again.* Toronto: Longman, Brown, Green, Longmans and Roberts.

Lempfrit, Timothee. 1985. *Honore-Timothee Lempfrit, O.M.I. His Oregon Trail Journal and Letters from the Pacific Northwest 1848–1853.* Edited by Patricia Meyer. Translated by Patricia Meyer and Catou Levesque. Fairfield, WA: Ye Galleon Press.

Lamb, W. Kaye. 1943. Five Letters of Charles Ross, 1842–44. *B.C. Historical Quarterly* 7:2.

Ogden, Peter Skene. 1848. Letter of March 10, Donald Ross Collection, A-833, Add Mss 635.

Seemann, Berthold. 1853. *Seemann's Voyage of the* Herald. Vol.1: *Narrative of the Voyage of the HMS* Herald *During the Years 1845-51. Under the Command of Captain Henry Kellett, RNCB. Being a Circumnavigation of the Globe, and three Cruises to the Arctic Regions in Search of Sir John Franklin.* London: Reeve & Co.

Slater, G. Hollis. 1950. Rev. Robert John Staines: Pioneer Priest, Pedagogue, and Political Agitator. Appendix. Fragment of a Letter by Rev. R.J. Staines to Rev. Edward Cridge, Oct. 10, 1850. *B.C. Historical Quarterly* 14:4:187–240.

Suttles, Wayne P. 1974. *Coast Salish and Western Washington Indians.* I. *The Economic Life of the Coast Salish of Haro and Rosario Straits.* New York: Garland Pub.

Warre, H.J. 1976. Overland to Oregon in 1845. Impressions of a Journey across North America. Public Archives of Canada.

———. n.d. The Journal. Public Archives of Canada, Ottawa. MG24, F71, vols 1, 2 and 3 (microfilm B-3074).

Laurel Point Burial Grounds

Gilmore, Berenice. 1980. Artists Overland. A Visual Record of British Columbia 1793–1886, Burnaby Art Gallery, Century Park, September 10 to October 18, 1980. Provincial Archives of British Columbia, Victoria. November 3, 1980, to January 9, 1981. p.44 (mistakenly labels the drawing as "Departure Bay").

King, Jonathon C.H. 1999. *First Peoples First Contacts. Native Peoples of North America.* Boston: Harvard Univ. Press.

London Museum. 1859. Ethnology Document 1310. Paintings and commentary of Tyrwhitt Drake.

Lord, John Keast. 1866. *The Naturalist in Vancouver Island and British Columbia*, vol. 2. London: Richard Bentley.

Mayne, Richard. 1862. *Four Years in British Columbia and Vancouver Island*. London: John Murray.

Monroe, Robert D. 1960. Two Early Views of Vancouver Island. *Beaver*, Summer: 12–14.

Stenzel, Franz, and James M. Alden. Indian Graves Laurel Point Sept. 17, 1854 (plate 9, p.33) and Drawing of Laurel Point 1857 (plate 23, p.7). In: *Collection of the Washington State Historical Society*, Tacoma, Washington. BC Archives NW 759.13 A358.

Victoria Gazette. 1858. The Burying Ground of the Songhish Chieftains, at Dead Man's Point. Oct. 15 (vol. 1, no.67).

———. 1858. Contains a View of the Songhish Indian Burial Ground, At Deadman's Point, opposite Victoria. Oct. 22, p. 3. (Also: *Weekly Gazette*, Oct. 16)

Chapter 5: Wage Economy & Warfare

Bowsfield, Hartwell, ed. 1979. Fort Victoria Letters 1846–1851. Winnipeg Hudson's Bay Record Society.

Cook, William. 1912. Reminiscences of William Cook. BC Archives Manuscript # 738 (May 14), E/B/C78.2.

Douglas, James. 1845. Letter of March 5, 1845. To George Simpson. In: Appendix A. McLoughlins Fort Vancouver Letters to Govenor and Committee. Third Series, 1844–46. Edited by E.E. Rich, Hudson's Bay Record Society, 1944:177.

———. 1849. London Correspondence. Letter of October 28, 1849 to Deputy Governor of the Hudson's Bay Co. HBCA, Reel 163, A11/72.

———. 1850. Letter to James Murray Yale, Aug. 15, 1850, James Murray Yale Papers,. BC Archives, Add. Mss.105.

———. 1851. Governor James Douglas Despatches to London, Oct. 31, 1851 to Nov. 24, 1855. Original official letter book. BC Archives AA/10.1/2.

———. 1852. Letter of November 5, 1852, to Archibald Barclay. Great Britain Colonial Office. Records of Office Transcripts, Vol. 1, 1822-52.

———. 1855–59. Letters to the Hudson's Bay Company, Vancouver Island, Colony, Dec. 11, 1855, to July 8, 1859. BC Archives A/C/20/Vi3A.

Kuper, Captain. 1989. Four Letters Relating to the Cruise of the *Thetis*, 1852–53. *BC Historical Quarterly* 6:3.

Lowe, Thomas. 1843–46. Journal Kept at Fort Vancouver, Columbia River, June 15, 1843, to Jan. 5, 1846. BC Archives, Ms E/A/L95.

Mackay, Joseph. 1852–53. Letters to James Douglas. Nanaimo correspondence, August 1852 to September 1853. B.C. Archives, Manuscript A/C/20.1/N15.

McKelvie, B.A., and Willard Ireland. 1956. The Victoria Voltigeurs, *BC Historical Quarterly* 20:3–4:221–39.

Rich, E.E. 1956. *London Correspondence Inward From Eden Colvile, 1849–1852*. London: Hudson's Bay Record Society.

Slater, G. Hollis. 1950. Robert John Staines: Pioneer Priest, Pedagogue, and Political Agitator. Appendix. Fragment of a Letter by Rev. R.J. Staines to Rev. Edward Cridge, Oct. 10, 1850. *BC Historical Quarterly* 14:4:187–240.

Scholfield, E.O.S., ed. 1914. Annual Report of the Provincial Archives of B.C. for the year 1914. Papers Relating to the Colonization of Vancouver Island and Letters of Sir James Douglas, KCB, to Dr W.F. Tolmie.

Smith, Dorthy Blakely, ed. 1975. *The Reminiscences of Dr J.S. Helmcken*. Vancouver: UBC Press.

Wood, James. 1849. Notes on Vancouver's Island. *Nautical Magazine and Naval Chronicle* 299–301.

Chapter 6: Northern Invasions

Aborigines' Protection Society. 1856. *Canada West and the Hudson's Bay Company: A Political and Humane Question of Vital Importance to the Honour of Great Britain, To the Prosperity of Canada, And to the Existence of the Native Tribes; Being an Address to the Right Honorable Henry Labouchere, Her Majesty's Principal Secretary of State For the Colonies*. William Tweedie.

Douglas, James. 1854. Letter to Barclay, July 13, 1854. BC Archives, A/C/20/Vi2A.

———. 1855–59. Letters to the Hudson's Bay Company, Vancouver Island, Colony, Dec. 11, 1855, to July 8, 1859. BC Archives, A/C/20/Vi3A.

———. 1856. Letter to William G. Smith, March 5, 1856. BC Archives, A/C/20/vi3A.

———. 1856. Letter to Isaac Stevens, March 6. BC Archives, GR332, vol. 2:346.

Gates, Charles Marvin. 1941. Readings in Pacific Northwest History. Washington 1790-1895.

Gorsline, Jerry, ed. 1992. *Shadows of Our Ancestors. Readings in the History of Klallam-White Relations. Dalmo'ma VIII*. Port Townsend, Washington: Empty Bowl Press.

Griffin, Charles. 1854. Belle Vue Sheep Farm Post Journal. Hudson's Bay Company Archives, Manitoba, Microfilm Reel #1M16.

Illustrated London News. 1858. Victoria, Vancouver's Island. Sept. 4:228.

Lowe, James. 1853–58. Correspondence Outward, Sept. 13, 1853, to May 11, 1858. BC Archives, E/B/L951.

Lambert, Mary Ann. 1972. *The Seven Brothers of the House of Ste-Teethlum*. Port Orchard, Washington: Publishers Printing.

McCurdy, James C. 1937. *By Juan de Fuca's Strait. Pioneering Along the Northwestern Edge of the Continent*. Portland: Metropolitan Press.

Moffatt, Hamilton. 1859. Letter on Fur and Liquor trade to A.G. Dallas, July 9. In: Letter Book, Fort Rupert, Fort Simpson & Kamloops, 1857–1867. BC Archives, A/B/20/R2A.

Nanaimo Correspondence. 1852–53. (Aug. 1852 to Sept. 1853). BC Archives, A/C/20.1/N15.

Nugent, John. 1859. Vancouver's Island and British Columbia. Message from the President of the United States, communicating The report of the special agent of the United States recently sent to Vancouver's Island and British Columbia. House of Representatives, 35th Congress, 2d Session, Ex. Doc. No. 111.

Richards, Kent. 1993. *Isaac I. Stevens. Young Man in a Hurry.* Bellingham: Washington State Univ. Press.

Stevens, Isaac. 1856. Letter to James Douglas, Feb. 17, 1856. BC Archives, GR332, Vol.2:345.

Suttles, Wayne. 1954. Post-Contact Culture Changes among the Lummi Indians. *B.C. Historical Quarterly* 18:1–2:29–102.

Victoria Gazette. 1858. Aug. 14, Sept. 18 (An Indian Mystery), Oct. 12.

———. 1859. Jan.1, Feb 5, Apr. 28:2 (Our Indian Population), Sept. 14, Sept. 18, Nov. 16.

Wilson, Captain Charles. 1866. Report on the Indian Tribes Inhabiting the Country in the Vicinity of the Forty-Nineth Parallel of North Latitude. *Transactions of the Ethnological Society of London* New Series 4:275–332.

Woolsey, John. 1859. Letter of May 18. BC Archives, Ms F54W88.

Chapter 7: Aboriginal Title & the Victoria Treaties

Banfield, William. 1858. Becher Bay and Sooke Inlet. *Weekly Victoria Gazette*, Aug. 12.

———. 1858. The Nitinat District. *Weekly Victoria Gazette*, Aug. 14.

British Admiralty. 1846. America, North West Coast, Vancouver Island: Becher and Pedder Bays. Map, surveyed by Captain Henry Kellett, RN in HMS *Herald.* London: British Admiralty.

———. 1878. North America, West Coast, Vancouver Island: Becher and Pedder Bays. Map surveyed by Commander Daniel Pender, 1870. Ministry of Lands Branch, 4T3.

British Columbia Government. 1875. Conveyance of Land to Hudson's Bay Co. by Indian Tribes. Papers Connected with the Indian Land Question, 1850–75. Queen's Printer, Victoria.

———. 1927. Special Joint Committee of the Senate and House of Commons Appointed to Inquire into the Claims of the Allied Indian Tribes of British Columbia, As Set Forth in Their Petition Submitted to Parliament in June 1926. Report of Evidence, King's Printer, Ottawa.

British Columbia Ministry of Crown Lands. 1851. Victoria District & Part of Esquimalt. Map no. 108577. Vault 5, Locker L. (With letter of Sept. 11, 1851).

———. 1855. New Victoria Harbour Plan, "Indian Reserve (10 acres)". Plan 5, Locker 13, 1855 (also Ministry of Attorney General #AG 640445).

———. 1855. Victoria City Lots. Plan 5, Locker 13.

———. 1864. Papers Connected with the Hudson's Bay Land Claims at Victoria. March 16, Dispatch No.5. "Tracing of Indian Reserve copied from town map dated 1855. Tracing of Official map of the town of Victoria, 1858.

Culin, Stewart. 1901. A Summer Trip Among the Western Indians. The Wanamaker Expedition. *Bulletin of the Free Museum of Science and Art of the University of Pennsylvania* 3:3:153–54.

———. 1908. Report on a Collecting Trip Among the Indians of California and Vancouver Island, October 5, 1908. Brooklyn Museum Archives, Culin Archival Collection, Collecting Expeditions [2.1], July 10–16, pp.78-92.

Deans, James. 1898. Minutes of the Natural History Society of British Columbia, July 31, 1:58. BC Archives, Add. Mss.1077.

Douglas, James. 1850. Letter to James Yale, May 7, 1850. BC Archives, Add. Mss. 105, James Murray Yale.

———. 1850. Letter to Archibald Barclay, May 16, 1850. In: Fort Victoria Letters, *The Hudson's Bay Record Society* 32:94-96 (1979), edited by Hartwell Bowsfield.

———. 1853. Transcript. Private Papers of Sir James Douglas Second Series. BC Archives, B/20/1853.

———. 1854. Letter to Archibald Barclay, Aug. 26, 1854: Tracing of an Indian Reserve, which has been accidentally omitted in Lot No. 24, Section XVIII. BC Archvies A/C/20/V.

———. 1856. Private Papers. Indian Population Vancouver's Island, 1856. BC Archives, A E H37 H37.13.

Duff, Wilson. 1969. Fort Victoria Treaties. *BC Studies* 3:57.

———. n.d. Unpublished notebooks, Royal BC Museum Archives.

Easton, Norman. 1985. The Underwater Archaeology of Straits Salish Reef-netting. Master's thesis, Dept of Anthropology, U. of Victoria.

Eliza, don Francisco de. 1791. An Extract from the Log, Surveys, and Discoveries. BC Archives, A/A/10/M57t/v.3.

Fort Victoria Treaties. n.d. BC Archives, Add. Mss. 772 (f1).

George, Edward. n.d. Private Manuscript, Carry George, Sooke.

Gunther, Erna. 1927. *Klallam Ethnography.* Publications in Anthropology. Seattle: University of Washington.

Helmken, John S. 1888. Letter to Joseph MacKay. Nov. 30, 1888. BC Archives, Add. Mss. 1917, file 15.

Hendrickson, James, ed. 1975. Two Letters from Walter Colquhoun Grant. *B.C. Studies* 26:11.

Hill-Tout, Charles. 1907. Report on the ethnology of the southeastern tribes of Vancouver Island, British Columbia. *Journal of the Anthropological Institute of Great Britain and Ireland* 37:306–74.

Hudson's Bay Company Archives. 1850. Southern Tip of Vancouver Island Showing Division of Land into Squares of 640 Acres. Map. John Arrowsmith, London. G/1/134.

———. 1850. Victoria District, Vancouver Island, Walter C. Grant. Map. Provincial Archives of Manitoba, G1/256.

———. 1853. District Map of Metchosin, Sept. 26. Hudson's Bay Company Archives G1/258f.

———. 1853. Peninsula Occupied by the Puget Sound Company, J.D. Pemberton. Hudson's Bay Company Archives G1/258m.

———. 1853. Victoria and Puget Sound (Esquimalt) Districts. Map (copy of 1851 original, on a single sheet reduced scale). Hudson's Bay Company Archives G1/181.

———. 1854. Fort, Government offices, Section V1 of Douglas and "Indian Reserve". Map. Hudson's Bay Company Archives [A.11/75] [808864.001 - 1854/09/01].

———. 1854. Plan of Sooke District, J.D.Pemberton. Hudson's Bay Company Archives G1/136.

———. 1854. Plan of Victoria & Esquimalt Districts, Vancouver Island, J.D. Pemberton. Hudson's Bay Company Archives G1/253.

———. 1862. Tracing No.5: Large scale tracing showing changes in Government Reserve and Governor Douglas' property between 1855 and 1862 – Indian Reserve, A.11\80 Fo. 169a(N3541).

Ireland, Willard. 1953. Captain Walter Colquhoun Grant: Vancouver Island's First Independent Settler. *B.C. Historical Quarterly* 17:1/2:87–126.

Jenness, Diamond. ca 1938. The Saanich Indians of Vancouver Island. Unpublished manuscript. Ethnology Archives, Canadian Museum of Civilization Ms #1103.6, pp.111, plus appendices.

Kennedy, Dorothy, and Bouchard, Randy. 1995. An Examination of Esquimalt History and Territory: A Discussion Paper. Prepared for the Esquimalt Nation by the B.C. Indian Language Project, Victoria, B.C.

Latasse, David. 1932. Letter to Commissioner W.E. Ditchburn, April 4 1932 (with document signed by Saanich and Malahat chiefs). BC Archives, RG 10, 11:303, File 974/1-9.

Lemmons, Bishop J.N. 1893. Letter (on the origins of the reserve population). BC Archives, RG 10, Vol. 1343, Reel B1874.

Lomas, William Henry. 1886. Notebooks, BC Archives, FSL 831.

Lugrin, Nancy de Bertrand. 1928. *The Pioneer Women of Vancouver Island, 1843–1866*. Edited by John Hosie. Victoria: Women's Canadian Club.

Macfie, M. 1865. *Vancouver Island and British Columbia, Their History, Resources and Prospects* (p.430).

MacKay, Joseph W. 1888. Letter to J. H. Helmken, Dec. 3, 1888. J.W. MacKay ADD. Mss. 1917, file 27.

Pemberton, Joseph D. 1851. Plan of Victoria and Puget Sound Districts. Map. Ministry of Crown Lands, Vault 5, Locker L. G.1/131 (N8362).

———. 1854. Letter to A. Barclay Secretary of the Hudson's Bay Company, Sept. 1, 1854. ("In the transfer of the Fur Trade of lot no. 24, Section XVIII. A reserve of 10 acres for the Indians should have been left.")

———. 1855. The South Eastern Districts of Vancouver Island. From a Trigonometrical Survey made by the Order of The Honorable Hudson's Bay Company. London: John Arrowsmith (BC Archives CM/B700).

Suttles, Wayne P. 1974. *The Economic Life of the Coast Salish of Haro and Rosario Straits*. Volume 1 of *Coast Salish and Western Washington Indians*. New York: Garland Publications.

Walbran, John T. 1897. Place Names – Their Significance. In: *The Year Book of British Columbia and Manual of Provincial Information*, edited by R. E. Gosnell. Victoria.

———. 1909. British Columbia Coast Names. Their Origin and History. (Reprint 1971. Vancouver: Douglas & McIntyre.)

Victoria Daily Times. 1864. The Secret Feast – An Indian Legend Founded on Fact. October 17.

Victoria Gazette. 1859. Fire at Sawmill. August 29.

Chapter 8: First Attempt to Remove the Songhees

Green, William Sebright. 1869. Memorandum on a letter treating of condition of the Indians in Vancouver Island, addressed to the Aborigines' Protection Society. Dispatch, Nov. 15, 1869, Governor Musgrave to Earl Granville. In: British Columbia. Papers connected with the Indian Land Question, 1850–75: 10-12.

Hendrickson, James E., ed. 1980. Journals of the Colonial Legislatures of the Colonies of Vancouver Island and British Columbia 1851–1871. Volume 2: Journals of the House of Assembly, Vancouver Island, 1856–1863. BC Archives.

Indian Affairs, Department of, Government of Canada. 1859. Records: RG 10, vol. 3718, file 22:560-2A, Reel B-299. General. June 15. (List of Renters).

Keddie, Grant. 1991. Victoria's Early Hospital Properties. *Discovery*, Friends of the Royal British Columbia Museum Quarterly Review, 19:3:4-5.

Trutch, Joseph. Memorandum to the Colonial Secretary, December 30, 1869. (On the history of the reserve rental.)

Halket Island Burial Site
Daily Colonist. 1912. Indian Burying Grounds. March 4.

Daily British Colonist and *Victoria Chronicle*. 1867. The Fire on Deadman's Island. July 2.

———. 1867. The Incendiaries of Deadman's Island. July 3.

Fawcett, Edgar. 1912. *Reminiscences of Old Victoria*. Toronto: William Briggs.

Flewin, John. 1938. Burial Ground is told – John Flewin recalls old days of Indians in cast off uniforms. *Victoria Times*, Feb. 25.

Chapter 9: Trouble in the Camps

Akrigg, G.P.V., and Helen B. Akrigg. 1992. *HMS* Virago *in the Pacific 1851–1855. To the Queen Charlottes and Beyond* (re: Captain John, p. 115). Victoria: Sono Nis Press.

British Columbia Government. 1860. Court Records. Charge Book, BC Archives, Ms. GR308, v.25:126 and List of Prisoners 1860, GR308, v.1.

Daily Colonist. 1860. Feb. 28; Mar. 8, 24, 30; Apr. 3, 30; May 26, 30; June 7, 11, 20, 22, 24, 26, 27, 30; July 3, 5, 26; Aug. 1, 2, 3, 4, 7, 23; Sept. 1, 4, 5, 15; Dec. 15, 20.

———. 1861. Jan. 3, 16 (Indian Reserve Water Frontage, p.3); Feb. 21, 26; Mar. 4, 7; Apr. 9, 14, 15, 18 (Invasion of the Northern Indians), 20, 24; May 11, 12, 18, 21; June 14, 20, 28, 29; July 2, 7, 18, 20, 26, 30; Aug. 26, 27; Sept. 5, 7, 8, 9, 21, 22; Oct. 15.

Garrett, Alexander Charles. n.d. Reminiscences of A.C. Garrett (an overview and extracts from original material owned by F.A. Garrett, the grandson of the Alexander). BC Archives, Ms E/B/G19.

Hills, George. 1860. Report of the Columbia Mission for 1860. The Indian Mission at Victoria, pp. 89-95. BC Archives, NW 283 C726r.

———. 1860. An Occasional Paper: Letters from the Bishop of British Columbia to Commissary Garrett, Penzance. *British Colonist*, October 13:1

———. 1996. *No Better Land. The Diaries of the Anglican Colonial Bishop George Hills*. Edited by Roberta L. Bagshaw. Victoria: Sono Nis Press.

Indian Affairs, Department of, Government of Canada. 1860. Indian Reserve 1860 and Indian Improvement Account 1860-61. PAC, RG 10:1021:13-29.

New Westminster *Times*. 1860. Feb. 25.

Pritchard, Allan, ed. 1996. *Vancouver Island Letters of Edmund Hope Verney, 1862–65*. Vancouver: UBC Press.

Sabbe, John C. 1859–62. Journal on HMS *Termagant* and HMS *Cleo*, Feb. 11, 1859 – March 14, 1862. Ms. BC Archives.

Chapter 10: The Victoria Smallpox Crisis of 1862

Anderson, Alexander. 1878. Extract from letter of W.E. Cormack, New Westminster, Oct. 21, 1862. In: History of the Northwest Coast, 3:270, BC Archives Add. Mss. 559.

Daily British Colonist, 1862. Mar. 18 – Oct. 20.

Douglas, James. 1853. Letter to Archibald Barclay, May 16, 1853.

Gibbs, George. 1855. Report of Mr George Gibbs to Captain McClellan, on the Indian Tribes of the Territory of Washington, March 4, 1854. In: Report of Explorations for a Route … from St Paul to Puget Sound by I.I. Stevens. In vol. 1 of Reports of Explorations and Surveys … from the Mississippi River to the Pacific Ocean …1853–4. 33rd Congress, 2d Session, Senate Executive Document N0. 78 (serial No. 758) Washington, DC, Beverly Tucker, Printer.

Harris, Samuel. 1860. Report to James Douglas, Aug. 1, 1860. BC Archives, Colonial Corresp., B1332, File 661-731A.

———. 1862. Letter to William Young, July 14, 1862. BC Archives, Colonial Corresp., B1332, File 661-731A.

Hills, George. 1863. Extracts from the Journal of the Bishop of Columbia, 1862 and 1863. In: *Fourth Annual Report of the*

Columbia Mission for the Year 1862, vol. 4:56–64. London: Rivington's.

Victoria Press. 1862. Mar. 18 to Oct. 20.

Wren, Charles. 1848. Correspondence outward. BC Archives, (E/E/R731/C12/W92)

Coffin & Colville Islands Burial Sites

Daily Colonist. 1938. Skulls, Bones and Gun Found, Feb. 23:1.

Dally, Frederick. ca 1866. BC Archives Additional Manuscript, E/B/D 16M.

Monday Magazine. 1986. A Bridge Too Far. Vol. 12:12 (March 13–19).

Victoria Daily Times. 1938. Bones Found on Island in City. Feb. 23:14.

Chapter 11: The Early Minority Years

British Columbia Government. 1864. Journals of the Legislative Council. Session 1864. Introductory Address by James Douglas at First Session of January 21, pp. 180–81.

———. 1875. B.C. Papers 1875. Schedule of All Indian Reserves in the Province of B.C., p.104; Schedule of Leases for the "Victoria Harbour Reserve", Section 69, Appendix 1 p.106.

Canada, Government of. 1913. Discovery and Chatham reserves – Schedule of Indian Reserves in the Dominion for 1913, p. 63, Ottawa. BC Archives, F52 B77.3.

Canadian Historical Association. 1975. An Exercise in Futility: The Joint Commission on Indian Land in British Columbia, 1875–1880. In *Historical Papers*, p. 80.

Daily British Colonist. 1863. Mar. 23 (Shingles), Dec. 31 (Shipping Vessels).

———. 1864. Apr. 6:3 (Songhees Meeting with Governor Kennedy), June 27:3 (re: Clallum visitors),

———. 1868. Sept. 12 (re: Haida village fire).

———. 1873. July 22:3 (Sojourning Indians), Sept. 27 (Indian Participation), Oct. 5 (Indian Police).

———. 1876. May 27:2 (A.C. Anderson Appointed by the Dominion Government as their Arbitrator in Settlement of Indian Lands).

Everett, Patrick. 1862. Letter to Department of Indian Affairs. BC Archives microfilm, RG 10, Volume 3623, file 5119.

Hendrickson, James E., ed. 1980. Executive Council of Vancouver Island, 1864. Minutes of Sept. 22, p. 145 (proposal to remove Songhees to Discovery Island); minutes of Feb. 9, p.170 (Letter 1st Feb., Jay and Co., Discovery Is.); May 29, p.180 (resolution of May 23); Introductory Address by C.B. Edward at First Session of November 28, 1865, pp. 373–5. Journals of the Colonial Legislatures of the Colonies of Vancouver Island and British Columbia 1851–1871. Volume 3: Journals of the House of Assembly, Vancouver Island, 1863–1866. BC Archives, Session 1865.

Hudson's Bay Company Archives. 1868. Esquimalt Account Book.

Details of Expenditures on Wharf and Buildings Construction at Esquimalt Outfit, 1868. B65d/1.

Indian Affairs, Dept of, Government of Canada. 1912. (re Songhees Reserve size). BC Archives, R6 10, Vol. 3718, File 22, 560-2A.

Nagle, Jeremiah. 1858. Indenture of July 28, Jeremiah Nagle for 5 acres – Songhee Reserve. BC Archives, Crease Collection, file 24.

Powell, J.W. 1873. Letter to George A. Malkum, Attorney General, Nov. 6, 1873. BC Archives GR0429, Box 1, File 2, 151/73.

Pritchard, Allan. 1996. *Vancouver Island Letters of Edmund Hope Verney, 1862–65.* Vancouver: UBC Press.

Provincial Secretary, British Columbia Government. Commissioners for management of reserve appointed, Aug. 13, 1862. BC Archives ms GR 504, file 1.

Trutch, Joseph. 1869. Memorandum to Colonial Secretary, Dec. 30, 1869 (re: the commission hiring a surveyor and land agent). (In: *Victoria Colonist*, June 17, 1909:2.)

Victoria Chronicle. 1868. Sept. 12 (re: Haida village fire.).

Victoria Evening Express. 1864. April 6:3 (Songhees and Kennedy).

Chapter 12: Potlatches & Winter Dances

Daily British Colonist. 1863. Sept. 26:3 (Grand Indian Potlatch), 28 (Aboriginal), Sept. 28 (Haida man and woman named "Hillswash and Titelision"), Sept. 29:3 (Indian Potlatch), Sept. 30:3 (Indian Rejoicings), Oct. 1:3 (Termination of the Siwash Festival).

———. 1874. Apr. 23 (The Indian Potlatch), Apr. 28 (The Potlatch).

Dally, Frederick. 1866. Miscellaneous Papers. BC Archives, Add. Mss. 2443, B1/F10.

Edgar, J.D. 1874. A Potlatch Among Our West Coast Indians. *The Canadian Monthly and National Review* 6:2:93–99.

Macfie, Matthew. 1865. *Vancouver Island and British Columbia, Their History, Resources and Prospects* (p. 430). London.

Owen, H.B. 1868–69. Reports of Rev. H.B. Owen, Missionary at the Indian Reserve, Victoria, to the United Society for the Propagation of the Gospel. Nov. 1 to Dec. 31, 1868 and April 1 to June 30, 1869, vol. E26a, pp.833–49 and pp. 851–59. Rhodes House Library, Oxford.

Victoria Evening Express. 1863. Sept. 28:3 and Sept. 29:3 (Indian Festivities).

Muir, Andrew Forest. 1951. George Mason, Priest and Schoolmaster. *B.C. Historical Quarterly* 15:1–2:47–70.

Chapter 13: The Politics of a New Era

Canada, Government of. 1877. Census of Indian Tribes, 1876 and 1877. National Archives of Canada, R.G. 88, Vol. 194.

Canadian Annual Review of Public Affairs. 1905. The Songhees Indian Reserve Bill was presented to the House on Feb. 22nd (p.381).

———. 1906. The Songhees Reserve on the west side of the harbour (pp. 485–6).

———. 1908. Political Conditions and Legislation at the Coast. BC Archives, N.W.971 C251.

Daily British Colonist. 1876. Aug. 16, 18 and 24 (on Gov. Gen. Lord Dufferin and the Gorge Regatta).

Daily Colonist. 1894. October 17:2 (Chief Charlie's Funeral).

———. 1899. Nov. 28:5 (The Board of Arbitration – Proceedings to Assess E.&N. Right of Way), Nov. 29:3 (Right of Way on The Reserve), Dec. 1:6 (Valuation of Reserve Lands).

———. 1900. Jan. 24:5 (Indian Reserve In Legislature), Jan. 25 (Letter from Thomas Sorby to Sir Louis Davies, Minister of Marine and Fisheries in Ottawa, January 15), Jan. 25:8 (The Harbour Improvements).

———. 1907. Jan. 11:3 (Report of Department on Songhees' Reserve), Jan. 11:3 (Frank Pedley, Reviews Negotiations with Songhees).

Gunther, Erna, trans. 1977. *Alaska Voyage 1881–1883. An Expedition to the Northwest Coast of America.* From the German text of Adrian Woldt. Chicago: University of Chicago Press.

Hibben's B.C. Directory 1877–78. Aboriginal Wages, p.35.

Hills, George. Journal for 1891. UBC Library Special Collections.

Indian Affairs, Department of, Government of Canada. 1885. Powel letters of Oct. to Nov. 1885; Powell letter of Dec.4 and 16 and telegram of Dec. 4, 1885. RG 10, Vol. 3718, File 22, 560-2 (microfilm reel B299).

———. 1887. Letter of Jan. 31, 1887: "Caretaker and Special Constable" assigned to Reserve.

———. 1893. John Raynes' letter to A.W. Powell, Jan. 17, 1893. R6, Volume 3847, File 75, 072.

———. 1893. Smallpox 1892 & Case discovered July 15, 1893. R.G. 10, Vol. 3905, file 104,623.

———. 1897. Letter from Indian Agent W. H. Lomas to A. W. Vowell, Indian Superintendent, Mar 21.

———. 1897. Minutes of a Songhees Band Meeting, March 20. RG10, vol. 3968, f154, 635.

Lomas, William Henry. 1886–93. Notebook 1886–1893. Songhees Reserve Census of Aug. 26, 1886 and April 7, 1893. Discovery Island census of March 3, 1893 (Ref: Oct. 21, 1892). BC Archives Ms. F/5/L83.1.

Pedley, Frank (Deputy Superintendent of Indian Affairs). 1907. Report of Department on Songhees' Reserve. *Victoria Daily Times* 10:1,7.

Powell, I.R. 1887. Letter of January 31, 1887, regarding school funds. Department of Indian Affairs, Ottawa, R6 10, vol.3772, file 35139.

Victoria Gazette. 1876. Aug 22 (Basis of Land Arbitration).

Vowell, A.W. 1904. Letter to Robertson, Dec. 13, BC Archives, RG10 Vol. 1343, Reel B, 1874.

Chapter 14: Employment, Recreation & School

Clarke, Captain. Pelagic Sealing, BC Archives Manuscript, Newcombe Collection, Misc. #29.

Daily British Colonist. 1881. June 15:3 (Arrivals From Clayoquot Sound).

Daily Colonist. 1893. Sept. 3:2 (Indians Returning from the Canneries), Dec. 5:5 (The City – Indians on their way from the canneries to the hop fields).

———. 1894. Dec. 20:4 (Employment).

———. 1895. May 8:8 (The Earle Lost).

———. 1896. April 15 (Sealing Vessels), May 20:5 (Disappears in Gale).

———. 1897. May 13 (Gardens and Fences; Conditions on Reserve).

———. 1898. Dec. 20:4 (Have Three Reserves – Songees Indians Better Off in the Way of Homes).

———. 1899. July 25:5 (New Buildings).

———. 1900. Jan. 1:5 (Sealers Have Great Success).

———. 1923. Nov. 25:21 (Old Salts Revive Sealing Memories as Treat Expires).

Fawcett, Edgar. 1912. Evolution of the Songhees (descriptions of life on the reserve in the 1870s and 1880s). *Victoria Times*: Mar. 23.

Howay, F.W., and W.N. Sage. 1942. The Fur-seals: Depletion and Conservation. 1867–1912. In: *British Columbia and the United States. The North pacific Slope From Fur Trade to Aviation*, Toronto: Ryerson Press.

Rohner, Ronald, ed. 1969. Franz Boas Letter of September 19, 1886. In: *The Ethnography of Franz Boas. Letters and Diaries of Franz Boas written on the northwest Coast From 1886 to 1931*. Chicago and London: The University Press.

Victoria Daily Times. 1900. Dec.22:3 (Victoria's Sealing Industry).

Victoria Sealing Company. 1889–1917. Log books for the *May Belle* and *Walter H. Earle*. BC Archives, Add. Mss. 16.

Williams B.C. Directory. 1892. (Description of Reserve, p.416).

Wright, Edgar W., ed. 1895. A Brief History of the British Columiba Sealing Industry. In: *Lewis & Dryden's Marine History of the Pacific Northwest*. Portland: Louis & Dryden Printing.

Chapter 15: The Ches-lum George Potlatch of 1895

Fisheries Files. n.d. UBC Special Collections Microfilm, Government Publicatons, AW1 5474, Reel G3, File 3185, Part 1. (Mud Bay boats.)

Lewis, David Owen. 1895. A Potlatch Dance. *The Canadian Magazine.* 5:4:338–44.

Taylor, William S. 1910. Results of an Art Trip to the Northwest Coast. *The American Museum Journal* 10:2:42–49.

Chapter 16: The Last Big Potlatches

Daily Colonist. 1895. May 23:5 (On the Reservation); May 23:8 (Among the Indians); May 27:3 (Notice of George Cheetlam Potlatch); May 30:5 (Potlatch Over).

———. 1900. May 22:5 (Potlatch On The Reserve; A Picturesque Celebration Marks Payment of a SubChief's Debts).

———. 1901. Jan. 1:1 (An Early Settlement of the Question of the Removal of the Indians Urged on the Government), Jan. 20:8 (A Songhees Celebration; Early Morning Feast at Which 300 Indians Were Present), Jan. 23:7 (Indians Mourn); Apr. 18.

———. 1907. July 1:2 (Risks His Life to no Purpose)

———. 1937. May 13 (Missing Indian Feared Drowned. Esquimalt Police Find Canoe, Oar and Hat Belonging to Jacob Chipps, West Coast).

Imperial Cannery Records. 1903–8. UBC Special Collections.

Register of Deaths. Death Certificate of Ida Jackson. BC Archives Microfilm No. B13095, GSU No. 1927123.

Roberts, Rev. A.E. 1907. A Hero of the Western Coast. *Victoria Daily Times*, July 20:10.

Chapter 17: The Final Move

Canada, Government of. 1911. An Act respecting the Songhees Indian Reserve. In: House of Commons Session of April and May 19, 1911, Statutes of Canada, 1911, 1-2, His Majesty George V, Chapter 24.

Canadian Annual Review of Public Affairs, 1910:542-543.

Daily Colonist. 1910. Oct. 26:1, 2 (The Indians all expressed their satisfaction with the proposal), Oct. 28:1 (Songhees and Government officials visit proposed Reserve), Oct. 29:1 (Map: Proposed New Songhees Indian Reserve, Esquimalt District), Oct. 30 (Ineffectual Protest Made on Behalf of Ten Female Members of Tribe – Act Gives Them No Voice), Nov. 6 (New Reserve).

———. 1911. Apr. 30 (Songhees Collect Last of Moneys New Reserve at Esquimalt is Now Held by Dominion Government as Trustees for Indians).

———. 1912. Jan. 19:3 (Will Burn Trees on Old Reserve), Jan. 31:6 (Squatters on Reserve).

Daily Colonist, Sunday Magazine. 1910. Nov. 6:1, 2 (Men of the reserve work in the city, in canning factories and on the wharves. Others cultivate).

Ellison, Price. 1910. Letters to H. Dallas Helmken: January 14 (interview with Chief Cooper); January 15 and 17 (discussions with Songhees for removal); July 2 (results before visit by Prime Minister. BC Archives, GR 1440, file 30718.

Harris, Martha Douglas. 1912. The Case of Tom James (letter to the editor). *Daily Colonist*, Jan. 7 and 9.

Helmken, H. Dallas. 1910. Letters to Price Ellison: Feb. 23, ("I had a very serious conference with Chief Cooper & William Robert"); Mar. 7 (re: Agent Robertson making a census of the Songhees); Mar. 12 (report of Agent Robertson's population figures and confirmation with Chief Cooper); July 16 (visited Cooper at Todd Cannery); Aug. 2 (Chief Cooper's duties at the cannery); Aug. 23 (reports what Chief Copper said to Charles Todd about Laurier speech); Aug. 26 (Songhees who make their living away from the reserve); Oct. 14 (report on Olympic Peninsula hop-picking). BC Archives, GR1440-file 30718.

Indian Affairs, Department of, Government of Canada. 1910. Annual Report of the Department of Indian Affairs for the Year ended March 31, 1909. In: Sessional Papers, 20a to 21, vol. 44:11:61, 174.

Roberts, William. 1912. Who Tom James Is (letter to the editor). *Daily Colonist*, Jan. 10.

Tate, Rev. Charles M. 1912. More About Tom James (letter to the editor). *Daily Colonist*, Jan. 11.

Victoria Daily Times. 1911. April 4:18 (Reserve Ceremony).

Appendix: Songhees Traditional World View

Bouchard, Randy, and Dorothy Kennedy, editors and annotators. 2002. *Indian Myths and Legends from the North Pacific Coast of America. A Translation of Franz Boas' 1895 Edition of* Indianische Sagen Vonder Nord-Pacifischen Kuste Amerikas. Vancouver: Talon Books.

Deans, James. 1891. Yicsack. *The Antiquarian*, 1:3:45–48.

Duff, Wilson. 1953–60. Miscellaneous notes on local Salish. Wilson Duff Collection, Records, Royal BC Museum.

Jenness, Diamond. ca 1934–36. Coast Salish Field Notes, Ethnology Archives, Canadian Museum of Civilization Ms #1103.6.

Harkin, Michael E. 1990. Person, Time, and Being: Northwest Coast Rebirth in Comparative Perspective. In: *Amerindian Rebirth. Reincarnation Belief Among North American Indians and Inuit,* edited by Antonia Mills and Richard Slobodin. Toronto: University of Toronto Press.

Hayman, John, ed. 1989. The Indian Story of Jack and the Bean Stalk. In: *Robert Brown and the Vancouver Island Exploring Expedition.* Vancouver: UBC Press.

Howay, Frederick W., ed. 1990. Robert Haswell's Log of the First Voyage of the *Columbia.* In: *Voyages of the Columbia to the Northwest Coast 1787–1790 and 1790–1793.* Oregon Historical Society Press.

Mills, Antonia. 1994. Reincarnation Belief among North American Indians and Inuit: Context, Distribution and Variation. In: *Amerindian Rebirth. Reincarnation Belief Among North American Indians and Inuit,* edited by Antonia Mills and Richard Slobodin. Toronto: University of Toronto Press.

Miller, Jay. 1993. A Kinship of Spirit. In: *American in 1492. The World of the Indian Peoples Before the Arrival of Columbus,* edited by Alvin M. Josephy, Jr. New York: Vintage Books.

Newton, Betty C. 1950. The Two Sisters – Story Told to Betty C. Newton in 1950 by James Cheachlacht, Songhees Indian aged about 77. BC Archives.

Stern, Berhard. 1934. The Lummi Indians of Northwest Washington. Columbia University Press.

Suttles, Wayne P. 1954. Post-Contact Culture Changes among the Lummi Indians. *B.C. Historical Quarterly* 18:1–2:29–102.

Index